STRENGTH:
BROADSIDES FROM DISABILITY
ON
THE ARTS

AN ANTHOLOGY OF WRITING ON:
DISABILITY, THE ARTS, AND DISABILITY ARTS

STRENGTH:

BROADSIDES FROM DISABILITY

ON

THE ARTS

AN ANTHOLOGY OF WRITING ON:
DISABILITY, THE ARTS, AND DISABILITY ARTS

Taken from

speeches commissioned between

1992 and 2002

and other writing

by

PADDY MASEFIELD

With funding from Arts Council England

Trentham Books

Stoke on Trent, UK and Sterling, USA

Trentham Books Limited
Westview House 22883 Quicksilver Drive
734 London Road Sterling
Oakhill VA 20166-2012
Stoke on Trent USA
Staffordshire
England ST4 5NP

First published 2006

British Library Cataloguing-in-Publication Data
A catalogue record for this book is available from the British Library

ISBN-13: 978-1-85856-380-0
ISBN-10: 1-85856-380-1

Printed in Great Britain by Bemrose Shafron (Printers) Ltd., Chester..

BALANCE by Phil Lancaster

Cover image:
David Toole
(ICON OF A DECADE #1)
(from CandoCo Dance's Back to Front with Sideshows 1994)

Consultant Editors

Dr Scilla Dyke MBE, FRSA
Leads the Professional Studies Programme with The Royal Academy of Dance, and is a former Editor, and now guest columnist for international dance magazine *Animated*

Julie McNamara BA, FRSA
Award winning playwright, poet and performer; formerly Artistic Director of the London Disability Arts Forum; founder UK annual Disability Film Festival at NFT; Advisor to *DAIL* magazine

Dr Alastair Niven OBE
Formerly Director of Literature both at the Arts Council of Great Britain and the British Council and a Booker Prize judge. President of English PEN

Adrian Phillips
Runs the High Wide and Handsome arts training and advisory consultancy. Spent ten years as an actor, before becoming an arts marketing specialist

Sarah Scott
25 years in the field of Deaf and Disability Arts; developing UK Sign Song, performing and producing. Formerly Disability Arts Policy Officer at the Arts Council of England

Allan Sutherland
Director of the Edward Lear Foundation, a Disability Arts think tank. Formerly Chair of LDAF and adviser to the Arts Council; scriptwriter, poet and journalist

Picture Editor and Researcher

Caroline Masefield
Studied at the Art School at the University of Turin. Formerly manager of the New Grafton Gallery, and editorial assistant at *Queen* Magazine

ACKNOWLEDGEMENTS

I should particularly like to thank:

Arts Council England, South West for demonstrating their growing awareness of disability issues through providing the funding to make this book possible; Moya Harris for her commitment to securing that funding and initiating the project; Julie McNamara and Joe McConnell for their contributions to the development of the project; and Colin Hambrook for making available his extensive knowledge of the visual arts of disabled people.

Special thanks are due to my six Consultant Editors for their generosity of time, wisdom and advice; and in particular to Allan Sutherland for overseeing the accuracy of disability details and for creating three specialist appendices. To my Picture Editor Caroline I owe the deepest gratitude for her research, for typing all my work and facilitating my access to all written material.

I should expressly like to thank all those who have so generously contributed original art work:

Phil Lancaster, Alison Lapper, Rachel Day, Caroline Cardus, Lyn Martin, Crippen, Geof Armstrong, Colin Pethick, Eddy Hardy, Kathleen Franklin, Aidan Shingler, Catherine Woolley, Pasquelina Cerrone, Kevin Hogan, Brenda Cook, topright designs, Clare Thomas, Emma Cooke – Stem Designs, Graeme Ross, James Braithwaite, Tony Seeley – Shout Communications, Nancy Willis, Tony Heaton, the Adam Reynolds Estate, Aaron Williamson, Philip Ryder, Steve Cribb, Philip Martin Chavez, Fatma Durmush, Colin Hambrook, Mark Ware, and David Hevey.

The publishers gratefully acknowledge the following for supplying photographs:

Hugo Glendinning (cover image), Patrick Baldwin (Nabil Shaban, Darryl Beeton, Lisa Hammond and Mat Fraser, Ray Harrison Graham and Deborah A Williams), Toni Foster, Amanda Headley-White, Granada, Michele Martolini, John Buckley Photography, Sheila Burnett, Ruth McKenzie, Alexandra Scott, Anthony Crickmay, Tom Olin, Christopher de Graal, Turtle Key Arts, Lizzie Coombes, Ravinder Dhaliwal, Mat Fraser, Ewan Marshall, Nemia Brooks, Carol Stevens (Director of Photography for Frida Kahlo's Corset) and Terry Flaxton (Director of Photography for Nectar), Tony Fisher and LDAF, NDAF and NorDAF.

The companies CandoCo, Inter-Action MK, Graeae, Amici, The Lawnmowers, Heart 'n Soul, art + power, Common Ground (Denise Armstrong, Isolte Avila), Extant, Mind the Gap and Roaring Girl Productions. With a particular thank you for the poems to GMCDP and author's estate for *My Place* by Sue Napolitano, Peter Campbell for *Decisions*, and Allan Sutherland for *Old Epileptics* and extracts from *Paddy: A Life, Transcription Poems*.

And finally my thanks to all who commissioned the speeches on which this book is based and most of all those whose shared experience inspired them.

DEDICATION

To the family of disabled people who were already there to be my relatives, my friends, my accomplices in small jokes, my supporters in hard times, new mentors in my world of ignorance, when I first found myself as a disabled person, aged 44. This book is dedicated to you, your descendants, and the friends who have gone before us.

CONTENTS

FOREWORD

David, Lord Puttnam of Queensgate CBE

From personal experience I know that Paddy Masefield is a truly remarkable human being. In the mid-1990s I served alongside Paddy on the Arts Council's Lottery Panel, where he bore the brunt of all decisions related to access and disability.

A fair degree of friction developed early on because almost every serious capital project, be it a new theatre, a re-developed arts centre or whatever included a full disablement access and facilities package, sending budgets soaring, sometimes to prohibitive levels.

Some of us nagged away at Paddy, urging him to be a little more flexible. But, to his eternal credit, Paddy was absolutely resolute. In every discussion about what to fund and what not to fund, he refused to cut corners or compromise. And it was through his apparent obduracy that I eventually came to realise that to move forward, to really get our priorities right, we had to listen to and learn from his experience. What Paddy made all of us realise was that the only way of achieving meaningful and sustainable change is to deal with these absolutely fundamental and enduring issues.

In one sense little has changed in the intervening ten years. We still need to recognise that these are not issues that will somehow be ameliorated today, tomorrow or the day after by short-term grants or coercive legislation. Nor are they simply about persuading people and organisations to meet a set of relatively negative compliance criteria – crucial though that can certainly be.

Thanks to Paddy, every one of us on the Lottery Panel began to look at the whole range of issues surrounding disability differently. We began to focus on the opportunity for Britain to take the lead in the technology and supply of products and services which might dramatically improve the lives of dis-

abled people throughout the world. We became excited by the notion of being a 'beacon of best practice' and even inventiveness in an area which had for far too long been undervalued, sometimes even ignored.

I learnt a huge amount from Paddy. I came to understand that significant change requires the creation of organisations *of* disabled people, rather than *for* them. It's all about empowering people to live independent and integrated lives on equal terms, and understanding the benefits of engaging fully with the social and cultural issues and the very specific challenges facing disabled people.

Much rests on persuading people to take risks, to abandon ingrained assumptions and habits of thought. For in the end, all the work that's being done around disability is not just about practical, pragmatic issues – it's also about something more intangible. It's about instilling confidence, vitality and a sense of opportunity in everyone involved.

And it's also about something far greater: the need for continual, long-term commitment to campaigning – the kind of commitment that Paddy has demonstrated unflaggingly over so many years.

Oscar winning film producer David Puttnam was Chair and Chief Executive of Columbia Pictures from 1986 to 1988. He now focuses on his work in education. He is Vice-Chancellor of the University of Sunderland, as well as founding and chairing the Teaching Awards Trust. He is also President of UNICEF UK and a patron of Action for M.E.

INTRODUCTION

This book is about the experience of disability. It is not about medical conditions or medical opinions. It is about the perpetuation of historic injustice, about apathy on the part of society and neglect on the part of government combining to appear as prejudice in the practice of the UK's arts establishment from which disabled people are largely excluded. It is about the arts – about the power, passion and variety of expression that occur in the extraordinary fusion when these two elements combine in Disability Arts. They are the force of this book.

It is written by a man who has spent 40 years at the heart of the arts funding establishment and the artistic leadership of its regional, national and international arts policies. After leaving Cambridge University in 1966 with an MA in Social Anthropology I experienced almost no consciousness either of disability issues or of disabled people until I became one at the age of 44. My professional arts experience thus divides exactly into twenty years as a non-disabled person and twenty as a disabled person. So I am ideally positioned to introduce non-disabled arts workers to the rank realities of disability experience and disabled people to the remarkable potential of the arts.

That one quarter of the world's population is estimated to be disabled people may come as a surprise to readers. What may shock arts professionals even more is the public exposition that in the UK, where one in five of the population is a disabled person, fewer than one in five hundred can be found in the entire arts industry. It is a matter of scandal that no legislation to date, no prescribed action, no forethought by arts leaders have significantly affected the figures of exclusion, altered public misconception, nor ameliorated the misrepresentation, nor the barriers and the hostility encountered daily by disabled people.

While much of society may pity or patronise towards disabled people, Disability Arts are most frequently inspired by the experience of disability. And they are specifically motivated by what others might wrongly presume to be the 'difficulties' of manufacturing their art.

Where society imagines weakness, Disability Arts show extraordinary strength. Strength of mind, strength of conviction, strength of communication of hitherto unknown experience, and frequently a strength of humour. Strength there certainly is in quality. But it has been the failure to recognise this by the arts establishment in the UK that has consistently precluded strength in quantity.

This book will fill a void in the present studies of the social sciences and the arts, where library shelves have lacked any comprehensive representation of Disability Arts and where the lost history of disabled people has been accepted as the norm.

Since the arts are the expression not only of ourselves as individuals and how we perceive others, but also of our society, the arena of the arts is a key battleground for change in the disability rights movement. Disability Arts only became a publicly recognised movement in the year I became a disabled person (1986). So I have been privileged to chronicle from the inside their development, experiments and growing assurance.

My experience as Chair of the national Think Tank of Year of the Artist, 2000 and as the only disabled person in the reformed UK UNESCO Commission lend me authority to speak on behalf of all artists disabled and non-disabled.

I have acquired a uniquely diverse portfolio of arts experience; work that ranged from arts administration to artistic directorship; from being sought as an arts marketing expert not only on disability but for young people; and from a decade as the UK's most prolific playwright to a decade as its leading arts consultant. But I have also been sought and bought as a highly respected speaker on the arts of the last fifteen years. Extracts from over fifty speeches commissioned by bodies as diverse

as the Arts Council of Great Britain, the British Film Institute, the Museums Association, the National Disability Arts Forum, Central Television, the Royal National Theatre, the University of Central England, school governors and the European Theatre Directors Forum are at the core of this book.

The illustrations will dazzle even professional arts workers hitherto unaware of Disability Arts. The four specialist appendices will assist students and general readers to develop their interest in this field more fully. This book is laid out as an anthology, but also one that can be read as one narrative of the journey of the author.

Chapter 1

FULL FRONTAL

None of you will go to bed tonight and wake up tomorrow a different colour; very few of you will go to hospital tonight and wake up having changed your gender; but any of you could go to sleep tonight and wake up tomorrow a disabled person. Indeed, if only due to the ageing process, it is highly probable that all of you may at some point experience disability.

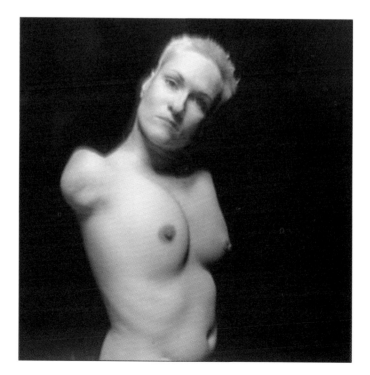

Alison Lapper MBE
(ICON OF A DECADE #2)
The Venus de Milo provided Alison with the inspiration
she needed to start using her own body in her artwork.

Research by the Department of Social Security (1997) reveals that around 20per cent of the adult population of the UK, that's 11.7 million people, are covered by the provisions of the Disability Discrimination Act (1995). So that's 1 in 5 of us. Yet in the entire arts industry of more than 650,000 people, disabled people show up as only 1 in 500. Surely that is not only the entertainment industry's greatest vanishing act, but also the most shameful act in the play of arts history?

– – –

And it gets worse. For by the most bitter of ironies, it is the arts from which disabled people have been most excluded that are the very platform they have targeted for telling their stories, painting their truths, advancing their dreams, and erasing the old prejudices that history has hung round the necks of disabled people since biblical times.

– – –

For in Leviticus, the third book of the Old Testament, it is said that:

> The Lord spoke unto Moses saying – whosoever he be of thy seed in their generations that hath any blemish, let him not approach to offer the bread of his God.

> For whatsoever man he be that hath a blemish ... a blind man, or a lame, or he that hath a flat nose or anything superfluous, or a man that is broken-footed or broken-handed, or crook-backed, or a dwarf, or that hath a blemish in his eye, or be scurvy, or scabbed, or hath his stones broken ... he shall not come nigh unto the altar, that he profane not my sanctuaries.

– – –

What an extraordinarily explicit list, just in case a single one of my historical colleagues might have slipped through the net. Rejected then, rejected now. Is it any wonder that we so fervently seek inclusion?

– – –

Despite all this, a significant sector of disabled people in this country have chosen neither politics, nor law, nor education, nor big business as their means of changing society, but the arts. They aspire to being seen as artists.

– – –

Artists are our last true explorers. With the known world now mapped, who but artists can – in fact and in fantasy – make the most wildly unexpected discoveries, tell us amazing travellers' tales, and show us images which rival the impact of seeing our first corpse, our first corpuscle, or our first hippopotamus?

– – –

A study in New Zealand a few years ago revealed that those who participated in the arts were far less likely to be involved in crime than those who participated in sport. The arts, it would seem are Monopoly's 'get out of jail' card.

– – –

But not if we're kept off TV.

– – –

In 1995, the TV play *Skallagrig*, whose issues and casting were almost entirely of disabled people, won a prestigious BAFTA award for drama. From the detailed follow-up research by the Broadcasting Standards Council, I have selected three quotes. Interestingly the BSC uses no names. Instead and inappropriately, they just use labels of impairment:

■ From an able-bodied woman in London: 'To me, the disabled are not people like your brother or son. It's someone in a wheelchair – probably dribbling. I just can't see it ever being right that they should be on national television, which after all is about communication.'

■ From a wheelchair user: 'I love my life as a disabled person, but society won't accept that.'

■ From a blind woman in Glasgow: 'If you saw more disabled people on television, maybe people would be a bit more sympathetic and not so frightened.'

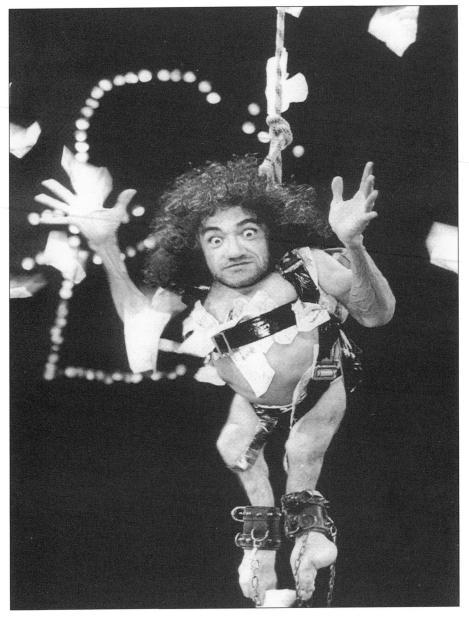

Nabil Shaban
(ICON OF A DECADE #3)
One of the finest actors of his generation, Nabil should have been a core
member of the Royal National Theatre Company for the last decade.
(from Graeae Theatre Company's *Flesh Fly* 1996)

A wonderfully challenging conference in 1995 arguing for inclusive education for disabled children called itself simply 'Invisible Children', because the average disabled child watching television, like the vampires of legend would find no reflection of themselves in children's television programming.

– – –

At a Human Rights Conference in Helsinki in 1993 I met a young German lawyer, Theresia Degener, who gave me this true story. According to German law, non-disabled people have a right to damages if they meet disabled people in their hotel during their vacation. The district court of Flensburg decided that a travel agency had to pay damages to its clients because they were confronted with disabled people in their hotel restaurant. The court reasoned as follows: 'The plaintiffs and their children could not enjoy their meals without being disturbed. The inescapable view of the disabled in a small room during meals caused disgust, and insistently reminded the plaintiffs of the possibility of human misfortune. Such experiences do not belong to a typical vacation.'

– – –

People tell me that Theresia's story could never happen in the UK. Well, improbable as it sounds, I was one of only two disabled people at my very first conference for 'arts workers in disability', after joining the Arts Council of Great Britain's Arts and Disability Monitoring Committee. And, yes, at the close of the day-long meeting, the non-disabled officer who was accountable to my committee proposed 'that the next meeting be held without any disabled people present, so that all of us can feel more relaxed.'

Do you begin to see where I'm coming from?

Disability is
not a choice –
your attitude is

Rachel Day 2004

In the exhibition THE WAY AHEAD, shown at Liverpool,
London, Poole and Milton Keynes, disabled artist Caroline
Cardus in partnership with Inter-Action MK supported
disabled people in Milton Keynes to present their views of
reality as authentic, life sized metal road signs.

Perhaps it was a reaction to finding myself as a newly disabled person, accused of being a *'burden to society'* that I drifted into the charity world, and in particular to the self-help groups of my own medical condition. Here I acquired a differently new suit of verbal clothing. I was perceived as a *'victim'*, someone who was *'severely affected'*, a long term *'sufferer'*. Newspaper reports of local charities raising fifteen hundred pounds to buy me a voice-activated word processor, labelled me as *'tragic but brave'* and *'struggling against a mysterious but crippling handicap'*. No surprise then that I began to search for a model that allowed some measure of self-esteem. I found it in this quote from an article by Liz Crow, a leading writer on disability issues in Britain:

> Discovering the social model was the proverbial raft in stormy seas. The social model (of disability) was the explanation I had sought for years. Suddenly what I had always known deep down was confirmed. It wasn't my body that was responsible for all my difficulties, it was external factors. I was being dis-abled; my capabilities and opportunities were being restricted by poor social organisation. Even more important, if all the problems had been created by society, then surely society could un-create them.
>
> Revolutionary.
>
> (Crow: 1989)

– – –

Patronising language such as I've quoted above is deeply offensive to disabled people. Yet, despite all the information packs supplied, it is still used on a daily basis by much of the press and media.

– – –

Sling the grappling irons of your mind at language – disability language, that is. Of course it's complex and fast changing, because the disability movement in this country is still so young that it's doing much of its thinking out loud. So keep up with it! I have to.

Language is not a matter of intellectual dispute about 'political correctness'. It is the fundamental measure of whether one understands an issue – in this case disability. The social model explains that it is society which disables us, if it fails to provide ramps for my chair where there are steps, access to public transport, and all my reading material in large print, so I can enjoy the same access to the same problems everyone else in the room shares. This will also help you to deal with the pedant who might ask: 'I wear spectacles, does that make me a disabled person?' The answer from the social model is no. Providing that your spectacles enable you to overcome your visual impairment, you are not being disabled.

– – –

Once one has grasped the principle of the social model, it becomes clear why we choose to call ourselves dis-abled people, and not *'people with disabilities'*, *'The Disabled'* or even more strangely, *'somethingly challenged people'*. And language is crucial because it creates images. So I for instance am not *'wheelchair-bound'* any more than a stockbroker is *'pin-stripe-suit-bound'*; what I happen to be is a wheelchair user, not a bondage freak. Because for me that is no more *'hellish, tragic, or brave'* than being a car user.

– – –

If the roads to Manchester all stopped at Stockport, Mancunians would be furious – and tired and dirty after ploughing across miles of fields. This is how I feel when my wheelchair cannot access the House of Commons, my local dance classes, a brass band rehearsal room, a pub, a bank or the door into my cinema, gallery, museum, or its shop.

And not only do I have to deal with this physical and institutional exclusion, I also have to face intellectual exclusions. I am frequently confronted by decisions in which I lack a voice. I may well think the decisions are wrong, but am compelled to live with the people who have taken them telling me that they are for my own good.

– – –

The words of this senior arts and disability consultant are hugely revealing. She was talking to a highly experienced personnel officer of a major arts organisation about the employment of disabled people in her organisation. The discussion centred on an Equal Opportunities approach to interviewing disabled candidates and how it would be inappropriate to conduct the interview on the basis of the impairment of the candidate. The personnel officer said this was fine with her if the candidate was, for example, a wheelchair user. But if the candidate had an invisible impairment, she wanted to be able to ask about it. 'Because if I can't see the impairment then I shall leap to the worst conclusion, and I shall start thinking: oh, it must be mental illness, and if the candidate has a mental illness, perhaps they will be on medication; and if they are on medication, perhaps they may forget to take it; and if they forget to take it, who knows whether they might turn out to be an axe murderer!'

– – –

Disability Equality Training is sometimes mistakenly perceived to be hectoring from the 'Good' sermonising to the 'Bad', suggesting an inverted morality. 'I'm OK, I'm disabled. You've got the problem, you're not!' But talking to non-disabled people is crucial. If arts unions and pressure groups are to commit to the Equal Opportunities view that disabled people should be given real access and genuine equality of opportunity to engage in all areas of arts, TV and film representation, then those non-disabled people will have to be prepared to share their space and their own hard-won rights. And they will also have to identify with the struggle by disabled people and so accept responsibility towards disability issues.

Please feel warmly welcomed to our unaccustomed company, rather than consigned to the hell fires of anyone's damnation.

– – –

If there were no sign language, we might be making the same crass assumptions about the 'limited abilities' of deaf people as we do today about learning-disabled people. It is for us to understand their communicative powers, not deplore their failure to understand 'our' languge. Yet the English have always expected other people to learn their language because they are such poor learners. And some speak very slowly and loudly to people with learning disabilities.

– – –

But the statistics show that disabled people make good employees, are likely to be more reliable, take less time off, have a better health record and stay in the job longer than a non-disabled person. Society however has a real problem getting its head round any such reassuring facts.

– – –

In 1995 *The Guardian* ran a formulaic interview with a current celebrity each Saturday. Most weeks one of the questions was 'What is your greatest fear?' By far the most common answer, uniting pop-singer with politician, It Girl with sportsman, was not death, not unemployment, not failure or rejection, not even going to bad parties! It was 'the fear of becoming disabled'.

Once you have mastered your fear, you may be ready to understand the gut-wrenching terror felt by many disabled people when voluntary euthanasia or assisted deaths come up for discussion. Remember that hospital consultants have openly admitted to refusing to undertake transplant operations on learning-disabled patients on grounds of cost-effectiveness or time-management. It is not only the railways who provide for different classes in different ways.

– – –

Crass assumptions about learning-disabled people?

SHE LOOKS SAD by Lyn Martin
now hangs in the Director's Office at The National Portrait Gallery

Can society afford to include disabled people economically? From the 1920s through to the 1980s, the political view was 'No!' But in the 1990s a former Conservative junior minister who crossed the floor of the House of Commons to join New Labour gave an emphatic 'Yes!' Alan Howard MP – later a Labour Arts Minister – argued that not only did disability purchasing power lead to disability political influence, but that disability employment contributed hugely to the general good of the economy. In fact by as much as £50 billion a year in 2005. All the evidence from the USA points the same way.

– – –

Making their Abingdon regional studio boardroom accessible after I joined the Regional Advisory Council of Central Television in 1993 cost them £35,000. But, hey, now regional people in wheelchairs can appear on regional television news in Oxfordshire – even newsreaders using wheelchairs. So it's 'Good evening and welcome' from them too.

– – –

But the picture still needs tuning. Hardly anyone feels entirely comfortable being the only 1 among 500. Ask a single woman among 500 males, or a single black person among 500 Caucasians. Yet most theatres in 1993 had only one accessible wheelchair space on any given level. Perhaps it was because research from Aberdeen University in 1992 concluded that architects received little or no training in designing for the 20 per cent of the population who are disabled people.

– – –

Nor is the licensing practice of local authority by-laws any better informed. So as a teetotal wheelchair user I was astonished when I was asked to leave a theatre bar on the grounds that I was a fire-hazard. Because when I was the non-disabled Artistic Director of the Swan Theatre (1977) I was also the licensee of the bar, where my principal aim – to support the funding of my actors – was to assist my audiences assiduously to become 'legless', usually while they were smoking.

– – –

And don't use my alleged fire-risk status to hide your own failure to make your building accessible. That smacks of the 1960s opposition to the rights of women to equal employment, on the grounds of the paucity of porcelain provision for them. If they'd been able to spend just one penny for every time they'd heard that, you'd be rich enough to retire now.

– – –

You see, the reason I shouted at Alan Yentob, then the Director of BBC One, as I pulled him behind me by the sleeve into the gentlemen's toilet, was because although I hadn't expected every event in the prestigious three day television and arts conference in 1992 to be wheelchair accessible, I did think the sole slot allocated to disability and the media should have been! And he was one of the organising committee.

So while my ambulant colleagues sauntered jauntily up some particularly resplendent Brighton steps at the front of the hotel venue, I had endured ten minutes orienteering first through the bar, then the kitchens, next the stock room, and finally – courtesy of an emergency fire exit – into the toilets. Alan was a silent companion, but we made the reverse journey in only three minutes, such were his programming skills.

– – –

Every goal disabled people seek is dependent on education. It is our right to demand inclusive education, but especially to ensure that applies in the first five years of life when learning is at its strongest, and play teaches interdependence. 'Arts education' are the magic words that wave us into employment, and wash away our invisibility. But we have to understand that education is a double-edged sword. In return for demanding the restitutions of their own educational rights, disabled people will have to accept the responsibility of educating all of society through the reasoning of disability equality training.

– – –

On the other hand the panoply of dropped-out disabled arts students tell us that much disability prejudice is institutiona-lised. And it can be an even greater burden on an individual and isolated student to be assumed to be the only source of knowledge on all disability and access issues across the vast steppes of a greenfield campus.

– – –

Interestingly, where you create access for disabled people many non-disabled people will eagerly follow. On a crowded railway station, I can sometimes look like the pied piper. People assume that if a wheelchair user can find his way, or be assisted to wherever he wishes to go, then the same will be true for parents with pushchairs, elderly people with luggage and even shoppers laden with bags from Harvey Nics.

NB

And please don't put the details of the availability of large print material in your wonderfully accessible building in tiny lettering at the bottom of the last page of your inaccessible leaflet!

SPOT THE BALL

You decide where to put your cross on one of the two advertisements set side by side below in a copy of a 1998 newspaper. On the left, a responsible caution, paid for by the Department of Education and Employment reminds us that; 'In '99 the Disability Discrimination Act will affect you and your customers in NEW WAYS.' On the right, and right beside it, a travel advertisement for Eurostar states; 'There are hundreds of reasons to take a day trip to Paris'. But the only one they could think of was: 'IT'S WHERE THE HUNCHBACK HUNG OUT.'

How far do we still have to travel to arrive in a thoughtful world?

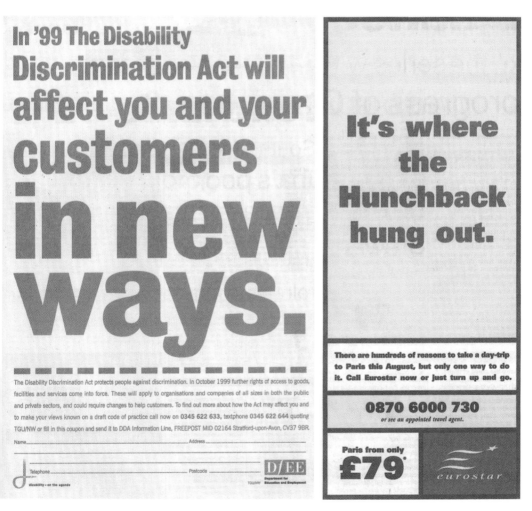

Chapter 2

ON PERSONAL TERMS

I don't want to live in bungalow land,
On the outer edges of the urban sprawl,
In a place designed for people-like-us
Kept safely separate, away from it all.

I want to live in the pulse-hot thick-of-it,
Where the nights jive, where the streets hum,
Amongst people and politics, struggles and
upheaval,
I'm a dangerous woman, and my time has come.

SUE NAPOLITANO
(1948-1996)

From *A Dangerous Woman*, published 1994

THE ARTS CAN REALLY SAVE LIVES

Address to a national conference for school governors and managers in 1996

Over a long time, and under different traditions of curricula, education has paid lip service to the place of, for example, poetry, plays, music and painting as an area of study, but has *never* understood that involvement and engagement *in* the arts should lie at the core of education in any civilised or civilising society.

Already the expressions of shock on the faces of representatives of that constituency tell me that I have set my wheelchair on very thin ice! But I speak with the passion of someone who started their working life as a teacher in 1961, and only finished a five-year stint as chair of a Worcestershire Theatre-in-Education company two years ago.

Then in 1993 as a British delegate who had disability-monitoring experience I was sent to chair in Helsinki a working discussion group of a 'Human Rights and Cultural Policies in a Changing Europe' Conference: *The Right to Participate in Cultural Life*. There in the presence of so much pain and anguish pouring from the representatives of former Yugoslavia, from a divided Cyprus, from neglected Scandinavian Lapps and militant Chechnyans, I found myself asking, over and over again how we could ever realise the dreams science fiction writers create of societies where there is no violence, and nations and states do not resort to the worst excesses of nationalism.

The only answer I could find is to understand that to prevent murder, rape, torture and deliberate degradation, one requires every potential perpetrator to be able to experience what it feels like to suffer the fate of the victim. Only then can we cease to be guilty of carelessly executing what we are actually unable to feel. Drama especially, and dance, music, film and video-making, painting, sculpture and poetry lead humans to the experience of being other than yourself. It is a potential that lies in all of us, a potential that needs only to be activated to be ex-

perienced, and it is this engaging – particularly in group arts activities – that enables us to experience what it is like to be someone else, to know someone else, to greet and not to fear 'the stranger', to play out our angers and our doubts, our dreams and our hopes. And through this to trust those with whom we make the art, to be prepared to reveal ourselves in our arts to others without fear or shame, and so grow in understanding of other gender, other colour, other age, and of the reality of being en-abled or dis-abled by society.

Surely if art and the experience of making art within education can do all this, should it not be the most fundamental basis for investment to ensure that whatever place my grandchildren may live in, they never have to experience the tragic self-destruction such as that of Uganda, the land where I was born.

UPDATE
Ten years on assessments on the Theatre Education Network (TEN), established in 2004, are making similar claims for 'life-rescuing experiences.'

– – –

I listened in a state of shock to a report on the radio one Monday in 1996, of a man's machete-wielding attack on infants holding a Teddy Bears Picnic in the playground of a Wolverhampton school. I listened doubly numbed, because only two months earlier I had told West Midlands school governors in a speech that the only possibility of both understanding and preventing the even worse massacre that had occurred that year in Dunblane, in Scotland, was to put participatory and community art forms at the heart of the school curriculum.

Then came the final chilling tag to the radio report. 'Although no lives have been lost, the children involved are likely to be scarred for life.' I wept with the bitterness of futility as I realised that all children disabled from birth, and as a result denied full access to the experience of the arts and the widest community, will also be scarred for life by the unthinking daily attacks of prejudice, apathy and exclusion from their educational rights.

IS THERE A FUNNY SIDE?

At The Edinburgh International Television Festival, 1997 I was asked to introduce and then chair a one hour panel presentation under Channel 4's choice of title.

Good evening and welcome to '*Funny Ha Ha; or Funny Peculiar*', whether you are a disabled person or in my favourite acronym from North America: a TAB. That's a Temporarily Able-Bodied person.

Disabled people seek representation on screen, as well as access to direction and writing in programmes right across the schedules, be they broadcast by terrestrial, celestial or increasingly bestial TV. But for many of us comedy representation is the ultimate goal. Because comedy is the serious business of turning the world upside down. And if it is a given truth for you TABs that disabled people represent your worst nightmare come true, then comedy is the location to explore and explode those fears.

So to the fears of unemployment, students, traffic wardens, PMT and flatulence – the great stud farms of seminal comedy in the 1980s – let's add the fear of disability. Get it out, exposed and flashing in the 1990s!

Let's apply the most basely-formulated litmus test of comedy – the banana skin test. The experiment is simple. Is a person slipping on a discarded banana skin funny? If like Buster Keaton, Chaplin and Rik Mayall, you think that prat falls are high on the clapometer of comic genius, then what is your reaction if it's a disabled person who – whoops! – slips on the banana skin?

My hypothesis is that provided they deserve their comeuppance, as for example the over-zealous Keystone Cops of the silent movies, or the Chair of this session on disability and comedy making too lengthy a point and a pompous self-centred one at that – then YES.

(I drew out an unloaded banana skin from my pocket and threw it on the floor in front of me.)

YES, if my entire power wheelchair were to slip right here into that orchestra pit in front of me – it would be hysterical.

And I turned my power on and began to move slowly forward. Immediately several cries of 'Don't hurt yourself!' came from the brightest commissioners of comedy in the TV industry present. It seems suspension of disbelief can be taken to new heights by wheelchair users. Though I still think I missed the real joke, which would have been to throw down four skins – one for each wheel.

The truth is that disability provides vast stores of humour. And as disabled people we particularly delight in finding it in Disability Arts Cabaret. The explanation is that we don't find it funny if you're laughing at our impairments whether it's Quasimodo or Mister Magoo, but if we're laughing together at society's absurdities, then we're at one.

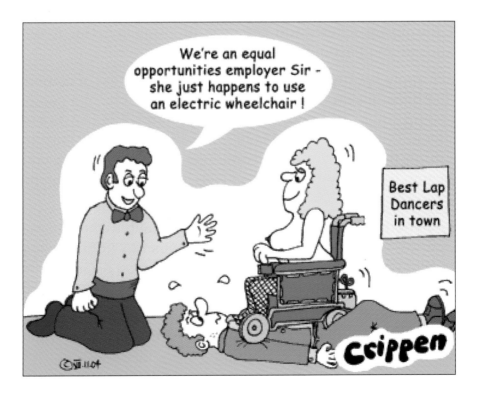

Strange that my local Tesco's should provide such extraordinary clarity between two different stereotypes of behaviour by the general public towards disabled people.

At 11.00am on a Monday morning, in a well staffed area but, happily for my power wheelchair, clear of almost all other shoppers with their similarly sized trolleys, I could not shake off the persistent attentions of a considerably older shopper, who was determined to help me with every choice I made. When I finally, and remarkably politely, explained that I was perfectly capable of shopping on my own, and that if not, the staff were trained in disability equality to meet any need I might request, she turned remarkably self-righteous – 'Some people just won't accept charity will they? Well, you see how you and your '*handicapped*' friends get along without people like me next time.'

So obviously I felt happier next time – at 6.00pm on a late-night Friday opening. The aisles were packed with shoppers tired by their day's toils, and tied up by their noisy kids, just picked up from primary playgroups, who towered over me. I was told 'Just eff out of the effing way you over-sized tortoise and get back to where you effing belong – in a cardboard box!'

Who said there's no humour in disability?

THE MOST IMPORTANT DAY OF MY LIFE
Like others of my generation I can still recall where I was and what I was doing the day Martin Luther King was assassinated; the day John F. Kennedy threatened to drop the nuclear bomb on Cuba's Russian-supplied nuclear missiles and make it the last day of all our lives; the day the Berlin Wall came down.

And now Monday, 4th March, 1991 is also part of my personal roll call of history. For that is the day I first heard Sue Napolitano read her poetry.

The place: The Midlands Arts Centre; the occasion: a Women's Cabaret. The reason I remember this?

Because that was the first day as a middle-aged and recently disabled man that I encountered Disability Arts. The first day of my life when, as Sue read, I fully understood how someone else could draw the unthought or unformed ideas from my mind, and shape them and speak them for me, and to me. The first day in the life of this world-weary former theatre director, who had spent a quarter of a century theatricalising the traditional themes of royal Shakespeare, of middle class comedy, of unreal detection, of overblown tragedy, that I heard, felt, understood and was immeasurably moved by one lone voice directing me to the present, the immediate, the urgent, the oppression.

So this is my definition:

> Disability Arts are art forms, art works and arts productions created by disabled people to be shared with, and to inform other disabled people, by focusing on the truth of disability experience.
>
> They are quite distinct from Arts and Disability, which is a blanket phrase to cover the irregular interest that mainstream arts occasionally demonstrate by including a single disabled person, disabled picture or oblique reference to disability in their otherwise usual arts practice.

What we especially need from disability and the arts is the time, space and funding to create Disability Arts.

Critics of Disability Arts sometimes accuse us of ghetto-ising disabled people. I don't want a ghetto any more than any excluded minority does. But I do want a rehearsal room for our arts, a greenhouse, a forge, a workshop, a think tank, a fusion, a spirit, an outpouring, an excitement – so that we can first explore and then develop our own culture and our own images, find our voices and signal our language.

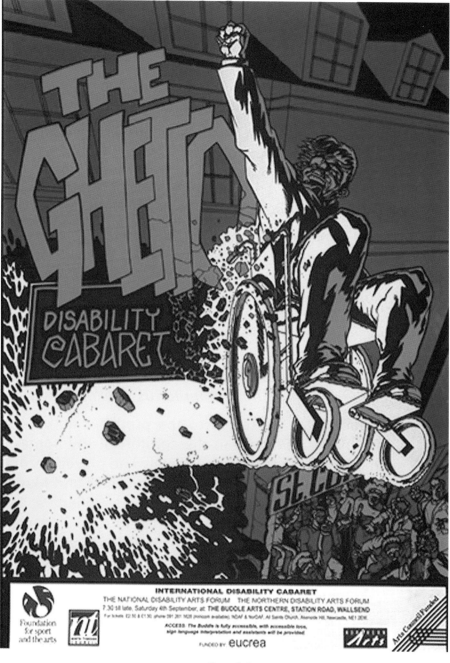

designed by **Geof Armstrong**
(ICON OF A DECADE #4)
(A National Disability Arts Forum poster from the Getting Noticed
Exhibition 2000) (The Ghetto International Disability Arts Cabaret took
place in Edinburgh 1993)

I don't think that makes a ghetto. I think that rejecting the stereotyped and patronising images of Telethons and Children in Need programmes makes sense. That's why I'm passionate about Disability Arts. And for me a Disability Arts Forum, by drawing disabled artists together, is the most certain means of achieving them.

As for Children in Need, we all know what's wrong with poor old Pudsey Bear: he's been stuffed.

GETTING REAL ON TV

Following my appointment to Central Television's Regional Advisory Council in 1994, an entire meeting was generously allocated to a discussion of disability in television. After my presentation it was sensibly agreed that I meet with the people with direct control over programme-making and production. So, reinforced by my colleague Chris Davies, I spoke to Central's Heads of Drama, Documentaries, Entertainment and Children's Programming. It was suggested they find a starting point for us to explore.

Some time later we talked to the producer and story-editor of *Peak Practice* in the comfort of my home. It seemed ideal. Its star Kevin Whately had played second gentleman for me in *Twelfth Night* at Worcester and I knew he had hoped to use his fame from *Auf Wiedersehen Pet* and Central's *Morse* as a bargaining base for introducing more social issues into peak time television. *Peak Practice* also had a burning need for new story lines. There are only so many cancer or meningitis stories to be explored.

They listened. We spoke. They took notes and said Mmmm! One story I still offer to any TV soap was that a mini-bus transporting The Lawnmowers, a role model theatre company for actors with learning disabilities from Gateshead, crashed at night in the Peak District, when returning from a Newcastle under Lyme gig to their Newcastle-on-Tyne homes. It was known that hospital staff lacked training in the understanding of communication with learning-disabled

people, so the plot possibilities for positive imagery in a rural surgery and hospital were endless. Indeed one London hospital now regularly books such training from a learning-disabled theatre company. So my addiction to irony could have been fulfilled if the gig just played by The Lawnmowers had been for medical staff!

We were pleased. They had serious faces. Payment was agreed. A co-operative future looked likely. Except that the producer was transferred to another show, and with him went his notes and his chequebook.

Unofficially many long-term broadcasters tell me that although Welshwomen, Scotsmen, Lancastrians and Geordies may all read the news nowadays, no disabled person ever will, unless they become disabled in the course of a long and successful career, or are the love-child of the Managing Director of the channel. I can only wish Sir Trevor McDonald a long and healthy life, and note that even the iconic 'Superman' Christopher Reeve could not summon up super powers to transform film or TV practice from a wheel-chair.

– – –

ONE THING LEADS TO ANOTHER

If disabled people manage to secure access to the arts, who will decide whether we are worthy of funding for touring, displaying or performing our arts? The answer is that every-one has the right to be judged by their peers. So if arts funders don't have the knowledge to understand the realities of disability performance, they need to ask those who do.

L et me give you a personal example. I adore 'signed song' as an art form. I have been known to wet myself at Caroline Parker's performance of *Bohemian Rhapsody*. But if I was being asked to be part of a system that would decide whether Caroline should receive funding rather than another talented signed song performer such as Sarah Scott, I could only decline.

That's because, sadly, I have no knowledge of sign language. So even while I'm laughing with Caroline, I don't have the slightest idea of the real truth of her performance, let alone its intricate details.

Which means disabled people have to secure representation. Ultimately neither the creation nor the training, employment nor funding of Disability Arts will be possible, unless we are fast-tracked onto the Arts Boards, and into the system that decides the fate and future of our sisters and brothers. The perceived harshness of ejection experienced by TV's wannabe '*Pop Idols*' is as nothing compared to the daily humiliation and rejection of disabled people's potential by the non-disabled people who occupy all the positions of authority and decision-making.

But even given peer judgement and representation, how can we conceivably achieve honesty of portrayal? The media world, the luvvies, even the public, sympathetic to the story of an exceptional disabled person, awarded an Oscar for the film portrayal of Christy Brown in *My Left Foot*. Disabled people gave gasps of horror at the absurdity of a non-disabled person portraying disability. It's time to realise that real history has always included disabled people. Shakespeare, Johnson or

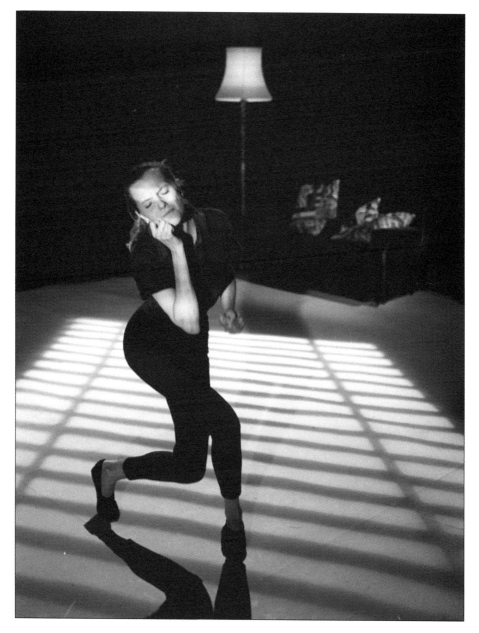

Sarah Scott
(ICON OF A DECADE #5)
In 1992 Sarah Scott and Ray Harrison Graham presented a Channel 4 Series *D'art*, made by Yorkshire Television, to introduce *all* young people to the special art forms of the deaf community (eg Signed Song and Sign Poetry). It aimed to make deaf young people aware that they can gain access to nearly all the art forms available to hearing people.

Goldsmith could easily have written or cast a disabled person as second gentleman or bleeding sergeant, without crudely stating against the cast list of *dramatis personae* that these parts 'must not be played by disabled people'.

– – –

RIGHTS

As I found out at Helsinki, rights can accidentally become wrongs. In the context of Disability Arts it is a basic artistic right that any disabled person may choose not to make Disability Arts of their art but to place their work and its merits on a mainstream menu – seeking comparison with Damien Hurst, Andrew Motion, Martin Amis, Darcy Bussell or Guy Ritchie, according to their art form. There are rare individuals, such as percussionist Evelyn Glennie, who have achieved super-status doing just that. And Yinka Shonibare worked for Disability Arts with Shape London and without them as a Turner Prize nominee (2004). Nor should their right to make such decisions be seen as disparaging to other disabled people.

Margaret Thatcher and David Blunkett chose solely political platforms and drums to bang on them, while others, such as ex-minister Clare Short, made it clear that nothing could make her ditch her commitments to women's rights and choice over their representation. Nor did Jack Ashley, an enormously respected MP for many years, ever choose to dump his massive commitment to the rights of disabled people to advance his personal career.

So when any group of oppressed people are looking to move their cause forward against a hostile general perception, it is also likely that those who elect to be non-combatants in this movement may expect to be asked to defend their position from time to time, however much it remains their absolute right not to do so.

Right?

The newly ennobled Lord Rix chose to make his maiden speech in the House of Lords in 1992, during a debate on the Civil Rights (Disabled Persons) Bill. He concluded his speech with this extract. (Hansard)

'Finally, I refer to a letter written to *The Guardian* by Paddy Masefield. I am sure noble Lords will forgive me for reading it out in full:

> As a middle aged male with M.E. who uses a wheelchair, I passed through Oxford Station last week. This station will be infamous to many disabled people, since, as a result of a reputed one million pound modernisation it still:
>
> a) requires anyone in a wheelchair to be pushed the length of the platform, across the tracks and back up another platform if they are changing trains.
>
> b) sites a toilet for disabled people on one platform only, requiring the cross track procedure if you are on the opposite platform.
>
> c) makes it impossible to transfer to a taxi under cover, but instead requires a journey of one hundred yards exposed to the elements up or down a steep slope.
>
> d) Provides insufficient staff to keep its travel contract with disabled people, so that I witnessed some months ago a vision-impaired traveller, frustrated by neglect, fall onto the tracks only minutes before a train passed over the spot.
>
> To add real insult to the risk of real injury, the member of staff assigned to push me saw fit to ask me how many years I had been in a wheelchair. I told him almost six. His reply was, 'Good God! If I'd been a burden to people that long I would have shot myself by now!'
>
> Who should I be angry with? One man's prejudice? Management's insensitivity? BR's inefficiency? Society's apathy? Or Government's refusal to bring forward disability legislation to make all such prejudice illegal?

And who is to compensate me and my 11.7 million colleagues in the UK, for being daily disabled by such attitudes and practice?'

Who indeed?

– – –

I accepted the offer of an OBE in 1996 from a Conservative Government without hesitation, even though I found the notion of honours as repugnant as the policies of the party who so kindly honoured me. But I knew that as a disabled person those dreadful words – *Officer of the British Empire* – would quite literally open doors to me, and encourage at least some people in authority to read my pleas on behalf of disabled people. Indeed on occasions VIPs even spoke directly to me, rather than to my companion standing behind my wheelchair. It was as if I had stopped being the monkey and had finally become the organ-grinder!

– – –

So where in 1995 should we break into the carefully drawn-up wagon circle that the arts industry employs to protect itself against marauding bands of artistic disabled people? No single point appears undefended so maybe we have to do it everywhere and at the same time. Hence the need for:

- legislation to provide a stick

- incentive funding to hang out a carrot

- a soap box for our views on TV soaps

- writing about disability

- involvement by renegade non-disabled supporters who do know the vulnerable spots in the circle

- and above all the visibility of disabled people on television breaching those spots, some, like me slung low beneath the bellies of their circling wheelchairs, their bodies disturbingly painted from a palette of mixed metaphors.

Chapter 3

THE THREE DOORS

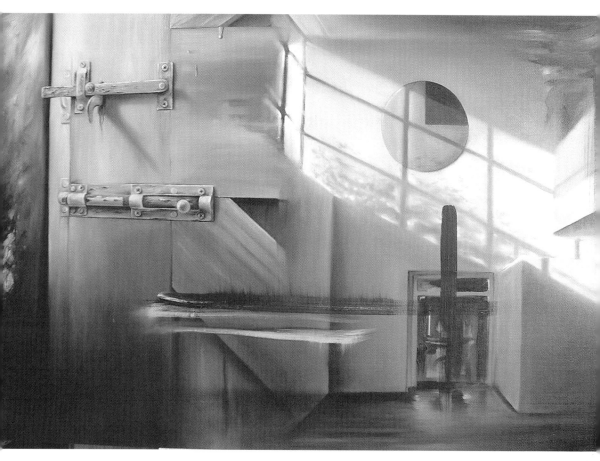

AXIOMATIC APERTURE 2003
Colin Pethick BA FA Hons
(oil on canvas 120 x 90 cms)

THE THREE DOORS

Originally entitled, 'I could do your job', this speech delivered in Birmingham in 1992 was my first on the subject of disability and the arts. It was addressed to regional arts employers, who had not employed disabled people. I was invited to welcome them, as I was locally a member of the Board of West Midlands Arts and, nationally, the Vice-chair of the Arts Council of Great Britain's Arts and Disability Monitoring Committee. It was they who had set up this 'Initiative to Increase the Employment of Disabled People in the Arts', chaired initially by Lord Rix. (The statistics are those we believed to be correct in 1992.)

Colleagues, you see before you a person in a wheelchair. Many of you see the wheelchair before the person, so you may assume not only disability on my part, but that I am an expert on disability issues.

In fact, what I am is an arts expert who only became a disabled person five and a half years ago. So perhaps I was asked to make this address because for twenty-one years I worked as a theatre director, administrator, playwright and consultant; in other words, frequently as an employer.

Yet somehow, although I worked for a whole panoply of highly motivated and ideologically OK institutions, I have no personal recall of ever plugging into the needs, issues or creative potential of disabled people. So the biggest professional hurdle I had to face on becoming disabled was the shock of my conscience, my ignorance and, most importantly, my lack of creative dialogue with a large sector of the community that I had allegedly been trying to write, direct and communicate with, and for, over such a length of time. From this sombre perspective of lost opportunities, I had to open some doors.

As arts workers, you're all used to proceeding through rather special doors: stage doors, recording studio doors, dressing room doors, front-of-house doors, even office doors. Where-

as over my life I've become aware of three historic doors that seem to dominate all others.

The first door had 'Men Only' written in bold lettering, and in my time in the arts industry I've seen that door dented, the sign removed, and the door hung on one hinge awaiting final demolition.

The second door said 'Whites Only' all over its antique façade, and in my working life I've seen an alternative entrance blasted beside it that recognised the strength of cultural diversity and the richness of black and minority ethnic arts in our society.

Interestingly the third door had no need of a sign. It merely had huge steps in front of it, high handles, impossibly heavy hinges, no raised lettering, narrow lifts inside, more stairs, sudden drops and cluttered corridors that lead to inaccessible inner sanctums of power – because this was the door that was built by non-disabled workers, to disable those who occupy wheelchairs, are vision impaired, are shorter in stature, or have different muscular co-ordination to those proud builders.

It is that door which explains why most arts employers are totally unused to working alongside disabled people. And as a result, you have allowed yourselves to be disadvantaged creatively, by shutting out our voice, our vision, our movement, just as certainly as contemporary society is abysmally impoverished if it uses only male and white resources.

– – –

WHAT A DIFFERENCE A CHAIR MAKES

If I look back at those twenty-one years of my own life and career as a theatre director, I ask myself if there is any reason why I should not aspire to the directorship of a major regional company just because I choose to sit on a mobile metal chair rather than a collapsible canvas one with my name written on it.

But if I had been using this chair all my life, could I have been guaranteed a job as a director at senior level today? I think not. I would almost certainly have been discouraged from drama at school, perhaps even banned; certainly have been denied entry to drama schools; probably have given up on youth theatres because they met in upper rooms on Sundays with no accessible public transport; told I couldn't take a bursary in a repertory theatre because the technical, re-hearsal and administrative areas had been made inaccessible; denied a schools touring job because schools had steps, hurdles and high jumps to keep me out – which seems to be where this cycle started.

Over my working life, I have started four theatre companies, been present at the inception of Theatre-in-Education, the birth of the Standing Conference of Young People's Theatre, the creation of the Directors Guild of Great Britain. I was a presenter on the first local radio station in Britain. And I've been to the USA, Canada and Holland to represent my country's arts.

What a tragedy, what a total waste of a life, if all that had been denied me because of apathy, ignorance, fear and prejudice, if society had so disabled me! Strong words? Do you have the feeling you're being got at? That you have come here in good faith and are being attacked?

I hope I'm only using images and emotions to make you receptive to facts, because the facts show we do have a historic and serious problem.

Let me demonstrate this by means of a simple conjuring trick, a disappearing act. Here on the one hand I give you society:

the employers, the conjurors. And here on the other are the conjurors' assistants, us, the 6.2 million disabled people in the UK who will now disappear before your very eyes.

We start then with a figure of over 10 per cent of society being disabled. But this 6.2 million may be a very conservative estimate if we bear in mind that there are some 8 million people who self-define as having hearing-loss alone. So we who are disabled should already be a very sizeable chunk of the arts audience, the arts market, the arts consumers, and certainly part of the arts workforce.

But watch closely ladies and gentlemen, because we are fading away before your very eyes. 'Abracadabra': the 1944 Disabled Persons (Employment) Act only makes it obligatory for employers of more than twenty people to employ a disabled person, if less than 3 per cent of their workforce is made up of registered disabled people. But even this 3 per cent obligation is not met. In 1990 only 24 per cent of employers met the 3 per cent quota, and since then the percentage of conscientious employers has dropped still further. So the disappearing act is accelerating.

But 'hold on!' shouts the audience of knowledgeable arts administrators. 'Surely the recent Attenborough Report, and the Arts Council's Arts and Disability Action Plan must have done something to make disabled people more visible recently?'

'Sorry, friends', says the conjuror, 'nothing up my sleeve. In your region (the West Midlands), only two companies in receipt of regional arts funding responded to that Action Plan, so it really is a pretty complete disappearing trick. After all, how many disabled people do you know who work full-time in the arts?' Lord Rix estimates that in a subsidised arts workforce of more than 500,000, less than 100 are disabled people.

But if you've been upset by our disappearing act, I can make us all reappear – because 70 per cent of disabled people of working age are unemployed. So here we are again, back

before you, demanding the same recognition you would demand if 70 per cent of *you* were unemployed.

Now, you will tell me that most of the employers present are committed to the pursuit of an equal opportunities policy. That is tremendous, and I applaud you! I genuinely applaud the ramps, the adapted toilets, and the induction loops you installed for your customers in the '80s.

But in the '90s, it's time to tackle the issue of access to employment. Let us ensure the boardroom, the administrative office, the box-office, the dressing-rooms, the stage, the studios, the galleries are all accessible. If you want to change public attitudes, then we need a profile not only of disabled people as ticket-sellers or front-of-house staff, but in security, in marketing, in publicity, in catering.

Perhaps that is one of our most urgent priorities – that you use your power as employers to change prevailing stereotypes and make visible the hidden community. We are not only saying 'Why not Hamlet?' to the theatre directors, 'Why not portraiture of disabled people?' to the television producers and casting agencies, but 'Why not a hearing impaired person in a police office? Why not a managing director in a wheelchair, in a background shot of a working office in a soap?' Why not? I don't know. After all, the managing director of my local airport works from a wheelchair.

But above all, 70 per cent of unemployed disabled workers are there waiting to do what you do, and to do it as well as you do or better. That's a pretty potent force for you to tap into over the next decade. Maybe that tapping will ensure that the arts of the 21st century are made more relevant to the whole of society by our successors than we have been able to make them in the 20th.

Julie McNamara
(ICON OF A DECADE #6)
in *Pig on the Rails, Pig Tales 2005*
Poet in residence at ICI, Julie is an award winning playwright,
performance poet, singer and songwriter. Her international acclaim is a
defiant celebration of difference.

UPDATE

In 1992 the Disability Discrimination Act of 1995 (DDA) was no more than a whisper in the wind. The first attempts at a powerful Civil Rights (Disabled Persons) Bill, despite much public and cross-party support, was talked out of parliamentary debating time by an urban expert on Scottish salt water fowl, later that year. So the only legislation relating to the employment of disabled people was the 1944 Disabled Persons (Employment) Act. This had been introduced in the context of the Second World War and the anticipated return to civilian life of a vast number of heroes, disabled in the service of their country and its freedoms.

Sadly, typical of so much legislation around social issues in the 20th century, there was buried within it an opt out clause. I only became aware of the existence of this Act after being invited to monitor the then Arts Council of Great Britain, who each year themselves successfully applied for exemption!

This Act was only repealed by the DDA in 1995. But such experiences lead many disabled people to believe that even this new Act might prove ineffective: toothless and easy to ignore. I feel this still in 2005 as we await the abolition of The Disability Rights Commission, which is to be subsumed into one 'catch-all' body for gender, race and disability rights.

At least the research by government agencies in 1997 and 1998, based on the DDA, revealed that the true number of disabled people in the UK was 11.7 million, or twenty per cent – not ten per cent – of the entire population. In Wales the figure is 24.1 per cent. The same research revealed that of the 5.3 million disabled people of working age in the UK, only 2.1 million were in paid work.

These are the figures I refer to in the rest of this book.

Chapter 4

THIS IS YOUR LIFE

In the morning I went to the grocer,

and top and tailed gooseberries.

In the afternoon I went and talked to the geese.

After tea my tortoise escaped.

Diary, aged 8

I received my first commission specifically requesting that my opening speech amuse and entertain, as well as instruct, a regional gathering of arts delegates only in 2001. They intended only on day two to get down to their serious business of developing a matrix hub for the installation of Continuous Professional Development (CPD) within the arts professions nationwide. But cautious that autobiographies can quickly slide from humour to arrogance, I decided only to expose myself slowly. Not an easy task when you're the person sat on the podium spouting.

PADDY SPEECH WRITING
by **Eddy Hardy** 2002
Commissioned as a wedding present for Caroline

HOW I GOT FROM THERE TO HERE

I've been directed to entertain you in the telling of how I found my way 'Here from There'. But rather than render up a shabby autobiography; as a playwright, I would prefer to create a fictitious character, who can thus embody so many more of the doubtful attitudes and attributes that so often addled the arts scene of the last 50 years in this country – The Universal Artist. So I offer you the silliest, yet slyest of glimpses of the life and times of Jake Middle-Stream.

Jake was born overseas. A background that seems common to so many artists; a child of itinerants always searching for an identity, a culture he could pull down around him like a security blanket. At the age of six months he contracted cerebral malaria, which is guaranteed fatal! Just the first of so many inaccurate assessments on his life. Jake arrived in the UK at the age of five. Naturally in the heady post-war world, he spent his first year as one of only three boys at a girls' school. You might have thought his gender alone would offer him casting opportunities in the school production of Snow White. But no! Three very small parts for three very small imps were added to the usual fairy tale.

It was at this time that Jake was first taken to professional theatre. This wasn't the 'Big Bang' orgasmatic experience many artists describe when reflecting on their earliest influences. Jake's Granny chose a West End production of *Peter Pan*, but having unfortunately got the time of the matinee wrong, five year old Jake found himself stumbling around a vast, darkened and frightening auditorium, just as Peter Pan and Wendy flew off. Confused rather than captivated, he wondered if they too were just lost children looking for their seats in this sweaty underworld.

Jake was moved swiftly to an expensive private school for boys (in which there were just three girls), where he was to win three prizes in seven years. In the bottom form, he obediently won the botany prize for the Father who collected the most wild flowers. While in his last year he won the all-school obstacle race by the simple device of noting that the

most difficult sector involved the finding of a penny in a vast sawdust heap, so entered with his own coin to hand! Sadly his performance career waned. He was turned down as a love-sick maiden in the school production of *Iolanthe*, and was virtually the only final year pupil not to be cast in the school Shakespeare, due to an alleged lisp. He briefly considered an action for judicial review but was instead provoked to enter the school speech prize, which he won with a blistering attack on the untrustworthiness of those who grew beards, like the drama teacher and later he himself!

Determined to prove he could prosper in the world of theatre, at the age of fourteen Jake accepted a holiday job in professional pantomime at Windsor as a follow-spot operator. Totally uninstructed in this art, he was told to follow the *Second Principal* at all times. Alas, with six other spotlight operators in unknown scenic surroundings, the only way he could identify his own spot was to take it into a dark corner of the set and waggle it vigorously until he was certain it was his. Occasionally this set a trend, and other adolescent operators would join him in their own competitive *son et lumiere* at the top of a fourteen foot black masking flat – the *son* usually supplied by the slap to the head from the Chief Electrician, whose wondrous skill was to operate ten archaic dimmer switches simultaneously by using two walking sticks, and yet still keep them available for swiping adolescent stage-crew.

Next Christmas Jake was demoted to call boy, a job now done by electrical tannoy systems. In those days it involved knocking several hundred times on dressing room doors in the course of each performance, thus becoming the butt of more 'knock knock' jokes than he ever knew existed. But it also afforded the first fumbling opportunities for romance in the darkened wings of a quick scene change, where no one could be certain of anyone's identity.

Jake's frustrations increased at his expensive public boys boarding school. Even the chance of a big break during a royal visit – playing the rear end of a cow which, bizarrely,

featured in the founding of the 400 year old school – was politely applauded by the four hands of their Britannic majesties on their way to open the new science block, without ever knowing Jake's identity!

Jake's parents took his intelligence for granted, as he had won a minor exhibition. Jake was in fact so thick that, having fought to become Assistant Librarian because this allowed more lesson time to be spent in self-study, Jake consumed the entire works of Jane Austin and Thomas Hardy cleverly sandwiched inside his Bleak House because he assumed anything so readable must be illicit.

He was the only boy of his year not to be made a prefect (so legally entitled to strike smaller boys), because of his alleged childishness. This was a correct assessment, since Jake's only memory of his one term of biology was persuading the entire class that the forlorn stuffed penguin that had taxidermed alone in a glass cage for 150 years should be liberated, named Gwyn Penn and entered in the end of term exams. 'Penn, Gwyn' as the staff formally called his name, came triumphantly top and was gently returned to his case, no more stuffed but forever a winner.

Four weeks after leaving school at eighteen correctly labelled as irresponsible, Jake was teaching Latin, history, geography, maths, cricket, English and French to eight year olds. What reflection should we draw on the report of Her Majesty's School Inspectors, in this modern 'Dotheboys Hall', that Jake was the most highly commended teacher on the staff (of five)?

It seemed to Jake that work was easier than studying. So in quick succession he joined the Merchant Navy as a cadet purser to tramp up and down West Africa; became briefly an athletics coach in Uganda, a chauffeur in Tanzania, a grain silo labourer, a grocery delivery assistant, and, on his retirement as a naval officer, having just secured promotion to the improbably named rank of Writer, an assistant lock keeper on the Thames, where he also cleaned public toilets on Sundays for the Thames Conservancy Board.

'Directed five or six theatre productions each year'

Having failed entrance exams to all the universities his father had taught at, he was surprisingly accepted by a Cambridge institution that became a full college on the day he left it. Fitzwilliam House had a brilliantly unusual policy of asking a student's referees not what the boy had achieved at school, but what he might achieve were he to gain a university education.

So Jake directed five or six theatre productions each year; started three new theatre companies, including one of the first all black casts in England, to produce some of the earliest work of Wole Soyinka, who later won the Nobel Prize for Literature. Two of his plays elicited perhaps the most instructive *Guardian* theatre review ever: 'It is rare for a national newspaper to urge its London readers to struggle to an obscure Cambridge lecture hall to be captivated by one of the most exciting productions to be seen this year.' Alas for director Jake, it continued, 'The discerning visitor, however, will contrive to arrive no earlier than the interval, since the opening short play has had whatever promise it might have contained studiously extracted from it by the director.'

Jake captained every college sports second team, from cricket to croquet, soccer to darts, and even winked his tiddles, since he found such sporting contacts a successful way of casting the rowing club as the Ironshirts in Brecht's *Caucasian Chalk Circle*, and persuading opposing rugby players to appear in leather skirts and scrumcaps as the mighty armies of Brutus and Mark Antony on the plains of Philippi, otherwise known as the Arts Theatre.

Jake's hormones led him, rather late in life, to the most tiring of life-styles. These were the days when to sleep together students were obliged to devise an SAS training route through darkened kitchens, over chapel roofs, down spiked railings and out through the music scholar's bedroom at 4.00am – risking immediate expulsion if caught. Surely the most successful form of contraception ever freely administered to an entire student phalanx?

When the first Cambridge University Students Representative Council was formed, the ingenuous Jake found himself standing against the sophisticated Norman Lamont – later Chancellor of the Exchequer and subsequently Lord Lamont. Norman was an intelligent, hard-working and ambitious officer of both the Cambridge Union and the University Conservative Club. Jake used to drink a good deal in the college bar, attend free nosh-ups in the guise of an after-dinner speaker, and provide occasional entertainment in the theatre above the bar. You can guess who was elected by a landslide, but who sobered up pretty quickly on finding himself appointed Secretary to the Committee to investigate the incidence of student suicides.

So was university the Great Gateway to life? Hardly! You see, Jake totally failed to grasp the significance, the opportunities, the means of education being so greedily lapped up by those on every side of him. He attended no lectures, read no books, wrote no essays. Not surprisingly he failed his Archaeology and Anthropology exams by a record margin.

But through the weird precepts of medievally-founded Universities, the Senate of Cambridge conferred on him a 'special' BA and automatically three years later on payment of five pounds an MA (Cantab)! Jake was exhausted by university, so failed also to grasp the concept of education leading to employment or a career. When he eventually did apply for jobs, he found that BBC Television trainee directors had to have first class honours degrees, rather than to have directed, and that for the more humble post of assistant floor manager or runner, a Cambridge degree was considered an over-qualification.

Naturally when the impossibly demanding but well-paid post of theatre, film and literature officer arose in the offices of the nascent North East Arts Association, Jake felt inspired. After all he was equally unqualified in all aspects of the job. So naturally he was given it, and found himself two months later at the age of 24, sitting on seven theatre boards, running a film makers competition and supporting three small poetry magazines.

Alas, it took him two further years to understand that he didn't want to foster, nurture, cradle and massage other people's artistic ideas, or even to fund them! He wished only to be back in his own crazy world of doing what he wanted, making his own disastrous decisions, not advising others on how to avoid the obvious.

So with no professional experience, Jake applied for the post of Artistic Director of the Newcastle Playhouse, lately vacated by Sir John Neville. Naturally what he was offered was the post of General Manager. Equally naturally he declined this amazing offer to apply for a Trainee Director's Bursary from the Arts Council of Great Britain, worth eight pounds a week. Armed with this, he went back to the Newcastle Playhouse to ask if he could run a second touring company for them, as he now had his own salary, and no one need waste their time training him.

It occurred to Jake years later that he had much in common with Yozzer Hughes, the unskilled and desperate loser in Alan Bleasedale's brilliant 80s television drama *Boys from the Black Stuff.* Yozzer always said – 'Give us a job. I could do that.' Jake too said 'I say, just a moment. I'm certain I can do that. I can be a playwright just er, just er, just offer me the opportunity.' Was it only the accent, or the expensively bought self-confidence that separated the two? It certainly wasn't education, which neither had actively attended to.

Jake's initial attempt at being an artist was a doddle. The first play he co-wrote went into six productions in two years and was the first drama ever to be featured on his local ITV station. The third won the Welsh National Dramatists Award for a Geordie dialect documentary about the incendiary who fired York Minster – the first time, that is.

Jake's Stagecoach Company opened new arts centres on Tyneside and Teesside, toured as far afield as Edinburgh and Exeter, attracted visitors from 27 countries in three years, and pioneered theatre in North Shields working men's clubs alongside participatory drama for each infants' reception class in every school in Gateshead, while drawing a live audience of

150 in Cumberland's bleak Cleater Moor, as the rest of the nation sat in their cosy homes and watched the first man walk on the moon.

Jake had only to stay where he was to rise to the very top of his profession. But No! It was given Arts Council policy that directors should be moved on every three years. And, more importantly, these three years had very nearly killed Jake. He was averaging 18-20 hours per day, directing by day, as well as driving the van and acting as roadie, and play-writing by night. The wife who'd been game enough to climb the chapel roof every week had figuratively changed the locks on the doors without Jake even noticing, and left. Perhaps she was reacting to what he thoughtlessly proclaimed in his celebrity interview in *Plays and Players*: 'I'm married to my work first, and my family second.'

So Jake at 30 retired from running a theatre company to become a part time playwright and full time single parent. And by now he was used to earning £24 a week. The only problem was that new plays for performance to young people sold for about £50 if you were lucky. So the arithmetic demanded you knock out one a fortnight. For a time, Jake was the most prolific playwright in the UK, burning up collaborators like a fast car rolls rubber to rubble. But the writer's bubble had to burst. Jake's appendix burst (twice). The money he'd been supportively given by the Arts Council to write a book called *1000 Drama Games* ran out at number 74: *How to become someone else without them noticing.* (It's actually a really good one.)

So Jake had to look for a new mangle to stick his head in, becoming Artistic Director of his first repertory theatre, a famous, stable, newly re-built Lancashire Coliseum. After a week in post he found he was not only the Artistic Director but also General Manager, Production Manager, Box Office Manager, Marketing Officer, assistant cleaner, night watchman and general dog's scrotum (or should that be factotum? – You remember Jake never listened in Latin class.) After five shows and the death of one quarter of his inherited pensioner audience, hastened by the new sprinkler system installed in the

rebuild automatically being set off over the audience every time a full lighting state was brought up, Jake offered his Board a choice – they resign or he resign.

The Board promised faithfully and conscientiously to ensure that Jake never work in repertory again, never guessing – astrology not being their strong point – that three years later the first question Jake was asked on joining the Arts Council of Great Britain's Advisory Drama Panel was: should we cut off the entire grant to this Colossus or only part of it?

Fortunately the Oldham Coliseum thrives to this day. Meanwhile, back at the stage door, bags packed and mind emptied, Jake decided to become an arts consultant, not that the job title existed then. A consultant – who would want to pay for one of those? But an offer to be paid for three months to look at 'Theatre Provision for Young People on Merseyside', amateur and professional, was much too unknown territory for him to turn down.

If Jake's life had any constancy, it was that he'd never been objective, never thoughtful. He'd normally made judgements on impulse, usually in ignorance and always when completely unqualified. So it's a strange and scary fact that Jake's 1974 Merseyside Arts report is still on many drama schools' reading lists to this day.

Drama schools! Jake had never been near one and had no idea how they operated. So what more appropriate job could there be than teaching Theatre-in-Education (which he'd never directed before), at a leading London drama school? Jake was fascinated that others could be as thoughtless as himself. So while his old hormonal problems prevented him from considering the morality of sharing a bed with a student ten years younger, just because he'd failed to organise lodgings; he was more critical of a Principal who explained that 'his' School took no black students, because English drama had no roles for black actors – though *Othello* may have been a set text for 'A level' examinations that year.

So Jake drifted on again; taking a job as Associate Director at a brand new Rep; marrying an actress in the company; putting out a tour with the actors the Artistic Director didn't want to work with. He lasted five months before accepting an offer to write a report on 'The Development of Theatre in Yorkshire'.

Let's just say not all Jake's recommendations were taken up. 'On no account should money be wasted on a West Yorkshire Playhouse, when three community companies could be sited for the same cost on three outer council estates'. And he urged the Sheffield Crucible 'never to repeat the early experiment of staging snooker'. But he did coin the phrase 'The Yorkshire Coffin' to describe the shape of the four fifths of its population distribution confined within the coffin shaped from Halifax to Harrogate, waisted at Wakefield and footed in Sheffield.

Was the coffin an omen? Was Jake beginning to slide? He ran another penniless repertory theatre, back to working twenty hours a day. He took some of his company to Holland to earn export income, and with them directed a Dutch play about 'Urban Drift' without speaking a word of Dutch. He, the world's acknowledged worst actor, appeared on stage with his Associate Director, playing all eighteen parts in the pantomime *Puss in Boots*, which he'd written, when his cast, returning from a day off in London by train, ran into the wrong sort of snow drift in Oxford, while Worcester's school children sat expectantly swathed in sunshine.

Another wife left him. He returned to consultancy just before the breakdown got him. He quit smoking 80 a day, drinking in his own bar three times a day, and getting in the car to post a letter. So why not start marathon running – he'd never done it before? But it seemed painful, difficult and time consuming, like so many of his previous experiences; and his lack of qualifications included feet so flat he'd have been universally excused military service.

Well, how much more detail of this fairground dodgem ride can you take? Jake wrote consultancy reports on whatever he'd never met – Puppetry, Independent Radio and Adult Education, Arts Development Strategies for St Helens ... and

for Lincoln ... and for Peterborough; a report on sports provision in Barrow-in-Furness; and a community play in the West Midlands about Woodbine Willie, a man who killed himself by over-work at the age of thirty-nine. At least Jake was safe now he was forty.

He wrote keynote speeches for meetings of national art gallery directors and about local authority arts practice, since he'd never worked in either field. And he addressed the Bishop of Lincoln's all star Working Party on the depth of bitterness between striking miners and police forces on more overtime pay than you could get from a successful bank raid. This while simultaneously directing a community play in Carlisle concerning the nationalisation in 1915 of their public houses.

Jake was at his Jakiest! His flakiest! Whatever he did he'd never done before. Whatever he was qualified to do lay neglected. He was spoiled for choice. And then one day Jake went to sleep ...

'Time for the mask to be stripped away'

AMICI Dance Company's *Stars Are Out Tonight*

THE PHANTOM UNMASKED

It's time for the mask of pretence to be stripped away. You see, sadly, Jake is me. This was just a small part of my life to the age of 44. But even more sadly, typical of so many of my colleagues who believed it was such a privilege to be working in the arts that it was almost unreasonable to expect to be properly paid for it! What changed was that Jake got lucky. Jake at 44 got the chance to start all over again. He went to sleep one night and Paddy woke up in 1986: a disabled person – only nobody told him.

If I had gone to sleep a man and woken up a woman, or gone to sleep white and woken up black, I might have had some understanding of my new situation. After all more than half my world were women, and I was a son of Africa.

So how could it be that I was so totally unprepared for disability, oblivious to any facts, unaware of behaviour, attitudes, or experience? Strangest of all, as a practising theatre director and playwright, much of my life had been spent in seriously studying the game of make-believe, the experience of living, speaking and seeing the world through the thoughts, actions and ideas of others. Had I really, in 44 years, never thought of disability, never worked, travelled, holidayed, shopped or partied with disabled people? So ignorant had this left me that for three years I did not even understand who or what I was.

For three years I was a very ill and confused man – and the two things are quite separate. I met injustice, oppression, persecution on a level I'd never imagined possible. Told I'd need twenty years treatment by a psychiatrist when he heard I came from a theatre background. 'Ah if you're in theatre, you've got an overactive imagination, a desire to be the centre of attention, and to play act', he postulated. 'But ... I'm ... not ...an actor', I struggled to say. 'I'm a consultant, an organiser, a problem solver, a little like yourself perhaps.' 'Oh well you can say that but ...' actually I hadn't managed to say a word of it. I'd lost the power of speech. Though I later disclosed the wonderful joke that what the condescending

psychiatrist took to be my polite wave goodbye was actually my feeble attempt to strike him.

Finally after two years I got my diagnosis. I was thrilled! I had an illness: M.E. A label! Though one nobody could read. I worked with a speech therapist to learn to speak again. I lost my stutter (though about the same time I lost my teeth, so really did acquire a lisp). Cautiously I went back on the speech circuit – only this time Women's Institutes, Young Farmers, Rotarians, any charities I could find. And I described how awful this condition was, as I couldn't read and write, couldn't think clearly, couldn't sleep at all, kept falling over; and oh yes, the *pièce de résistance*, I was incontinent.

Fortunately for me, whenever I'd had a problem in my working life, I'd always been to discuss it with the greatest arts officer ever to work in the arts funding system – Jean Bull-winkle, then Deputy Director of Drama at the Arts Council of Great Britain. So I picked up where Jake left off and lurched in to tell her that I had no expectation of ever working again. She bluntly suggested I take a job (unpaid of course – I'm still part Jake!) by joining their recently formed Arts and Disability Monitoring Committee, on the grounds that it contained real experts on disability but fewer with a long career and under-standing of the arts. Then I got lucky. The person I sat next to at my first meeting, Chris Davies, television presenter, journalist, author, OBE, coincidentally even looked rather like me (well, we both had beards, both used wheelchairs, were forty somethingish and I bought a black hat like his) – except that he was born with cerebral palsy. For the first time in my life I'd met a role model. Now all that remained was for me to find a teacher.

The 44 years of my life thus far had been divided almost exactly into 22 years of parentally-expensively-bought and largely useless formal education, and then 22 years of trying to lose every part of that, and instead to enrol meaningfully in the University of Life.

But by this strange stroke of fortune, this metamorphosis into a disabled person, here I was suddenly open to real learning:

'A Role Model'

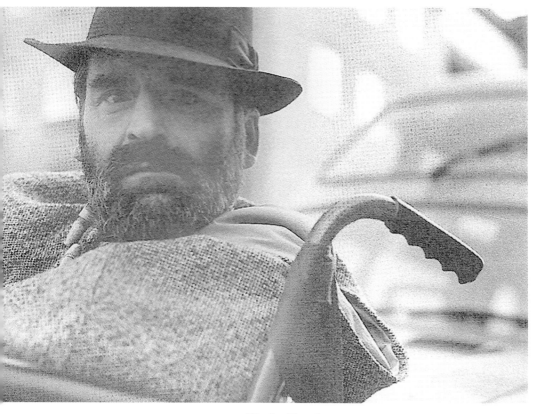

Chris Davies OBE
(ICON OF A DECADE #7)
Television presenter, journalist, author, teacher, historian

a third chance to re-start my education, because now I had a real need to understand, a hunger, an excitement about the opportunity to learn, that I'd never felt as a young student. My teacher was to be Ann Pointon, who was to point me away from my negatives, and to direct me to that positive Social Model of Disability, while also sufficiently instructing me to be able to write my 'Three Doors' debut speech.

It never occurred to me then that this was my first intro-duction to a wonderful concept of life-long learning; or in your formal context, Continuous Professional Development (CPD). Though the first time I ever met those words was not so auspicious. They appeared in the papers for a meeting on

the seventh Arts Council Advisory Panel I had served on over a twenty-year period – its Touring Panel. And when in over-enthusiastic Jake-mode I said how excited I was by this new thinking, one of our oldest and more august members, later a member of Council, looked at me disapprovingly and said: 'Paddy, there's really no need in our business. Actors chose to come to you because of your reputation; then they learned from you; then they moved on; that's how our profession self-perpetuates itself!' The old Jake stirred in me and I trembled, not with pride, nor with fury, but with the guilt of the confessional.

A memory from 1978 came flooding back with awful clarity. I'd just completed my first short season as director of the desperately under-funded Swan Theatre in Worcester, and I was interviewing my tiny resident company one by one to see if they could be persuaded to sign up for a second season. Things went quietly, and predictably, until it was the turn of the absurdly-talented Imelda Staunton (now of the RNT, RSC, TV series, films and cabaret), then in her second year as an actress.

'Why, Paddy, would I conceivably want to stay on? I've learnt nothing from you as a director!' 'But Imelda, do you realise how much I've learnt as a director from you? Had it never occurred to you that I need to learn just as much as you do?' Oh if only I'd said it before the door closed and the indignant footsteps tapped defiantly down the uncarpeted stairs below my deliberately dilapidated office!

There is no denying that the arts themselves, when rooted in truth and the honesty of the artist, are still the most wonderful and powerful form of learning ever created by humanity. But tragically it is that very assumption of the arts as universal education that has so held back the learning needs of the artists within the system that 75 per cent will have abandoned their profession by the age of 40. This, even though, as the Department of Culture, Media and Sport, identified in the year 2000, the economic value to this country of the Creative Industries was quantified at £60 billion annual turnover,

greater than the entire contribution of manufacturing industry to Gross Domestic Product, and growing at twice the rate of the economy. And from where do the Creative Industries draw their creatives, their product ideas, their packaging and execution? Why, largely from the arts and artists.

The arts are no longer some piddling little light entertainment to be dabbled with at 7.30pm after a suited day at the office. Instead they represent probably the best long term bet this country has for the prosperity of its economy, for the harmonious integration of its fascinatingly diverse citizenry, and as a stop to the daily casual violence that arises out of an inability to develop imagination, and so fails to understand that the bigot has a causal responsibility for the emergence of the terrorist.

Why should any board or committee in the land lack an artist, when they desperately seek lateral and creative solutions? Why? Because we carelessly tossed those artists away before their maturity, lost them to their first middle-age yearnings for mortgages, children, stability, an income, for life. Because we so totally failed to offer them career paths, business advice, skills acquisition, and the basic space to think.

So roll on, glorious CPD. Let it right all our wrongs; let it light us to a brighter future; but let us also now, today, this instant, understand the historic strength of the gabions that we shall have to dismantle, rock by rock, hard-won right by accidental precedent.

Since you've paid me the compliment of inviting me to make this presentation, let me risk abusing it by offering you some possible steps through your Matrix Retreat. And, because I'm a massive fan of modern dance developments, I offer you ten steps that put together make a Quick Step for Change.

TAKE THE FLOOR PLEASE
What's needed immediately? Well as a FIRST STEP, investment in our entire arts workforce. Merely halving the present wastage will double the return in value to the arts funding system. So let's stem the haemorrhage. And let's hope some

other speech will offer me the opportunity to deliver the line 'let's stem the haemorrhage and the haemorrhoids will take care of themselves' so that I don't have to say it now.

CHANGE YOUR TUNE
STEP TWO: As a former member of the Arts Council's Lottery Board, whose dispersal was just over £1 billion pounds in capital expenditure in my five year tenure, I'm just about entitled to suggest we got it mostly wrong. Why don't we stop investing in buildings, some of which actually contain a few artists, and start directly funding artists, some of whom, snail-like, come with buildings attached.

THREE STEPS TO HEAVEN
STEP THREE, then follows logically. Let's pay artists for what they actually do. It took my old union more than 50 years to work out that a director of a play did much of his or her work before s/he turned up for rehearsals. So a director now gets at least a week's creative thinking time paid for. How can we possibly justify not paying artists what we automatically pay their funders? And please take me seriously. It would be un-thinkable that any Arts Council or Regional Arts Board Officer be asked to serve on a committee or attend conferences 'at their own expense' without a strike being threatened. Yet for more than 50 years artists have tolerated giving up a day's pay for the honour of advising those who decide how their own funding is allocated.

SWING YOUR PARTNER in STEP FOUR
Let's share what we value in equality. If it is crucial to the recruitment of arts funding staff to allow them to take MBAs and sabbaticals, to attend symposia as well as symphonies, to demand pension and relocation packages, and now even to expect performance-related bonuses, why should all these not also be the rightful inheritance of the artists they fund? (Boy, as a theatre director, would Jake have loved to have been able to offer performance-related bonuses to perform-ing actors.)

'A Quick Step for Change'

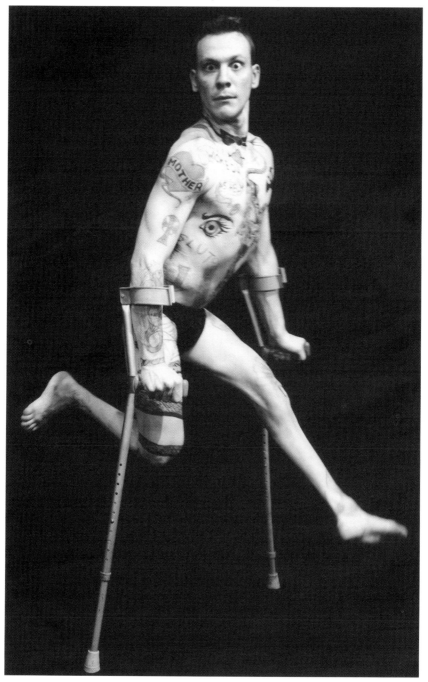

Darryl Beeton
in Graeae Theatre Company's production of
What the Butler Saw 1997

STRUT YOUR STUFF

This then leads to STEP FIVE – status. I've just finished eighteen months of chairing The Year of the Artist's 'National Think Tank', and as artists we concluded unsurprisingly that artists in the UK are accorded appallingly low status. When Jake worked in Holland he found that artists were treated like university professors – a little whacky perhaps, but brilliant in terms of respect and the payment of sixty-mile taxi fares to return them at midnight to where they lived. Let the work of the entire arts support system in the UK be about achieving for artists the status sports persons have today. (But without it being mandatory that you marry into the pop industry! Oh why not? Let's make that mandatory too!)

FORM A CHAIN

STEP SIX: Let's go big on mentoring, shadowing and job exchanging. Why does formal education only turn to mentoring when its pupils are dropping out – because, for example, the system fails black or disabled students? Let's make access to shadowing as easy as dropping in. The Director's Guild of Great Britain does it every year, and theatre directors shadow TV directors, while TV directors shadow film directors.

LET'S TWIST AGAIN

STEP SEVEN: Let's use disability as a benchmark and not an afterthought. Real disability access, in human and economic terms as much as physical access, is a metaphor for universal access. Disability equality training a metaphor for equal opportunity policies that work for inclusion. For the last eighteen months I've been part of an advisory group at the Liverpool Institute of Performing Arts (LIPA) that has set up the very first community arts foundation course solely for disabled people in this country. Since so many disabled people have been denied inclusive education, 'Solid Foundations' can't use academic criteria for course acceptance, so it's gone back to what Fitzwilliam House did for me 40 years ago: judging potential rather than past achievement, certainties rather than certificates. It seems to work. The first year

ended with a 100 per cent pass level, except for the two who left early to take jobs! What's more, the course is largely taught by disabled people and has a serious component of Disability Arts history on its curriculum. So even the teachers are learning.

TAKING LESSONS
Adopt step seven and we float across the floor to STEP EIGHT: The teaching of self-sufficiency. It's fascinating that only a few art forms – like photography – and a few arts institutions – like LIPA – teach financial survival alongside artistic excellence. As Ben Elton might have said ten years ago: 'at the risk of being just a little bit political'. If government is to continue to use our Arts Council at an arms-length principle to avoid direct inter-ference in the financial valuation of individual artists, then let's teach those artists how to apply those principles to their own funding applications. Maybe then arts companies wouldn't have to pay to learn how to raise funds from consultants who included an inflated value of their own worth. (Temporarily Jake has taken a sabbatical from being an arts consultant!) If cucumber growers can run the Cucumber Board, why can't artists run the arts funding system?

DON'T PANIC
STEP NINE: Lifelong. I found the word in your CPD draft literature – Jake never met it in his entire life. Could it be that steps one to eight could really eradicate lack of status, lack of confidence, lack of finance, lack of education, lack of oppor-tunity, so ending short term thinking, debt and panic – the traditional motivators in most artists' careers?

TANGO FOXTROT ROGER AND OUT
STEP TEN: It's our collective responsibility to explain to government, to academics and industry, that artists are as essential to society as nurses and teachers, helicopter pilots and quantity surveyors. Let's scrap the awful phrase I used to hear whenever I was trying to get disability employment initiatives off the ground. 'It's not *our* responsibility'.

Jake would vote 100 per cent for all of that. You see, he may have worked out how he got from there to here. But the real challenge still facing Paddy, is how to get from here to a non-disabling world called everywhere.

A DELIVERY NOTE

It's always nice to feel a speech has helped delivery. So I've been delighted to learn that in 2005, ArtsMatrix Ltd, funded by the European Social Fund as well as my speech com-missioners Arts Council England, South West, has finally hatched into a fully independent, artist-led agency dedicated to the continuing professional development of artists in the South West of England. I'm particularly pleased that among its many professional tentacles, it has a special attachment to higher education, training and funding providers. The development of the latter should provide continuity to the former.

I LIVED THROUGH IT ALL
I actually lived a life
for about five years
in which I allocated myself three hours sleep a night.
It's amazing that my work had
any quality at all to it
given that it was produced
under those circumstances.

A lot of it was fairly
not so much thoughtless
as thought free.

(Taken from *Paddy: A Life*
Transcription poems by Allan Sutherland
From the words of Paddy Masefield 2004)

Chapter 5

WHAT'S YOUR PROBLEM

Kathleen Franklin 2004
From Inter-Action's exhibition
with Caroline Cardus
THE WAY AHEAD

LIFE LINE
Aidan Shingler (ICON OF A DECADE #8)
BEYOND REASON
THE EXPERIENCE OF SCHIZOPHRENIA
'The plumb line acted as a point through which cosmic energy was
passed into a vessel containing urine. When I felt the liquid was
sufficiently charged I drank it to receive the energy.'

HOW CAN I TELL?

I've gradually grown accustomed to the astonishment of my non-disabled acquaintances, when I'm chattering on about the talents of one of my disabled colleagues. 'What's wrong with them?' I've been asked. 'Sorry, I mean what's their impairment?' they correct themselves. – 'I've absolutely no idea, it's never been relevant for me to ask,' is my usual response. That someone requires wheelchair access or a sign language interpreter, is all I need to know. I'm usually completely unaware of their medical history until I read their obituaries.

No surprise then that I only ever referred to the classic table of categories of impairment in one speech. Remaining consistent, this is the only chapter in this book in which – for very positive reasons – I wish to dwell on what divides us, as opposed to what relates us within the family of disabled people. For this is not only a vast and ever increasing family, but a widely disparate one as well.

It's traditionally said that we can be divided into four categories of impairment.

- **Physical**: covers a wide diversity from mobility impairments to people of short stature or those who use prosthetic limbs

- **Sensory**: includes vision impaired and hearing impaired people

- **Cognitive**: usually taken to refer to people with learning disabilities

- **Mental Health**: in their preferred vocabulary *Survivors* of the mental health system

- But there is of course a fifth: **invisible or hidden impairments**: such as epilepsy, cancer and illness

What may confuse you is that many of us have multiple impairments, which you won't identify by one glance at us. So beware false assumptions. Labels tell us nothing.

Let me use myself as an example. When I was at school this country's Poet Laureate was John Masefield. So to answer teachers' questions I had to remember my Father's explanation that John was my third cousin twice removed – which made them wish they'd never asked.

Meet me in the street and you'll observe I use a wheelchair. And for many observers that's where it ends. Accompany me to a committee meeting and you'll discover that the reason I'm packing a suitcase rather than a briefcase is because I work in large print (trebling my volume of papers). Shadow me through the day and in the toilets you'll find me changing my shirt every two hours as the result of continuous hot flushes. Escort me back to my hotel and you'll realise I'm in bed within fifteen minutes and stay there until half an hour before my homeward train journey. If you absolutely insist, I will confirm my medical condition is called M.E. What you will never hear from my lips is that while I was proactive in the specialist domain of the debate over how to spend those arts lottery billions, I was simultaneously receiving cognitive outpatient therapy to induce return of short-term memory! So unless you get to know me very well, you will never be aware that I'm your third cousin twice removed.

In 2005 ITV ran a competition for the public's favourite television sketch of the last fifty years. Paraded and rejected between numbers two to fifty were Harry Enfield's creations, French and Saunders, Smack the Pony, Benny Hill, Harry Hill, The Two Ronnies, The League of Gentlemen, Goodness Gracious Me and of course Monty Python's dead parrot. Instead the funniest of all ITV's history was judged to be one of Little Britain's sketches.

In the mid 90s to try and delight my grandchildren, I unwisely agreed to accompany them to our nearest Splash Pool. And while my son-in-law sought out a water adapted wheelchair to push me into the depths of the pool, my granddaughter goaded me into climbing fifty steps so as to hurtle down the water chute.

Now in Little Britain's hands an almost identical scenario was voted the funniest television sketch. Somehow I suspect they were not laughing *with* me. I've certainly never received any royalties.

You see, not only do many of us have multiple impairments but we may have fluctuating or partial impairments. And what I've just described to you I've kept private from all but my closest friends for a decade, precisely because it can confuse.

Even I could be spectacularly ignorant. Bill Kirby, an inspiring man in many ways, had been an art lecturer when he finally lost all his sight. I was used at committee meetings to hear him quietly listening to his recorded committee papers or notes on what he intended to say. He was probably the most thoughtfully prepared member of the committee. But he still shocked me when he enquired one day if the small growth on the right eye of the bust of the large Lord Goodman which looked down on our meetings was medical or merely abstract. He was irritated at needing to ask. I hadn't even noticed the bust, and as I'm not a visual artist I couldn't work out the answer anyway.

But it may have prepared me a little for a speech Bill gave one day, in which he pointed out that being blind had in no way changed any of his favourite pastimes including visiting Cathedral architecture, by changing from large print layouts to tactile mapping. Though he did raise my awareness of visual art intended to be felt, explored and examined in a tactile way – something not that different to one of my own starting points in theatre workshops.

How ever it had never occurred to me that a total loss of hearing could be a source of inspiration to a visual artist until I was entranced by Cathy Woolley's LadyGirl. Cathy explains:

> I went deaf at puberty so all my memories of sound are as a girl, and all my memories of being deaf are as a woman. Even when I become an 'old lady' I will still continue to hear or imagine sounds as I would have experienced them as a child. So I will always be LadyGirl. I decided to use the

LadyGirl
Cathy Woolley 2004
(watercolour on paper 28 x 38cm)

word 'lady' instead of 'woman', as it implies someone much older.

The title LadyGirl came about because of the subtle difference between the sign for 'lady' and sign for 'girl'. Lady is two strokes down the cheek with the index finger and girl is just one stroke. The figure is holding up her hair to reveal her ear.

What this teaches us are the depths of the arts in which certain disabled people can give us insight into worlds falsely assumed by us to be known. The arts of learning disabled people, of signed song and signed dance, of theatre by people who are visually impaired or deaf, of wheelchair dancers, of tactile sculpting, of disabled filmmakers you will encounter throughout this book.

The magical experience I want to introduce you to here is the art of Survivors – Art-e-facts I have found to be among the most illuminating experiences of a lifetime rich in wonder.

The charity MIND reminds us all that at any moment in time 14 per cent of the population may be experiencing mental health issues, but I think Survivors is a wonderfully defiant expression. A demonstration of hope for a future, where one is no longer followed like a criminal by a psychiatric record that can prevent some Survivors from fostering children, obtaining a driving licence, passport or visa, or insuring themselves. Many criminal convictions are declared 'spent' after five years, while Survivors' records remain stuck to some as thoughtlessly as one might attach a cattle tag.

So the word Survivor was chosen to denote not only survival from an often inappropriate psychiatric system but also survival of the threatening impact of discrimination fostered by a rabid tabloid media, and the resultant emotional stress.

Survivors Poetry was founded in 1991. Improbably, it was an art form that had for centuries been recognised in different countries and in voices as different as John Clare's and Sylvia Plath's, now given a wonderful new impetus. In the '90s, Survivors Poetry groups began to spread across England, pub-

lications earned plaudits and some of us finally understood how only through art could we begin to understand what society has chosen to call too complex for us non-professionals to engage with. Yet paradoxically, some self-styled Survivors find it difficult to think of themselves as disabled people.

Peter Campbell, one of the four founding Survivors Poets, has replaced Donne, Keats or Tony Harrison as my poetic guru. His poem *Decisions* is so taut in the information conveyed in every line, so understatedly revealing of an all too dramatic ex-perience, so light in its brushes of humour, so honest that all I can do is share it with you, and hope it will be a portal to the poetry of many other Survivors.

This being the real world however, that which is best is all too easily destroyed. Arts Council England has concluded that in

DECISIONS

I tell him I am Zeop the Centurion.
He writes it down into my case notes.
In the green room he plays with paper clips,
Talks to the girl from the Migraine Unit,
Decides he will sleep on it.

Next morning the staff team convenes.
Porcelain cups for psychiatrists,
Plastic for everyone else.
Decisions have to be reached.
I sit on a straight-backed chair.
'We don't think that you are Zeop the Centurion.'
'I know that' I say.
'Why else do you think I'm in here.'

Peter Campbell
(ICON OF A DECADE #9)

Peter Campbell has been using in-patient mental health services for more than 35 years. The diagnostic interview and the multi-disciplinary ward round are a key feature of acute ward life.

EUPHORIC VOICE
Phil Lancaster
(see also Frontispiece by the same artist)

2006 funding should be withdrawn from Survivors Poetry. If we lose them, then the discordant element of society's opportunistic attempts to whip up those darkest fears of ours for their own advancement or sales will have no counterpoint.

We have one hope. The forceful revolution in the visual arts of Survivors demands widespread attention. The work of Aidan Shingler, Colin Hambrook, Colin Pethic, Phil Lancaster and James Braithwaite, to single out only five from more than fifty, offers a wagon-train ride across new frontiers. You will find their art work arguing its own worth through this book. I consider Aidan Shingler's *Beyond Reason – The Experience of Schizophrenia* to be a truly seminal work. That it had to be self-published is a stain on the art publishers of the UK. Now I long to see Survivors move into film-making.

Phil Lancaster says of his *Euphoric Voice*:

> I suffer from Paranoid Schizophrenia and I'm tormented by Psychotic Voices in my head so I decided that I'd identify, photograph and document them (something never done before). Of my five voices, the Euphoric Voice, like all other voices I hear, can totally dominate my thought processes, so that everything I see, hear or do is filled with an elated sense of euphoria. So if you see a mad person talking to themselves and continually laughing or giggling for no apparent reason it's probably because they're tormented by this voice?

It is still an ongoing struggle to persuade medical therapists that art is not for therapy, it is rather a statement of who we are, who you are and therefore how we can all begin to understand each other. Several friends medically labelled manic depressive have convinced me that in centuries to come all humans will acquire the perception to see and think on many levels simultaneously. But it is still difficult to believe that their drama, biographies and short stories will be accepted as freely as Christy Brown or Alison Lapper's books have been – two icons of any age but both from that physical impairment category.

So it fascinates me that while there are even fewer professional disabled athletes than there are artists, they can nonetheless attain such high profile and recognition. Take for instance wheelchair racing multi-champion Dame Tanni Grey-Thompson – the second most recognised wheelchair user in the UK after Professor Stephen Hawking. Yet that recognition derives from the largest base of impairment distinction known to disability. The Olympic games cover an immense diversity of 301 sports from hurdling to handball. The Paralympics have even more events in half the time: 417. Because within each sport, such as the 100 metres run on the track or swum in the pool, there may be as many as seven categories for competitors who lack one foot, one leg, two feet or both legs, let alone degrees of sight, and other impairments.

In the arts world we're rightly enthralled by the evidence that David Toole was a 'once in a decade' dancer, while Ian Stanton was a folksinger/songwriter who wove a wonderful lyric into the loop of *Talking Disabled Anarchist Blues*. To the superficial observer they appeared to have similar impairments. But because most artists don't compete, that is irrelevant to their choice of art forms.

Television viewer figures for the Paralympics are increasing rapidly. Could this be because this impairment segregation is perpetuating the voyeuristic instincts that drive up the ratings for TV programmes about children whose parents seek miracle cures or whose behaviour, due to medical disfunction supplies the same fascination audiences once derived from unequal contests between maned animals and adherents to a new religion in Roman Amphitheatres?

As a former athletics coach and occasional television worker, I don't know. What I do know is that Jude Kelly, who was once offered the job of being my Associate Theatre Director and is now heading up the obligatory arts festival element of the 2012 London Olympics, will have to seek the wisest counsel if she is to make of it anything as long-lasting as paralympic sport. Or indeed to echo the ambition of Manchester's failed 1993 Olympic bid, when Manchester City Council committed themselves to bequeathing a legacy of sporting stadia and Europe's first new build disability-specific arts centre. It might have in-

corporated adapted accommodation on site for performers, car access to the heart of the building and not its perimeters and, instead of loads of lifts, a whole section of floor that could transfer bar customers to theatre auditoriums or drop stages into restaurants. I was only a junior partner to the proposals by access consultants Victoria Waddington and James Holmes-Siedle, but they lit an Olympian flame of desire within me, and Mayor of London Ken Livingstone is a man who can spot a spark a mile away. He still has time.

What we need to find in double quick time is an arts equivalent of Tanni Grey-Thompson. An articulate, sensitive wheelchair sportswoman of our era, her role model status was appropriately recognised by making her a Dame. And that in turn led to her spectacular television profile as a key member of London's historic trip to Singapore to clinch that Olympics deal. Now she is a member of a committee that recommends which among sportspeople receive royal honours. Jealous? No – I'm actually inspired!

Specialist Disability Arts companies and individuals have all had to fight their way out of the social constraints with which medical models encircled them. They have had to do this largely unfunded. There exists no venture capital for brilliant young disabled artists.

Until recently there has been no disability-centred publishing house, until Chipmunka Arts bravely blazed the trail in 2005. No major galleries or theatre buildings have dedicated themselves to seeking the new artists they feed off, from the fields of disability. Only in cinema have festivals of disability been held with any regularity – but in far too few locations.

If we do not recognise, cherish and pass on our experiences of the arts work made by disabled people of all impairments, and especially by Survivors, we will have been as heretical as the burners of libraries, as wasteful as exploitative colonial powers which thoughtlessly consume the natural resources from developing countries, and as offensive as the destroyers of globally recognised works of art.

I believe that we are all equally guilty, because every one of us has the capacity to contribute to what is to all our advantage.

Chapter 6

DIFFICULTIES IN LEARNING

Pasquelina Cerrone
2004
From Inter-Action's
exhibition with Caroline
Cardus
THE WAY AHEAD

WHY HAVE WE FOUND IT SO DIFFICULT TO LEARN FROM PEOPLE WITH LEARNING DISABILITIES?

Before I leave the issue of impairment labelling, I need to draw your attention to some of the deepest wrongs in society. When I speak of learning-disabled people I'm talking about my family and some of my closest relations within that family of disability.

When society speaks of them to this day, both in the street and on Hollywood screens, it lapses into a defamatory language of 'retards' and 'dumbos' and a stream of films such as Dumb and Dumber. *Dumb is a word whose usage serves only to dumb the speaker down.*

People who have learning disabilities may lack an extensive physical voice but still possess sensitive powers of communication. Some read and write. Yet they are a group who as recently as the 1960s were largely institutionalised in what were then publicly termed 'lunatic asylums'. They share, along with me and many elderly people, a lack of short-term memory. To this day it is customary to hear courts of justice refer to such people as having the mental age of six – or any other age where some psychiatrist's compass point has randomly stopped. It is further assumed by many from an earlier era of local authority social service departments that they should be treated like young children and that, despite constant instances of a positive opposite, they should not be allowed to live independently, make clear their adult sexuality, nor express a tender fondness for each other that could lead to marriage. Above all, a conspiracy prevails that they should not be allowed to speak for themselves when decisions are being taken about them, even though this 1.2 million make up 2 per cent of the population.

Drama groups for learning-disabled people sprang up early in the 1980s. These were often almost an accidental consequence of the practice of taking those who were not institutionalised to day centres, where basket-weaving had been the staple activity of the previous decade. Drama immediately injected a confidence about role-playing relationships, disagreements or social activities such as visiting a pub or catching a bus, and even making job applications.

When music was spliced to the drama it became clear that memory for this art form was more readily achieved than for words alone. The addition of video making equipment freed them from dependence on acquired memory. The visual arts were a tool which could be applied even more widely. So in perhaps twenty or thirty pockets of Britain, wherever an inspirational arts teacher and a sensitive team of facilitation workers could square the circle, companies accidentally began to emerge where people worked five days a week in various art forms.

Suddenly the attitudes of learning-disabled people towards themselves and towards others began to change. The perceived definitive barriers to potential were shown to be socially imposed and not part of a medical condition. I believe we stand on the shore-line of an ocean of potential, once we the foreigners have discovered the relevant language of communication. I am fascinated by the speed with which learning-disabled audiences can pick up complex stage humour in the theatre. The arts, it seems, really can reach parts that other communication may not. But one thing is paramount – the arts of learning-disabled people are the strongest tools to enable society to put an end to its own difficulty in learning.

Three occasions marked my developing awareness. The first occurred in 1988, as recorded by Chris Davies, who was interviewing me for an article in *DAM* in 1993. The participants in the first two pieces made it clear that they preferred to be called 'people with learning difficulties, although 'people with learning disabilities' is now more generally used.

No 1 PROUD OF MY PASSPORT

At the time of Paddy's introduction to the disability community not only could he not read nor write but he had 'no memory recall and very limited vocabulary and powers of speech'.

In this condition he revisited a theatre where he had once been artistic director although he had little understanding of the play being performed. 'It was a loud noise, which was uncomfortable to my over-sensitive hearing.'

The visit was a revelation. At the theatre, Paddy encountered two groups of people – those he had once known as colleagues, and some of the people with learning difficulties in the audience. Their reactions to Paddy were singularly and significantly different.

'None of my colleagues or former acquaintances came and spoke to this weird, strange man, who had lost about four

stone in weight and probably looked as if he had AIDS, and who was not easy to talk to, because I could not remember who they were. And instead I was swept up with enormous warmth into another group of people – people with learning difficulties, who welcomed me as if I was one of their party. That night was a passport into a different country. The medical condition I have has returned various faculties – or I've been able to retrain them – so I can no longer fairly describe myself as a person with learning difficulties, only as a person with some intellectual impairment.

I'm sorry I don't have a permanent visa into that world. Because as a writer, as someone with a burning sense of curiosity, I was there to learn and understand in a way that, as an outsider, I can't as readily do. But I still have the passport stamp of memory that proves that I visited that country and that I'm entitled to go back. And that's both a proud and exciting thought.'

The Paddy Masefield Award
2004

In February 2002 I was unexpectedly told that I had terminal cancer and at best six months to live. A rare type for which there was little treatment. Any natural depression I might have been experiencing lifted when half a dozen very special friends and colleagues in the South West of England, to which I had only moved twelve months before, asked me if I would give approval to an annual arts award bearing my name. My embarrassed answer was 'yes, of course, but shouldn't you wait until I'm dead?' They assured me they wanted me to know the respect in which they held me, before I left.

My delight grew when I discovered that *art + power*, a Bristol-based group of artists with learning difficulties, were to be the leading partner. Only six months earlier I had been invited to open their Year of the Artist Exhibition *Strength to Strength*, which so dazzled and inspired me that it took most of the pages of my cheque book away with my breath.

Since then, to my continuing amazement, I have been personally involved in the presentation of *The Paddy Masefield Award* for the last two years, as in this introductory speech to the Award Ceremony in 2004.

No 2 I CAN SEE CLEARLY NOW

I wonder if you can still remember the first time someone showed you a telescope? They probably explained that if you looked in the right end, everything would appear larger. But sometimes it seemed funnier to look through the wrong end and make everything much smaller.

Today every one of you has the option to look through the wrong end of the imaginary telescope in your mind's eye, and to see this event as a small, unimportant, merely regional affair.

Whereas if you're looking through the right end of the telescope, you can clearly see that this award is the first in Europe to be reserved exclusively for the talents and visions of artists with learning difficulties. And having spent a decade learning and listening, I believe them to be still the most frequently insulted people in society.

Is it right to bring politics into art? Of course it is. We know art has a place in politics: it can even change the course of history. Unfortunately far too little change has been effected in the politics of the arts world for people with learning difficulties. It's now more than fifteen years since the Theatre-in-Education Company I chaired in Worcester (Collar and T-I-E) sent a company of four professional actors working with four full time actors with learning difficulties from Other Voices, also from Worcester, to the Edinburgh Festival with a jointly devised play.

It is almost ten years since I presented a paper to the Arts Council of England, crying out for dedicated funding, after attending the most incredible festival created by 30 theatre companies in this country – all comprised of people with learning difficulties.

So now you know why this award goes to an artist with learning difficulties who *'best uses visual art to change people's attitudes to disabled people.'* The prize money may only be £1,000, but it's still worth more than an Olympic Gold Medal! Remember the Olympics in Athens in 2004, with all its headline stories of drug-cheats? Well, one extraordinary event seems to have gone almost entirely unnoticed. Direct your telescopes back to Sydney, Australia. Four years earlier, at the Sydney Paralympic Games, the Spanish basketball side, comprised of people with learning difficulties, was infiltrated by four non-disabled athletes. They were found out only after they'd won their medals. So what happened to them – the four non-disabled cheats? Why, organisers of the Paralympics decided to throw out not them, but *all* events for learning disabled people, because the judges felt it was too difficult to tell who had learning difficulties and who did not.

If you spend any time listening to people with learning difficulties, you'll know that what they most resent is name-calling. Don't take my word for it, look at Brenda Cook's prize-wining picture, STRENGTH (opposite) and hear what she says about it:

> My art is about my life. How I've been treated. How people use you and look at you. People say disabled people can't do anything, they say you're slow, but I can. My art has

STRENGTH
Brenda Cook
Winner of the Paddy Masefield Award 2004
(for outstanding communication through art)

grown and got bigger. It'll make other people think and move away from the bad things. My art shows people what I'm made of and who I am.

In real everyday life, it seems it is only too easy for people with learning difficulties not only to be pointed at and picked out, but also picked on. But today the diminishing act comes to an end, because we're all looking down the right end of the telescope, and seeing the big picture. No longer are people with learning difficulties to be pushed out of the picture, because today they are in every picture on display here.

Sandy Nairne, Director of the National Portrait Gallery, was our guest Award presenter. It was felt that we should mark the occasion by presenting him with one of the short-listed paintings to take back with him to London. This will be the first picture by an artist with learning difficulties to be on show in a national art gallery – and this picture will not be stored in the basement. It won't be hidden in a corner of room 475 on the 32nd floor. It will be prominently displayed in the Director's Office, the room through which, on occasion, Arts Ministers, Arts Funders and Directors of other national art galleries pass, when they are too busy to visit the galleries themselves. The picture is *She Looks Sad* by Lyn Martin (see page 11).

Additionally each artist was asked to say something about how they would like to spend the thousand pound prize. Brenda Cook was very direct.

> If I got the Award I would work with someone to set up my own website for my art work, my poetry, my film, all my dreams. I would want the website to be accessible to everyone.

There is one further element of the Award. The winning artist receives as much support as they need to achieve their ambitions. Indeed Brenda's dreams will shortly be made reality. Because Sandy, rightly proud that the National Portrait Gallery website has over three million visitors a year, proposes that he establish a direct link from his Gallery's site to

that of art + power. His inspired and inspiring gift may do more to banish the difficulties that non-disabled people have in learning about the accomplishments of people with learning difficulties than any arts funder has yet achieved. We could call it a telescopic vision.

No 3 CONFERENCE OR FESTIVAL?

The incredible festival I referred to earlier was held at Aston University in 1993 and attended by more than 170 people with learning disabilities and 30 facilitators. The weather was hot, the campus large and DAM had commissioned me to play the role of cub-reporter with the aid only of a new dicta-phone and a decidedly elderly power chair.

THE DIARY OF A DELEGATE
Friday July 22nd (20:45)

Three hours gone. Have motored furtively into the echoing toilets of the Student Union as the only place I can mutter into my dictaphone without my colleagues thinking I'm a media workshop. Everybody busy networking, which is exactly what the organisers (The Open Theatre Company) wanted. My only criticism is that there are still times when instructions are too dependent on words, spoken or written. Still, I found some-one to read the menu to me, and at other times followed the organisers' tour-guides, resplendent in their yellow hats and sashes, to wherever I wanted to go.

Friday July 22nd (midnight)

Wow! Supposed to be in bed. But in fact reflecting on a stun-ning piece of theatre – *Pain Without, Power Within* – by Strathcona Theatre Company, whose performance earlier in the evening disturbed all the prejudices or pre-expectations I have about theatre by people with learning disabilities.

On the one hand it was two hours of magic – visual poetry, theatrical effects, smoke, gauzes – as I last saw them used on a visit to a Leningrad Theatre Company – a kaleidoscope of

lighting colours, a sorcery of beguiling sound effects, images that will last half a life-time. A boy flying a kite and dancing with the clouds, a dive into a river to rescue a precious cap, a collective oppression of faith-healers.

It was a piece of theatre I would have been proud to have directed in repertory. It held its audience stunned. It was stylised, drilled, precise, presented by its directors in a way that suggested actors as puppets. The use of language seemed weaker than the choreography of music and movement. Is this evidence that words get in the way of, rather than enhance, theatre by people with learning disabilities? Questions are dancing round my brain like the actors in the piece.

Saturday July 23rd (14:00)
The pace is getting really hectic. I'm nearly late for the communal warm up at 09:30. It's a great innovation. Wonderfully warm, and I seem to make physical contact immediately with almost all the participants, who are especially sensitive to my pain potential and different sense of space. (Reflection to self – I wish all non-disabled professional actors could combine the same warmth with such awareness.)

The communal workshop is partly led by members of The Lawnmowers theatre company. This suits me as I have decided to shadow them for as much of the day as I can. So I stick with them as my choice of twelve workshops on offer.

To form improvisations the company ask us to suggest issues from our lives, drawing on experiences which have made us angry. Somehow I find myself as best man at a wedding, being denied access to the church because of its steps. However I am only a sub-plot. The central issue is the mother of the bride's determination to stop the whole wedding because both bride and groom are people with learning disabilities.

At the end of the session The Lawnmowers face a volley of eager questioners, who want to know how they can do it? Where do they perform? Are they paid? Who funds them? How does one get money?

I begin to feel I can not hide behind the invisible press card stuck jauntily in my metaphorical trilby, and admit the subject of funding troubles me deeply as a party to both regional and national arts funding bodies.

Saturday July 23rd (19.30)
About 30 delegates have given up socialising time to talk finance at my request. Representatives from afar as Yorkshire, Devon, the North East, East Anglia and Hereford tell their stories. If dramatised, they could make a three act tragedy featuring a lack of funding preventing development, the benefit trap too often preventing payment to the actors, and appropriate artistic assessments from arts funders being conspicuously absent.

This session has developed from the morning workshop which channelled anger into positive improvisations. So perhaps I should not be surprised at my own anger that the collective arts funding system has neglected this field of work so consistently that government cannot see that the work experience of being a paid actor is a real step to escape from the world of benefits, and yet is denied by the maze of regulations that is the benefit trap.

Sunday July 24th (00:30)
Tonight The Lawnmowers gave a performance of their *Big Sex Show.*

This is the perfect antithesis to Strathcona's piece. *The Big Sex Show* is short, straightforward, educational, side-splittingly funny and fleshed out with all the little details of personal life that make outstanding community theatre. Whereas Strathcona play medium sized theatres and arts centres, The Lawnmowers play local centres with a minimum of scenery and a maximum of direct exchange, even ad-libbing, with their audience. In the years I directed community theatre around Tyneside, I would have been proud to have been associated with this piece of work. It seemed to me that the actors had developed immensely since I saw them

THE BIG SEX SHOW
Andrew Stafford as Condom Man
The Lawnmowers 1993

three years earlier. Interestingly, I am told, their shows never exist in script form, and are recorded only in story-board memory aids.

I am impressed that their information support packs about the issues of sexual relationships for people with learning difficulties are presented mainly in picture form, and at 50 plus I still find them instructive. The show ends with the audience being invited to step into the role of one of the central characters to examine for themselves how they would resolve a tense situation. The waves of laughter that develop seem to wash right up to the shore-line of the evening's last event – *The Heart 'n Soul* Roadshow and Disco.

Much has already been written about *Heart 'n Soul*. Founded in 1984, they have become European role models ever since. Their drama work is normally encapsulated in a rock musical format. But their cult following is mostly for the Beautiful Octopus Club, a regular disco at the Albany Theatre in London that is a ghetto blaster in every sense of these words.

All three companies who have performed have been the subject of TV programmes, and they represent three of the most widely differing styles of theatre presentation that could have been offered as a weekend menu. Clever.

I resolve to report forcefully on the injustices that need urgent appraisal by regional and national funders.

Sunday July 24th (17.30)
I'm almost finished. This morning I followed the coloured banner to the Video Workshop provided by the *Fast Forward Project.*

Their workshop is simple and instructive. But two hours is not enough for the group to get as far as we wanted. And even though one of The Lawnmowers company shows himself totally at ease with his performance in front of the camera, we all want to spend longer discussing camera angles, lighting and the framing of shots.

Road Map

Beautiful Octopus Club Map
Heart 'n Soul are my first ...
(COMPANY ICONS OF A DECADE #10)

I lunch, saddened to realise I have been unable to attend workshops by: The Ark, Interplay, Carousel, Other Voices, Mind the Gap, Solent People's Theatre, ACTA, Jabadao and In The Boat. I realise how wide and fast flowing is the river of this movement, both locally and nationally.

Much later

I peer through the back window of the transport of my memory, and reflect – Conference? Festival? Celebration? Family Reunion? Then remember Open Theatre's closing promise that 'it will not end here'. A working party representing companies and individuals who have been here will continue to meet, help to report, and plan for the future. That's it! This is the label that I've been searching for. This weekend has been a three-day *party*. But never at any conference have I seen delegates *work* so intensively and continuously. What I've been at has been a wonderful *Working Party!*

REFLECTIONS

The Aston conference was a steep learning curve for me, and I followed it up by spending time with Other Voices in rehearsal, workshops and performance in my then hometown. I was also fascinated by the depth of involvement achieved through the leadership of workshops by Mick Wall, a rare actor/writer/director also highly skilled in clowning, circus, magic and music, by the group at Coventry Belgrade Theatre, where I was then a member of the board. Today that group has adopted the controversial name of The Shysters, but the Belgrade must surely be the only repertory theatre in England to *take ownership of* a company of learning-disabled actors as well as their resident professional company. If all 50 Reps in the UK were to do likewise, the spread of learning-disabled companies might be as great as was the spread and attachment to Reps of T-I-E companies. Theatre-in-Education was itself also founded in the adventurous 1960s forge of Coventry's Belgrade Theatre.

And in 1995 I delivered my promised Sharp Retort to ACE.

TIME CHECK

Heart 'n Soul continue to work in-house at the Albany Theatre in London, and in outreach in various media, accompanying a touring package that derives from a residency. Three such outreach projects have resulted in new established groups across the City. Heart 'n Soul also provide practical venue awareness training for staff relating to work with both audiences and performers with learning disabilities. In keeping with recent awareness of the lack of documentation about Disability Arts and the loss of crucial archive material, they are also establishing a new opportunity for their performers to record and document their work.

At the opposite end of England, in Gateshead, The Lawnmowers, through links with Heart 'n Soul's Beautiful Octopus Club, have founded their own Krocodile Klubs and Krew which are now developing across Tyneside. They have had a skills exchange with Carousel in Brighton and their play in Gdansk was shown on Polish television. In 2005 they featured in the first six months programming at the new concert hall, The Sage Gateshead. Wisely, they have as their Chair its Director for Community Music Development at The Sage Gateshead. Their work is always accompanied by distinctive booklets as follow-ups to such programmes as *The Big Sex Show* and also in a series of Guides to Running the Country. They too have their own premises, and in 2003 set up Liberdade, an apprenticeship programme in dance and physical theatre.

But reading the credits on a 2003 Lawnmowers' annual report reveals at what cost in time and energy financial survival has had to be scraped from more than 24 separate donor sources. This may account for the sad disappearance of Strathcona from the map.

While The Lawnmowers' successes are undoubtedly disability led, the facilitation with which they have been resourced by a non-disabled world has seemed to me the best in the land. For more than a decade it has been provided by Them Wifies, a Newcastle-upon-Tyne based women's com-

To honour the year of disability, 2003, the Krew took on the challenge of hosting the Big Snapper, Celebration at the Telewest Arena, Newcastle's Biggest rock venue.

'Can you do it again next year?'

The evening was a spectacular success with over 600 people celebrating their culture.

'Its been the best night of my life!'

David Andy Geraldine Paul

Sharon

Lisa

June

The Krew were involved in all aspects of organising the evening; visiting the venues, designing flyers, undertaking outreach work to tell groups about the celebration and performing DJ sessions on the evening.

The Lawnmowers 2003
(COMPANY ICONS OF A DECADE #11)

munity arts collective. And those last four words should explain to all of us, as well as all funders, what the best model of development is. I ask only one more thing of The Lawnmowers: that having invited Mick Wall to lead a circus workshop, one of their company becomes the first learning-disabled person to fire-eat in a North Eastern Working Men's Club. This cheap trick was taught me in the 1970s by Bruvvers, in the same region, when women actors were first allowed into a male bastion, only to breathe fire on their condescending audience. And I directed the earliest drama to be presented in those clubs.

AND FINALLY

Should your interest, your future activities, or your undoubted lobby powers be concerned with the arts of learning disabled people, you will find a broad array of introductory websites, CD Roms and booklets from MENCAP, Mind the Gap, Working with Words, Dada-South and the companies featured in this chapter are listed in the resource appendix at the back of this book. And Arts Council England publishes Action for Access to meet the requirements of the DDA for free.

Chapter 7

COUNSELLING THE COUNCIL
WITH FUN AND WITH FURY

THE COUNCILS
For the first 40 years of the 20th century the funding of the arts in England remained much as it had since Shakespeare's time. It was largely dependent on wealthy patrons, astute managers and the poverty of all but a few celebrated artists. Gone, however, was any royal patronage, and the outpouring of industrialist-generated charity that had in the 19th century given this country a free library service and museums and art galleries in our cities. Much of this funding was subsumed by the two great world wars.

It was the Second World War, though, that was to give the arts their greatest government support since Elizabeth I. In 1939 a Council for the Encouragement of Music and the Arts (CEMA) was thought vital to the morale of a nation at war. It proved so vital that in 1945 it became the Arts Council of Great Britain But only when Jenny Lee was appointed the first ever arts minister (1964) in Harold Wilson's Labour government was its funding able to match its status.

Throughout the bulk of my arts career however, the largest funder of the arts has been the combined commitment of the country's local authorities (LAs). Originally they were more concerned with ameliorating the extremes of poverty and celebrating civic pride in parks, town halls and public squares. Only in 1948 did Aneurin Bevan's Local Government Act allow them to raise up to a sixpenny rate for arts and cultural activities – that would be $2^1/_2$p on your Council Tax today – although none achieved more than a fraction of that allowance.

It was partly because of a lack of arts expertise in these local authorities that a vacuum was perceived, which Regional Arts Associations (RAAs) were to fill. The first was born in the early 1950s in the South West of England. But it was the North East Arts Association that created a model in 1966 and this was replicated until within a decade England (with the exception of Buckinghamshire) was covered. My own arts career began in 1967 when I became only the third specialist arts officer appointed by an RAA.

So a tri-partite funding-sourced system operated from the 1970s to the end of the century. This undoubtedly allowed many more art forms and arts innovations to spring up than would have been the case under a single centralised source. Community arts, gay and lesbian theatre, festivals, theatre-in-education, local music or film societies, living sculpture and contemporary classical music are a few examples of art that was praised by one funding source while reviled by another. The parties settled into a consolidated *accorde* – until the new millennium. Then an emboldened Arts Council made a hostile takeover bid for all ten of the RABs. The bid, in the absence of any alternative, real debate or public polling of the artists they fought each other to fund, was successful.

Bruises apart, a new Arts Council England – further enriched by subsuming the arts lottery funds into its budget – might have led this now artist-focused policy into a brave new millennium, to the applause of those funded artists. Unfortunately central Government's handouts to local authorities were being squeezed ever smaller by the Blair government's strange alliance of hawkish war-making, health service revival and centralising responsibility for education away from local authorities. Margaret Thatcher had already decreed an end to the practice of free music provision for every school, so eroding subsidiarity.

Result: The tri-partite funding democracy had collapsed in the name of centralism. If one was in favour with ACE, then conditions got better and better as half a century's theatre indebtedness was cancelled at a stroke (partly due to my

exposure in the West Midlands of its theatres' accumulated – but undeclared – borrowing totals – something hither to considered unmentionable). Now the European model of committing funding for up to three years to an arts organisation became thinkable. In all my years as a labourer whose work was procured by ACE, I cursed the invention of the Julian Calendar which translated arts funding into a childlike playground song of:

> *We're only funded for a year at a time,*
> *so your accounting and employment must fit our rhyme.*

Not 'a model way to run a railway.' If one is out of favour with ACE there are now few alternative options.

My knowledge of this system is unusual. I have served for about 20 years on each side of the fence, first as non-disabled and then, with one bound, disabled and I also sat on it at length. So I should be as well placed as any historian to determine whether ACE policy can be turned around to the genuine and long term-committed benefit of all arts-aspirant disabled people in England.

The two extracts that follow, taken from speeches only 14 months apart, may help determine whether this is so.

The first is offered as evidence of an Arts Council at its best.

THE COUNSELS

No 1. A PRESENTATION WON

(A PRESENTATION TO THE ARTS COUNCIL OF ENGLAND TO ADOPT THE 'INITIATIVE INTO THE EMPLOYMENT OF DISABLED PEOPLE IN THE ARTS')
3rd March 1993

Chair, Council Members, I represent in many ways a very typical product of the Arts Council's success. I worked in subsidised theatre for 21 years, placed there by a trainee director's bursary from the Arts Council. I was the recipient of grants for new plays from the Arts Council that enabled me to work full time as a playwright for young people's theatre. Arts

STORM
James Braithwaite
Sound Minds (acrylic on canvas)

Council grants supported the theatres I ran and the community plays I wrote. I started four theatre companies, directed 75 plays, wrote 30, and produced 21 consultancy reports. So I'm hoping that you're happy with me as the return on your investment.

You have heard however from the Head of the Disability Unit, Wendy Harpe, of the total absence of investment in the employment of disabled people in the arts. And while I joined this initiative with scepticism due to my own experience, I ended it wholly convinced of the enormous creative potential of disabled people. This conviction was strengthened only weeks ago when I was making a presentation on disability and the arts to a meeting of West Midlands Arts members in Walsall.

Next to me on the platform was a young disabled person named Arvind Aheer, who showed a video he had made about the prejudice concerning the employment of disabled people in Shropshire. (Coincidentally, the number of disabled people in the West Midlands is equivalent to the entire population of Shropshire.) I thought his presentation was fascinating, his potential considerable. His was the sort of sensitivity and talent that I as an ageing director want to be replaced by. But at present all he could say to me was that despite his burning ambition, he could see no way to acquire my training, my experience, or what he saw as my self-confidence.

Members of Council, if you accept the recommendations of the report before you, I can go back to Shropshire with a real answer. I can tell Arvind of the apprenticeship scheme for disabled people to be launched in the year ahead. The Employment Initiative can go back on the road in the autumn to talk to arts employers in the South West, in the North West, and I very much hope in Wales and Scotland. Even more personally, I can reassure my disabled colleagues that the Arts Council's belated adaptations to make its building accessible is a signpost and not a sop.

If you adopt this report I believe it will influence arts companies large and small, flagship and grassroots, to engage with disability issues. And when there is real prospect of

employment in the arts industry, there is a real chance that education establishments from primary to specialised tertiary training colleges, will have to change their policies of exclusion. That is the potential and the excitement of this initiative.

As an individual who was nurtured by your predecessors' vision, who has been given the opportunity of access to this building, even to this Council meeting, by your commitment, I very much hope you will want to be party to making this new vision a reality, and to ending the waste of twenty percent of society's talent.

This second piece, I suggest to the jury, reveals a Council determined to shoot itself in the foot on Disability Rights Day. A Council enshrined in law with the role of making the arts accessible to all had chosen that very day to announce the impending closure of its Arts and Disability Unit.

No 2. A PRESENTATION LOST

A BRIEF FOR A STAY OF EXECUTION OF THE DEATH SENTENCE PASSED ON THE DISABILITY UNIT
11th May 1994

Chair, Council Members, my five colleagues and I, all from your Arts and Disability Monitoring Committee, are present not as antagonists but as advocates. We are here to ask you to rethink your decision in the name of modernisation, to demolish a Unit and its staff which has taken you five years to get working, and is at last reaching the real core of the problem.

Only fourteen months ago, with the personal approval of the Prime Minister (then John Major) and the declared support of two government ministries, in this very room, you adopted the *Initiative into the Employment of Disabled People in the Arts*. This year you are funding ten apprenticeships for young disabled people in the flagship arts organisations you subsidise most heavily, administered by Liz Crow.

The first two are at the Royal Shakespeare Company (RSC) and I am one of their mentors. It has taken us three months to discover that the RSC has no real equal opportunities policy in place, despite their claims. We have had to re-write all the relevant application forms. We have discovered, despite the RSC's immensely successful international marketing, that there is no truly accessible toilet at Stratford. And finally some of the staff involved in taking on an apprentice have – let me be blunt – prejudices around disability.

Let me explain. We are not dismayed. This was precisely what we had expected. But this is the visible face of the failure of previous Arts Council Access goals. What we are delighted about is that the RSC are talking to us openly, frankly, and extremely helpfully about changes. But it has already taken ten years for your Disability Monitoring Committee to move you to this point.

Do I berate the Council for that decade – of course not. I review your achievement with modest applause, pride and collaboration. What is more, following the public mauling that your recent decisions on the closure of several regional repertory theatres and a London Orchestra have provoked, your disability policy is one of your biggest success stories, and nowhere more applauded than by disabled people.

How has that happened? It happened when the Arts Council started to listen to disabled people. It happened when you brought disabled people not only into your building but also into your decision-making process. It happened because you appointed disability-experienced staff to run the Disability Unit. It happened because they introduced you to movements such as Disability Arts. So your funding was seminal to the setting up of a professionally staffed National Disability Arts Forum (NDAF) and a nationwide and internationally admired Disability Arts Magazine – *DAM*. In turn these initiatives led you to commission research into the issues of disabled women in the arts, and culturally diverse disabled people seeking self-expression in your arts world.

The list is not long. The budgetary record of spending on disability is a mere 0.5 per cent of your budget, and your disabled arts officers form roughly 0.5 per cent of your overall staff. Nonetheless it is a success story of sorts – or should I say was – until for reasons you have completely failed to communicate to disabled people, and against the strongest objections of your own advisory disability committee, you have now voted to wind up your Disability Unit in twelve months time.

As Acting Chair of that advisory committee, does that mean I instantly resign? As a board member of NDAF, am I forced to resign? As a critic of an Arts Council decision, do I resign?

Absolutely not! I refuse to go away. I refuse to go quietly and so make things easier for my career-long friends and colleagues on your staff. I'm here to tell you that I'm going to be staying here on every occasion I can, explaining that you've made the wrong decision and turned the clock back twenty years to an age of darkness.

REALITY TIME CHECK

The Unit was closed twelve months later. The amount of funding ring-fenced for disabled artists and arts organisations in those twelve months was never equalled in the subsequent ten years, despite the Council's overall budget increasing by more than 250 per cent. The closure was marked by public demonstrations, national television news coverage and a special conference set up by the National Campaign for the Arts.

Bizarrely, not only was I not asked to resign but I was appointed to succeed Lord Snowdon as Chair of The Employment Initiative. More significantly, the Council felt confident enough to appoint me to their ten strong Arts Lottery Board for five years – the only disabled person to serve in the first term of any of the Lottery's five *Good Causes* Boards – and this enabled me to ensure that our lottery expenditure was in every case conditional on 'maximum access for disabled people'.

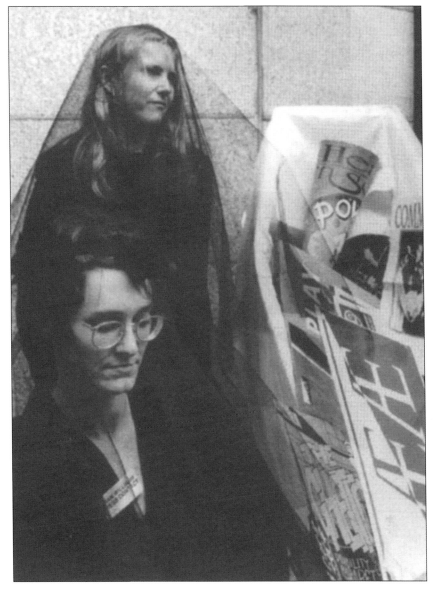

Mourning the Death of the Disability Unit
Sian Williams
(ICON OF A DECADE #12)

and Sarah Scott (above) sit in vigil over the coffin of the Disability Arts Unit, in which the future of many Disability Arts organisations have been laid to rest, at the door of the Arts Council of England. Both subsequently proved their commitment by working for ACE in different roles.

Those last five words were written for me by Chris Davies, to insert in the first of our defining criteria for awards. The subsequent arguments, advice, passion and knowledge, referred to in David Puttnam's foreword, were taught me and fed to me by my colleagues from the former Disability Unit to empower me in our struggle. No praise can be too high for the achievements of the personnel of that Unit, Wendy Harpe, Bushy Kelly and Alison Smith.

The responsibility of engaging the leadership of Arts Council, England in bringing funding and recognition to Disability Arts and disabled people in the arts is even greater today. But it appears that they still need us to teach them and to help them understand not only why but how. In 2005 we at least have the comfort of knowing that Dr Tom Shakespeare, a singularly reasoning and resonating voice in the world of disability, is now being heard as a member of the Council.

I have served on more advisory boards, panels, committees, working parties and initiatives for the Arts Council and for more years than anyone else in their 60 year history. So I could not leave you with the idea that there was only fury in our relationship. There was also fun. As so many career arts administrators have confessed, it's a tough enough world, without losing the fun of the arts.

The following short extract is from an address to the same council I had counselled as reported in the preceding pieces.

No 3. MAKING DISABILITY EQUALITY TRAINING FUN!

(December 1993)

Chair, Council Members, I know this is usually your boardroom in your Great Peter Street Offices, but for the next few hours it is also Westminster's leading Arts Centre, and, in terms of the talent, the performers, the amplifiers, the speakers, the sound desk, and the mikes, we may currently be Europe's loudest as well as leading Disability Arts Centre for the day. We're surround-astounding you with live performances, because the positives of Signed Song, Survivors

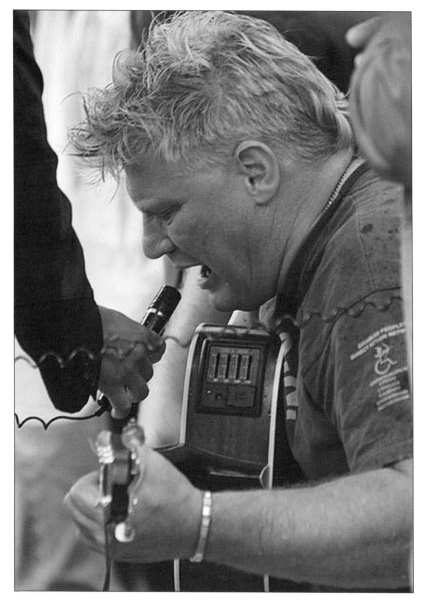

Johnny Crescendo (AKA Alan Holdsworth)
(ICON OF A DECADE #13)
Singer, musician, recording artist, composer, Disability Equality Trainer;
composer of 'Choices and Rights', anthem of the disability movement.

Poetry, Disability Stand Up, Disability Rock and the full panoply of Disability Arts will show you so much more than any written paper. And I make no apology that Wendy Harpe and I are two of the most mismatched MCs since Ernie Wise and Syd Little shared a wig and a routine.

Fifteen years ago, in Gröningen in Holland when the Provincial Council bought in my arts expertise as a theatre director for a co-production with their regional theatre, they requested that the first performance of our play commissioned to dramatise a 1000 page report on urban population drift be previewed in their Council Chamber. I still like the idea of art in a Council Chamber, it's a reminder of what you spend a lifetime having to make decisions about. So today enjoy, be surprised, learn and don't panic.

Our performers achieved a truly fantastic day, and the programme really did speak for itself; as it could today and every other day, dependent on your influence for change.

Chapter 8

BUYING DISABLED PEOPLE

Of course you should market the arts to disabled people, but do so for loftier apirations than mere bums on seats, or spaces for bums like me who come with their own seats.

In the year 2000 the Arts Marketing Association (AMA) of the UK invited me to present two disability workshops for their annual conference held in the newly opened Lowry Centre in Greater Manchester. AMA has a large and wide membership who seemed crucially positioned to be the gatekeepers for a first contact with the arts by disabled audiences. And while UK surveys suggest that around 75 per cent of adults attend at least one arts or cultural event a year, it is the onerous task of the marketing team of each arts organisation to drive that figure upward.

However, trends in the early 2000s have told us that attendance figures for many of the performing arts in the UK have been dropping. So the pressure on arts marketing officers grows each year. I proposed to offer them an almost instant solution. Statistics also told us that disabled people very rarely attended mainstream arts events, so overcoming the difficulties in securing access for disabled people could well be the arts companies' salvation. Nowhere else would they find an almost untapped 20 per cent of the population at whom to direct their marketing techniques.

The conference theme was:

TEARING DOWN BARRIERS

So I chose the language of the demolition industry for my own Slow-Mo Demo.

Let's start by uncovering the archaeological foundations.

Why bother with disabled people?

- They are more trouble than they are worth
- They offend other audience attenders
- Surely you haven't forgotten they are a fire hazard
- They never seem to thank us when we make 'special' arrangements for them
- They block up the car parking and drop-off points
- They don't seem to enjoy the experience of taking part in the arts
- They object to 'reasonable' requests that they be accompanied by a 'normal' person
- Then they object to paying for two tickets
- In fact guide dogs are the only good thing about disabled people

Comments of this kind have been heard only too often by disabled people.

CHANGING BROOMS

So before you kit yourself out to tackle such attitudes, remember that they are deeply entrenched. To dismantle long standing barriers will need long lasting action. Disability Equality Training (DET) is the WD40 in your tool bag. But never forget that DET is not just for jump-starting, but is a regular annual MOT for all employees – even disabled ones – and especially for board members.

HIRE YOUR TOOLS FROM THE PROFESSIONALS

Physical access is clearly fundamental. But what there is to be learned, needs to be learned directly from disabled people and not from charities or collections of non-disabled people who claim to speak on their behalf. An excellent starting point could be your local Disability Arts Forum or Coalition of Disabled People.

One legacy of the lottery's arts capital building boom has been some interesting publications. *Free For All* is a wonderfully detailed account of how consulting representatives from every experience of disability led eventually to shared solutions in the new Sadler's Wells Theatre in London – an iconic building for access.

Its other lesson is that all marketing departments might benefit from setting up their own Disability Focus Group. The solution to 50 wheelchair users trying to use a single accessible toilet in a fifteen minute interval of a performance by CandoCo – some of whose members use wheelchairs – is totally different to meeting the need of a blind person in a lift with no automatic speech information at each floor – who might be visiting a production by Extant Theatre, a company of blind and visually impaired performers.

It is worth remembering that disabled people are everywhere and everyone. Disabled people come in all age groups, all colours and all genders and sexual orientation, in all religions, and even in the Prison Service. They come in all political parties. So while manufacturing new marketing tools to access this new market, don't throw your existing tools and priorities out of the van. It is a priority that all young people are given an introduction to the arts – providing they include disabled people.

PUT A HARD HAT ON ATTITUDE

Ultimately access is about a state of mind as well as about marketing. If this conference fails to advertise its accessibility it will contain no disabled delegates. The sort of detailed access guide that is now put out on behalf of London

Theatres is as essential as being honest on your websites about the merits and deficiencies of the access you provide.

Those same advisory access groups, transformed to user groups, can act as key links to the particular communities you are trying to attract to your venues. For example it may be only a popular urban myth that Deaf Theatre productions never advertise publicly but are always sold out. I'm not a deaf person so I don't know. But there will be signs.

PRODUCTION LINES

Ultimately all marketing strategies are dependent on one factor – product. And the lessons learned from marketing to ethnically diverse audiences tell us that few people are interested in an arts world that has no depiction of themselves. No disability representation in product: no disability audience.

This may challenge even an experienced arts marketer. But why not start tomorrow with the introduction of existing acclaimed disability products into your buildings and your schedules?

The posters are from

■ **EXTANT THEATRE'S** production of *Resistance* (Top left) – Extant is at present the only British blind theatre company, and therefore skilled at incorporating live audio description within the script, so that no audience members have to wear headphones.

■ **COMMON GROUND SIGN DANCE THEATRE** (Top right) This particular image being their generic poster 1993-5. It portrays where Sign Dance Theatre begins: the hands and the arms 'showing the audience our language, our vision, our Common Ground.'

■ **CANDOCO** (Lower right) are Europe's leading integrated dance company, who have performed or devised specific workshops from West Africa to America's West Coast.

■ **MIND THE GAP** (Lower left) are an increasingly influential Yorkshire based company of learning disabled actors.

All are British-made, but each may attract a particular and different audience. These performance companies are chosen to illustrate this particular set of workshops. But we should be aware of art exhibitions, film festivals, poetry readings, discos and cabarets, which might each have a particular relevance to a different venue.

As a former theatre worker, I am used to the regular delivery of workshops. My logic is that one can construct a workshop for almost any problem-solving exercise, provided it is clear what the goals are, and that the keys which are to pick the locks of the problem have been presented or discussed be-forehand.

So, tooled up, let's move into the workshops.

TEARING DOWN BARRIERS

HANDS ON AND SWEATY
Premise: These workshops were intended for arts marketing professionals, so they assumed instant skills in copywriting as well as familiarity with every aspect of their building.

Instructions: You should break into groups of no more than six people, so that each can contribute as fully as the 30 minutes allow.

WORKSHOP EXERCISE A
If your venue is a mainstream performance area you will be promoting three consecutive performances by CandoCo Dance. This much-travelled company will supply your production staff with details of their performance and backstage requirements, but you should know that they usually attract a considerable number of wheelchair users in their audiences.

If your venue is small, you should imagine that Extant Theatre Company is making their first visit with a small scale production that might play studio spaces. As the UK's first theatre company of blind performers, you would hope to

interest a number of blind or vision impaired people, for many of whom this might be their first visit to your venue.

Each production provides an opportunity to attract, meet and learn from disabled people in the audience. But keep your excitement tempered by five important planning questions. Please keep a written record of all practical proposals as they apply to your venue. And please think laterally. If this is the first performance by disabled people in your venue, you will have to develop your own checklist. But be aware that your audience will not conveniently separate itself by impairments. I may be a wheelchair user, but I am also a theatre-goer eager to see Extant perform.

Q1 What barriers in your venue must be identified to be dealt with? Please list them. Some examples may be:

a) *Physical*: Car parking (set down points and spaces), accessible foyers, bars, point of ticket sales, minicoms, induction loops, BSL interpretation, audio description facilities, wheelchair spaces, adequate stage lighting for those who lip read, captioning, lower level box office counters for people of shorter stature.

b) *Attitudinal*: Front of house staff Disability Equality Training, including temporary staff for this production, ushers, bar staff, stewarding and the presence of a front of house sign language interpreter. Remember particularly that interpretation is a two-way process. Deaf people may be found both on the stage and in the audience. So the interpreter may only be needed for those who have not learnt BSL. Also consider accessible programmes and signage in the building.

c) *Promotional*: Be honest at all times. So your advertising should be guided by the company as well as your Focus Group specialists. Consider language, large print, not only in your programmes but in your quarterly advance leaflets, Braille, pricing structures, group booking offers, changing the sites of your usual poster displays, targeted leafleting and only *positive* press and media stories.

List those barriers with solutions and those unsolved.

Q2 Write about 50 words of general use advertising copy, informed by the company's press pack:

a) to appeal to disabled people who will be first time visitors to your venue.

b) to appeal to your regular audience base who may never have experienced a performance by disabled people.

Are your a) and b) versions different? Should they be identical? Can you arrange to monitor other agencies' use of your information, such as press, ticket agencies and 'what's on' in your local authority information material?

Q3 Where will you place your ads and spend your budget to reach 2a? Are information technology, websites, databases, disability press, commercial radio rather than newspapers, particularly relevant?

List your suggestions.

Q4 Has addressing these issues left you uncomfortable about the current situation? If so, where will you turn for support, advice or information?

List your suggestions.

Q5 After considering your answers, prioritise the five most important barriers to dismantle, and list them.

Now move to Workshop Exercise B for a further 30 minutes.

TEARING DOWN BARRIERS

HARD HATS OFF: THINKING CAPS ON:
WORKSHOP EXERCISE B

Your CandoCo or Extant presentation has been a success. Your Chief Executive/General Manager/Artistic Director is impressed by your initiative. S/he is now amenable to your proposals that your organisation should seriously commit itself to trying to develop an audience of disabled people.

S/he is, however, too pressured to devise a strategy her/ himself. So s/he is asking you to brainstorm the ideas relevant to your venue and its work. If your normal venue presents insoluble access problems, you may feel it is better to hire other spaces that are more accessible, and your boss may feel that the Disability Discrimination Act requirements make this necessary.

Your boss will take your ideas to the Board of Management, who will consider making available a special budget if you convince them of a financial return (and if they in turn believe new Arts Funding or Government Schemes may contribute). So you can think ambitiously or modestly.

Q1 What will be the focus for what you present? A short season? A festival? Workshops? A conference? Regular scheduling? Does it exist to be bought in? Should it be curated/created by your organisation? If so, with which co-producers? Should it be done in association with amateurs, youth organisations, special performances or exhibitions?

List your answers.

Q2 How do you plan to develop over the years, so this is not just seen as a one-off gimmick that will disillusion cynical disabled people? What approaches are relevant to different sectors of the disability market? Signed performances? Audio description? Participatory activities? Pre-show sensory inductions? Induction workshops? Ticket price concessions?

List your priorities.

Q3 Who will you turn to for advice, support, funding, or experience? Disability Arts Forums; coalitions; Disability Equality Trainers; Local Authority access departments; Arts Council England; colleagues; unions; management umbrella organisations; your own Focus Group?

List the most likely assistance.

Q4 At the end of your initial trial year, what self-set targets will you have hoped to achieve? How will you measure

achievement? Will it be on-going? Is it a question of improved attendance figures, attitudes, access, or youth policies? Will this require building access improvements? Are these achievable? Have you invented completely new marketing strategies, or adapted old principles?

List the answers which lead to a development strategy.

Q5 After discussion, list the five most attainable answers that you consider will most facilitate your overarching goal.

AND FINALLY

Come together in a plenary session to share the answers you listed to Question Five in each of the workshops.

Please retain your working notes for twelve months, so that you can reflect on whether any changes have been effected. Before you leave, please collect the advertising material supplied to this session by companies of disabled people. You may care to reflect whether this country should adopt a custom quite often used elsewhere in Europe in the context of the selection, marketing and programming of theatre visits to schools. That is a national gathering of those who produce new work with those who book it.

Having identified your barriers, set your minds at them in a manner reminiscent of my brakeless wheelchair careering downhill, and I guarantee you success. For there is a momentum in society and in social thinking right now, as well as a legal act that requires it, and a disability economy to buy into it. It should never be a matter of waiting for a governmental change to policy, or expecting a national Arts Council to be the sole mover in what is an issue of rights. Because that vast potential new audience already exists. It is waiting to be welcomed, dazzled, captivated and turned into season ticket holders. So go out and sell and you may find you've changed the way the world works and thinks. How many other jobs offer you that opportunity?

Image by Nancy Willis 1994
ANNUNCIATION

Chapter 9

DON'T MAKE A DRAMA OF IT

Theatre directors are defined as problem solvers; Play-wrights as people paid to re-write the rules. Little wonder I've had difficulty balancing the two.

Theatre was one of the earliest art forms to develop co-hesively within Disability Arts and to give voice to their exis-tence. It also provided such a life-enriching experience for me that I have returned to it regularly in my workshops and speeches. Here in an introduction to integrated casting work-shops for the third European Theatre Directors Forum in Athens, Greece in 1999.

A NEW TWIST ON AN OLD TAIL

It may seem arrogant for an Englishman to come to Greece to tell you about your own legends. But the story I tell may not be known to you. Yet it is a true story, and in its truth it unites ancient legend with today's uncomfortable reality.

In the furthest depths, the most eerie, dark and silent hidden centre of the labyrinth of our fears, is a monster. The monster is so terrifying that it is almost beyond description. It is human and yet it is quite unlike any human. It seems more animal than human, and so it has animal tastes for cruelty, and it eats humans. It is called the Minotaur, and the labyrinth is its prison.

What is the reality behind such tales – which have echoes and copies in the legends, sagas and fairy stories of every land and every culture? In almost every case it is disabled people! Super heroes like Theseus, the Minotaur slayer, Hercules, and

Odysseus, were the fantasies humans wish to achieve. They were the best looking, the best athletes, the best fighters, the cleverest people, but all embodied in one Super Hero. Today they are called Superman or Batman. And as they come from *his*-story they are usually male.

Villains and monsters derive from the most feared, mistrusted and vilified examples known to mankind: dwarves, witches, ogres, hunchbacks, people with one eye, one leg, a completely hairy body, a huge head, Minotaurs, Cyclops and Gorgons. The three Graeae sisters, named 'horror', 'dread' and 'alarm' in the English translation, shared one eye and one tooth between their grey heads. Today they are called The Aliens, or The Phantom of the Opera and, since this again is *his*-story, many are female.

For centuries this has been the fate of disabled people – to be held responsible for all the ills of the world. The Minotaur was just a disabled person. But so disgusting that he had to be locked away in a labyrinth. And in the history of the world very little changed until 1981, the first United Nations Year of Disabled People, when Graeae Theatre Company first travelled abroad.

In Greece, some disabled people are still locked in the closet even today – shut in a cupboard when neighbours call; left at an orphanage in the dead of night; abandoned on an island where no one can visit. Channel 4 documentaries attest to this and to people with learning disabilities padlocked in cages. Colleagues in Greece, a member state of the European Union, tell me that a disabled family member is still a barrier to their siblings' marriages. Extraordinarily, it is believed that all disability is inherited and so a 'threat' against future breeding. Hence these criminal acts are thought 'reasonable' behaviour.

So you will understand that if I am to be cast as Theseus, I have no desire to kill the Minotaur. Rather, I want to help him to escape from the labyrinth, to appear blinking under the floodlights on the wider stage of life.

You are the story makers of the future. You therefore bear the responsibilities for ensuring that the prejudices still found daily in television fiction as well as in your theatres are teased out of their mazes and tossed aside. What is paramount in all theatrical direction and in every actor's approach to a role is truth and honesty. So the truth of the 21st century lies in your hands, not mine.

But just as Theseus depended for finding his way out of the labyrinth on Ariadne's ball of thread – then called a clew – I will try to provide you with some clues – the word derives from clew – to disability-friendly theatre.

A QUESTION OF CASTING

I had the courage to ask this question of my fellow union members – actors and directors from Equity *– at an integrated Casting Conference, I co-chaired with Susan Tulley in London 1994.*

Question? By what right should disabled people claim they are the only ones appropriate to be cast as disabled characters? Because I've usually argued within our profession that actors are actors; so of course they can play people other than themselves. And if so why not disabled parts?

Well, one reason why actors can play drunks, millionaires and murderers, is that these specimens, like most other cast parts, have had high media profiles. If we read novels and newspapers, watch films and television and talk to each other, we probably think we know how such characters might think and act.

But because disabled people, as we now recognise, have been kept so marginalised and invisible for so long, most non-disabled actors have incredibly little personal awareness of the realities of disability behaviour. So the rare representations of disability on screen and stage are frequently perpetuations of historic stereotypes and not representative of present day reality. I'm accustomed as a wheelchair user to being depicted as resentful and revengeful, suicidal or alcoholic. But on Central

A Question of Casting

Mat Fraser
(ICON OF A DECADE #14)
Actor, writer, drummer, compere

with **Lisa Hammond**
in **BBC Television's** *Every Time You Look at Me* **2004**
A rare drama built around the relationship of two disabled people, and
only secondarily about their relationships with non-disabled families and
friends; produced by former Graeae director, Ewan Marshall.

TV's *Morse* this month, we saw that the motivation for being a murderer and a drug smuggler could be solely because of being a wheelchair user. And in a touring stage production for children, Cruella De Vil was motivated to be a dog butcher also because she sat on a wheelchair. This is just not acceptable.

Back in Athens, the directors' first workshop task was to look to move forward through integrated casting – meaning the casting of one or more disabled actors in a company that has hopefully already integrated gender and ethnic diversity. Possibly casting that disabled person as the lead character in order to lead to a new interpretation of an old classic.

■ To take one example, Shakespeare's *King Lear* might be a person who has become disabled in later life. How would this affect his decisions, the way other characters respond to him, and the way certain key scenes are interpreted? If he has become blind or deaf, you need a blind or deaf actor to play the role.

However, you should consider whether this is an example of a negative portrayal of disability? That disabled Lear cannot cope with disability, so goes mad? Is this a thoughtless assumption about blindness or mental health experiences? Would you prefer to find a positive role model? Should the hero of *Romeo and Juliet* be played by a disabled actor? But might this be another reason why Juliet's relatives find him unacceptable? So your task is to select a role and a play in which the depiction of disability will be positive and not negative. *Lysistrata, St Joan* or *The Good Person of Szechuan?* It's your decision.

■ The second task was to cast that disabled actor through a whole season of plays, without panicking. Note that in Britain very young actors are frequently cast in repertory as elderly characters, while in many countries famous but ageing actors often appear as Juliet or Hamlet. Sarah Bernhardt famously played Hamlet at the age of 55, but sadly never after she lost a leg in 1905.

Disability integration might seem less bizarre.

While at the Theatre Managers Association Centenary Conference in Cardiff in 1994, I tried to deal with seven questions in one answer.

Since I live on Income Support, who pays for my theatre visit?

■ Who pays for my accessible taxi to get there?

■ Who rings the theatre to check wheelchair access and the availability of a wheelchair space?

■ Who rings the box office to ask the time the show ends, so that the only accessible taxi working after 10.00pm can be booked two weeks in advance?

■ Who knows that the Crushed Bar in the interval will be totally wheelchair unfriendly?

■ Who therefore brings their own drink – despite the 'no food or drink in the auditorium' sign?

And

■ Who is obliged to bring an escort to conform with local bye-laws?

ONLY SOMEONE WHO WANTS TO SEE THAT PLAY VERY, VERY BADLY

That is until they find the only disability references – not written by Shakespeare, but inserted into a modern-dress RSC production – were to 'spastics', about being 'deaf as well as dumb', and a complex sight gag about too large a raincoat put on over a rucksack making the wearer appear to be 'a hunchback'.

What I had not anticipated was that this had been directed by a former colleague of mine who was usually very sensitive to my changed status when we met. I found more humour as a guest at their party at the Warwick Arts Centre, to celebrate innovatory access to their main auditorium. Though I still had to remove my legs in order to effect the turning circle required of my wheelchair – my wheelchair's legs, that is, which I was left holding on my lap. The production was *Much Ado About Nothing* however.

I accepted the invitation to join the Board of Coventry's Belgrade Theatre partly because it had a large and easily accessible box at the back of the auditorium, which enabled me to sit with other wheelchair friends, close to the accessible toilet and ramps to the bars. My one proviso was that I should be able to reach their excellent restaurant without having to go through all three courses of the kitchen flooring.

More purposefully, I suggested to the TMA that they might like to be proactive in the creation of a national and permanent British Deaf Theatre. The message this could send out to the eight million people who self-define as hearing impaired might be more audible than eight million posters to unsigned performances. Assuming they wanted to maintain their centuries-old tradition of theatre being a voice for the common man – and more recently woman – and a fun palace for young people, that voice would be expressed through British Sign Language (BSL).

Tony Heaton entitled the picture opposite *White on White*, thus playing with the ambiguity of the titles to many modernist works of art. But its subtitle: *Barbara, Johnny and the Quiet Revolution* told a more melodramatic tale. Johnny Crescendo and his partner, stage-named Wanda Barbara, were the main acts for a Disability Arts Cabaret at a 'special' school. Johnny has a rock and roller's predilection for not just volume but raw language. The non-disabled organiser's taste was for censorship. So he simply pulled the plug on the amplifier.

In response to the paternalistic way many people in institutionalised settings are treated, Johnny and Barbara circulated a poem. Its message was that disabled people were allowed to say thank you to mainstream performers who entertained them with their charity, but were not allowed to express a contrary view. Each verse concluding 'but they do'! Tony's reference to a 'Quiet Revolution' was that only in 2003 has sign language been recognised as an official language! In this art work the top line of arts conservators' white gloves spell 'smile'. But to read the bottom line you will need to find a BSL user.

WHITE ON WHITE
Barbara, Johnny and the Quiet Revolution (2001)

Tony Heaton
(ICON OF A DECADE #15)
(mixed media)

This piece 'concerns language: the language of art and BSL (British Sign Language). Next to English, the language I use and need most, but not offered as part of my compulsory state education that forced oral and European options only'.

The true role of theatres that call themselves National, such as London's Royal National Theatre, has concerned me for many years. During the enlightened artistic direction of Sir Richard Eyre, I was delighted to speak there against the attempted political extermination of Theatre-in-Education. But true to my view that we should not just wait for an Arts Council to put us centre stage, I returned to the RNT in this review I was commissioned to write of Graeae's The Changeling *on a national tour in 2001 for DN (Disability Now, published monthly by SCOPE).*

A NATIONAL CRITIC

Jenny Sealey explains in a programme note that the production of *The Changeling* which opened in Exeter on 11 October and tours until 17 November, is funded by an Arts Council Breakthrough Award.

And every aspect of this production represents a breakthrough: from writer Clare McIntyre's resetting of Middleton and Rowley's 1622 play to 1960s Liverpool, to the dazzling company, all of whom can sign some of the best songs of the 60s.

The play itself is dark, macabre and twisted – a fascination that seems to run through much of Sealey's work. But also with Sealey you can be certain that comedy, satire and irreverence will be as wholeheartedly integrated as the signing of the production.

What first Ewan Marshall and now Jenny Sealey's leadership has brought to Graeae is a consistency of casting that would put many regional reps to shame and an outrageous house style in which invention, bald humour, physical dexterity and an almost melodramatic simplicity of staging and lighting are the hallmarks of a confident and united company. (David Toole and Caroline Parker were among the cast).

It is a consistency and theatricality that cry out for a further breakthrough. If Graeae are already Britain's National

For the RNT 'Not to have cast Deborah or Ray is to have been unobservant'

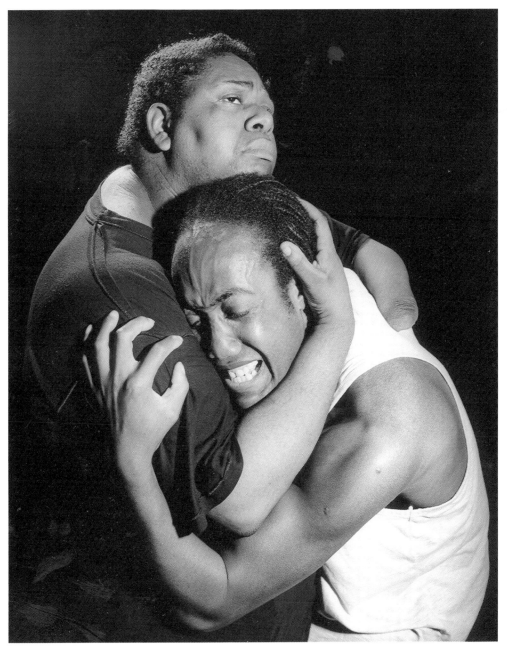

Deborah A Williams and Ray Harrison Graham
(ICONS OF A DECADE #16 and #17)
in Graeae Theatre's Production of *Soft Vengeance* 1993

Theatre of Disabled People, they are now more than ready to be integrated into our other National Theatre on the South Bank.

If newly designated National Theatre director Nick Hytner does not mount a large-scale project with Graeae in his first 12 months as British Theatre's Supremo, he will have missed an opportunity to give himself and a much wider audience a real Breakthrough.

Failing to cast Nabil Shaban, Deborah Williams, Ray Harrison Graham or Sarah Scott is to have been unobservant. A good professional club football scout watches Sunday park kick-abouts to spot youth potential. I wonder when an RNT casting director last visited half a dozen disability theatre productions. She wouldn't even have needed to travel very far. Sarah Scott played the lead in a West End production of *Children of a Lesser God* for some years.

UP AND DOWN THE SCALES

At the opposite end of the scale in 1973 in Durham I was invited to lecture on a Workers Adult Education course on pre-school play. I took as my thesis:

THE NAUGHTY TEDDY

My premise was the observation that most two and three year olds spend an inordinate amount of time each day being dressed and undressed – to get up, to go to play school, to eat, to go out in the rain, to get dry, to get mucky, to get cleaned up and then to go to bed. This is not an optional activity for small children, but their co-operation is authoritatively demanded of them by parents

The role of play is to explore repetitions, variations and even reversals of reality. So one consistently popular game involves nothing more than a Teddy Bear being constantly reprimanded by a three year old for putting both legs in one trouser, wearing a shirt as a skirt, a sock on one hand, a shoe on the other, a scarf as a sash and as a crown those much too tight knickers which conveniently allow a bear's ears to be accessible for sucking, after cuffing.

Chapter 10

TRUST ME

My life's work has been about shifting the arts from a spectator-centred activity to an activity-centred spectacle; about the demystification of the arts and the democratisation of the arts.

Trust me that the truths of education are not exclusively found in books, lecture halls, or even in theatre's case on illuminated stages. This integrated drama workshop is the validation of my claim that of all the arts, drama especially can change the way the world acts. These exercises provide an insight into how drama works, just as pictures show us how the visual arts speak. Drama workshops are being increasingly used around the world to spread the message of safe sex in sub-Saharan Africa or to connect disparate communities, as well as allowing disabled people a communal experience that can develop the confidence required for leadership.

This formed part of the last workshop I ever gave in New Delhi in 2003. It was with a young multi-national teenage group and included my two grandchildren.

ALL YOU REALLY NEED TO KNOW

'd like, with your help, to discover in half an hour just three things which you might be able to take with you when you return to your own lives.

■ Making drama should be fun and enjoyable, so all we are going to do is to play games.

■ Every initial idea you bring to drama should be as simple as possible. That allows everyone the freedom to make it as elaborate as anyone wants, as it develops.

■ The most important word in drama is *trust*. It is one of the simplest, yet it will allow us to play some amazing games.

First up, I want you to play the simplest form of tag. I start as the tagger, but when I touch someone they become the tagger and so on. Get running, because I'm wheeling at you.

Fine. We have some movers among us. Now let's see if we have any gymnasts. This time I need one volunteer to stay as the tagger throughout. Every time she touches anyone, they must freeze where they are. But if someone crawls between their legs they can be freed and resume running. Go get 'em!

Great scrambling! I think we have to call that a draw. Now let's make the tag a little more interesting. It's played like the first game, only this time we have three tags operating at the same time. One tagger can only tag your shoulder; the second only your foot and the third only your bottom. Three volunteers please? One, two, three, Go!

– And stop. Stay where you are. Who is now the shoulder-tagger? – Two of you? The foot-tagger? – Nobody? The bottom-tagger? – Four of you! – It seems even the simple can become complicated. (I must have played this game well over 500 times, and it never once came out right!)

TYING A GARLAND

For the next game let's attempt something complicated and make it seem simple. Please form a circle, holding hands. Now you've become a garland. Pull too hard and you break the garland everywhere. But if I just untie it – here, now it has two ends. And the two ends are to interweave as inventively as they can – twisting round, crawling between legs, stepping over hands; whatever you can think of without breaking the line, dropping hands, or causing a flower to shed a single petal.

Please will you accept these instructions:

■ You must stay silent, so that: if someone in the middle is hurting from being pulled in two directions, you can hear them calmly saying: 'STOP'! Then everyone freezes until you resolve the problem.

■ Be as clever, inventive and original as you can.

After two minutes: STOP! Stay just as you are please, while I take a mobile phone photo of your design. Now, imagine you're almost weightless on the moon. Drop hands and walk slowly and silently outwards to the walls and slide down them until you're sat on the floor.

Now equally silently and slowly move back into the centre of the room and find your EXACT position in the original photograph. No talking, no one giving orders, all are equal. Are you happy that's it? Then let's test it. Very gently begin to unwind (no letting go of hands please), until you arrive back at the very first garland. Tie the two ends together again. Brilliant. (It never ceases to amaze me how often this works out.)

DON'T PICK YOUR PARTNER'S NOSE

Let's work in more detail, using absolute trust. Choose a partner as unlike yourself as possible in height and weight, who you don't usually work with. Stand opposite each other, an arm's distance away. Close your eyes please. That's the only rule in this game. Now place the finger you point with, very gently on your partner's nose; eyes staying shut. You don't need any more rules, because if someone sticks a finger up your nostril, they may find their own ear has been spiked. Eyes stay closed. Try doing it faster, with alternating hands – that really is some trust. Open your eyes.

PULLING MY WEIGHT
(please see editorial note before attempting)

Stick with this dependable partner and sit on the floor, feet touching, holding hands. I'm going to demonstrate this one, so you can see it really is safe! So if someone could assist my fifteen stone (or almost 100 kilos) out of this chair, I'll collapse opposite the smallest person in the room. Grab my wrists very firmly, and I'll hold yours. Now, we're simply going to lift each other up at the same time. This is for real. I really can't stand by myself. If you're the lighter person you just have to lean back a lot further than the heavier person, trusting that they're not going to drop you. Further back, further still, and pulling; and amazingly we're both on our feet. Which is a bit shaky for me, so could we please sit down, using the same technique.

Now each pair try it, in your own time. Once you've mastered it, try swing-boating! Some old fashioned fair grounds still have 'swing-boats' where you sit and pull a rope, and when one end is right up the other is right down. Only here the rope is made by your hands. See if you can make it so like a dance that either you bounce off the floor, or harder still, never ever quite touch the floor.

TRUSTING A NON-DISABLED PERSON

Amba has a
problem

Workshop Exercises

Ami's in
control!

YOUR REFLECTION IN THE MIRROR

While you get your breath back, stand opposite your partner and imagine they are your reflection. You're both looking into the same mirror, but from different sides. Every movement you make, every facial expression must be the mirror image. But neither of you is the leader. Just let it start really simply – there you've both smiled – gently correct any mistake silently, and see how complicated you can get.

ARE YOU LOOKING FOR A FIGHT?

Now I've had a request from my grandson to show you the beginning of stage fighting, and since you're trusting your partners so well, I can reveal the magic. To make it look real, do the exact opposite of real fighting, because in stage fighting the hurt person (the Victim), is in total control and the aggressor (the Bully), does almost nothing – except act. It's like many Eastern-based martial arts philosophies. You reverse the logic. It's that simple.

Amba, I'd like you to pull your older sister Ami round the room quite fast and painfully by her hair. Or should it be the other way round? No, I don't think so, Ami wants to lead this one.

So – Amba, place the flat of your totally relaxed hand on the top of Ami's head. Ami, seize Amba's wrist, as if you want to pull it away from your head, which makes sense. Only, in fact, you're going to be pulling Amba's floppy hand down onto your head, so that you, Ami, will actually be leading Amba round the room. Try it.

Wonderful, you look like a pair of old fashioned folk dancers. So let's add some spectacle to the simple. Ami, it's mostly down to you. Be as imaginative as possible, try running, (slowly at first) but remember you're running towards Amba, so that he appears to be pulling you. That's good. Now think 'Garland': try dropping down to the floor as if you're trying to get away. This is where both of you have to remember to stay really relaxed, while you add some shouting, some facial expressions, some acting in fact.

Take a minute to discuss what the fight is about. What will work for you so realistically that if I call a Security Guard in, it will make him blow his whistle? So lots of bullying language, and even more expression of pain. Give it a first gentle try. It's only your first rehearsal.

Smashing! But not all your friends were as impressed as I was. So instead of criticising Ami and Amba's mistakes, pair by pair, show us how you could make it look even better. But always keep to the same rules.

ALL YOU NEED IS INSIDE YOU

Though what's always interested me more than running, pulling and screaming is to do as little as possible, silently, in order to make anybody watching want to be inside your partner's head. Then you have the same control over the audience as the victim had over the attacker.

So sit down again on the floor or on chairs, facing each other. Decide in each pair who is the Ami, and who is the Amba. Every Amba has a problem, but *you* can decide whether it's from real life or imaginary. But just start thinking about it, and whether it makes you sad, angry, frightened, confused or just not knowing what to do. Don't 'act' those emotions falsely please; just think about them so deeply that maybe even your toes become tense, you feel cold, or you find you're rocking backwards and forwards without even realising.

Amis! Just sit with your partners. Look at them. You have only two minutes to work out what their problem is without sounds, only with sympathy. Only you know if you'd like to hold their hand, or lift their chin so you can mirror their eyes. But the whole of your brain, and therefore your body, is focused on getting the answer, as if your life depended on it. And this is the one time when you can suck your thumb or clean wax out of your ear if that helps your concentration.

Right. It's been quite astonishing to watch. You've left me desperate to know what the problems have been. So, Amis please, in turn, what do you think your partner's problem is?

Thank you. Amba, now tell us, honestly please, how near they were. You see the fascinating aspect for me is not how many of you are right, but what a stunning experience it's been to watch you. (I am always amazed that young people can score up to 50 per cent correctly, while adults are lucky to get even one right.)

Mirroring with Mind The Gap

OK I'm a happy man, because you've proved to me that the best acting is when it's completely truthful and thoughtful, and is even better than the tricks of stage fighting or stage magic. I promise I could have shown you how to escape from the handcuffs inside the mailbag tied up by the audience, who also fastened padlocks to your cuffs, if only time had allowed. Instead, to celebrate how much I've enjoyed working with you, I'd like to share one last exercise, which really will reveal if every single one of you trusts everyone else in the room (which would have been unlikely at the outset).

You will have noticed that my legs tire very quickly, which is why I've brought my own chair with me. Imagine there are no chairs in the room. The floor is wet and cold. So we only have each other. For the last time please form a circle. As tight as possible, arms by your sides. Now turn to your right. You should all be directly behind each other. Shuffle a touch more towards the centre (on your left). Now very gently, when I say 'SIT!' prepare to lower your bottom onto the knees behind you. Don't be embarrassed by your weight. I'm the heaviest person here, and I'm standing in front of the smallest person.

Don't panic at the thought of my weight! Because we're a circle the weight will spread itself evenly between us. So each of us will be genuinely comfortable – and the world record for me is 122 people!

Gently go for it. Sit! Now fold your arms. Now open them to read a newspaper. Finally, very gently make your own chair legs walk forward very slowly starting with the left leg, now the right leg, now the – whoops! (It's usually more fun for young participants to end up in a heap on the floor. If that's not appropriate, count to ten as they sit, and share a bout of group applause, before each seated person lifts up the one in front of them simultaneously.)

With thanks to VK and the 50/50 group.

Editorial note: We live in a constantly evolving world of what is considered dangerous, physically irresponsible or sexually inappropriate. In some countries, including the UK, the pulling up exercise is contra-indicated. In others bottom tagging is inappropriate. *All drama exercises should be led by an experienced and informed professional.* Trained actors performing sword fights, classical dancers, circus artistes, as well as disabled artists such as Nabil Shaban and David Toole make a living by defying the common sense of Health and Safety regulations. Workshops are for those of us who wish to emerge unscathed and more confident. So you might like to consider an alternative exercise?

THE CHAIR IS THE ANSWER

As a wheelchair user it's an ironic footplate to drama exercises that my favourite exercise of all time is built around chairs! In fact it pre-dates my conversion from marathon runner to wheelchair user by at least ten years. But all workshops can be made accessible with forethought and given different emphasis. The actions can be carried out by a facilitator to a disabled person with no more difficulty than asking an assistant in a paint shop to fetch us down eight different shades of blue.

PEOPLE ARE THE PROBLEM

We're talking about the simplest lightest wooden or metal stacking chairs, likely to be found in any rehearsal space in any country – one for each actor.

The chairs were usually brought into play when I was working with adult amateur actors, or integrated adults who had no previous experience of drama but were shyly being drawn towards a community play in their own location.

The problem I encountered with both groups was their inability to express emotion in front of others, to be able to touch each other in a non-military way, or even to begin to improvise language based on someone else's needs and not their own anxiety. So I was tasked to release the sensitivity, quirks and depth of imagination that lie inside us all. My solution was to replace people, or in this instance a partner, with a chair.

TAKE YOUR SEAT PLEASE!

I would ask each person to examine in as much detail as possible the exact properties of their own individual chair. This is the starting point for much arts exploration, and was part of persuading my group in New Delhi to mirror each other and to look inside each other. Allow as much time as is needed, and slowly middle aged cake makers begin to lick the taste of the chair, steel welders to caress its outlines, and house-husbands to balance it like a juggler. And all, like a sculptor, to understand its wonder and also its limitations.

To initiate speech, I asked participants sumultaneously to introduce themselves to their chair, suggesting that sitting on it, or picking it up, might be more appropriate than leg-shaking.

GETTING TO KNOW THEM

To bridge isolation and the fear that someone else might be 'doing it better' than oneself, the obvious extension was to have everyone introduce their chair to other people's chairs, preventing nervousness by creating pressure over having so much to achieve in a short time. Chairs were to swap names, addresses, mutual interests, hobbies and hormonal interests. I

was asking the participants to do what I wanted them to do with each other, which they couldn't do as people but could do through the mystic medium of an inanimate object.

It would soon become apparent that the most popular relationship between person and chair was usually parental rather than ownership. It felt good to throw the unexpected at them, so I asked each individual to assist at the birth of their chair. I've seen twins delivered, I've seen parents faint, I've watched every detail of the miracle expressed in a watching face.

STAGE DRESSING

To maintain their flow, I asked them to clothe – in mime – an uncooperative young chair but to make their own decisions about gender, style, income, weather conditions, location, purpose and so on. If fed my suggestions like a gently dripping tap, some parents would in irritation at my input undress a nearly finished chair and start again.

Perhaps it was my sense of inadequacy as a young parent that led me to ask them to feed their young chair. But once, in a darkened distant corner of a vast hall, I caught the merest glimpse of an excruciatingly shy young Dutchman, who had come reluctantly, brought by his enthusiastic wife, experiencing the pleasure, and the pain, of suckling his already overweight chair.

Each parent was asked to prepare, convey and then leave their fast growing chairling at its first day at school. And then, after some dashing back in to reassure themselves or to break up squabbles, I would ask people to work for a moment chairless, as they waited to pick up their chair at the end of the school day, and to hear its news – just as complete strangers who share a common emotional experience but don't know each other do.

JUST FOLLOW YOUR CHAIR

Largely responding to the inspiration they were showering on me, I would attempt to develop each session along lines that felt right at that time. So I've seen chairs taken on holidays

abroad, fly for the first time, have a first teenage anti-parental rant, experience suspicious substances, require surgery, pick drunken fights or pick the wrong job. Sometimes I said little as scenarios unfolded themselves.

But we usually moved towards a similar conclusion – real depth in a relationship, openly expressed in public. So the newly adult chairs, cloaked in inexperience would be offered the social opportunities to form a new relationship. And by now my participants would be ahead of me, drawing on their own experience of where, how and maybe how futilely, their chairs would expose their secret dreams.

AND YOU'RE INVITED TO THE WEDDING

The most suitably matched chairs in the groups would be chosen for a wedding. They'd be flying themselves by now, so elopements, shotguns, civil ceremonies, ostentatious cathedral dos, and even chairs left at the altar have been part of my experience. I never for a moment wanted to break our compact by asking if it was experience or imagination that so coloured each scene.

And as must be, the moment came for parting, on a private and personal level – albeit only three feet away from another couple – from not only their chair but their partner of the last 40 minutes. I encouraged expression of deep emotion. And as the forlornly bereft people drifted away from moments of their own magical making, I gently asked them to comfort each other, to re-assure each other, to share with each other, *and –*

NOT AGAIN!

– Of course the exercise fell apart, embraces were a metre apart at crutch level, eye contact was impossible, touch became a trauma, and they ganged up against me for asking the impossible. Ah well! Only I know that a chair is just for Christmas, but never for life. No-one is *'wheelchair-bound'*.

Chapter 11

ARTS OF THE NEW MILLENNIUM

STEEL RING
Adam Reynolds
(ICON OF A DECADE #18)
Commissioned by Frimley Park Hospital, Surrey, 2000 -01

DEDICATION

This chapter is dedicated to

Adam Reynolds

Sculptor, artist, scholar, teacher, board member, humorist.
(1959 – 2005)

Adam was not only the leading disability sculptor of my decade, but also the only disabled artist to run his own gallery in London. He died in 2005 three days before he was to present an epic performance work, entitled Sisyphus on the Foreshore directly in front of Tate Modern – while I was writing this chapter.

Adam says of STEEL RING:

> As an artist I have been working with simple geometric forms for some years. I have been particularly keen to help others enjoy the contradictory nature of the universe. In my own case I am clear that my greatest strengths stem from the fact of being born with muscular dystrophy, to others apparently my weakness.

> The steel ring is simply that. A ten-foot circle floating in space. It can be used as a frame through which to look up to the sky, and as you walk about beneath it you may trigger off unearthly notes, see it reflecting the lights around or quivering slightly in the wind.

STEEL RING is part of *Out There*, a total re-design of an intenal courtyard including three inter-active art works by Adam Reynolds commissioned by Frimley Park Hospital, Surrey.

– – –

It is too simplistic to expect all sectors of the arts world to pick up the disability world as if we were a pumpkin to be squashed into their still life fruit bowl of the high arts. Some will certainly anticipate our pumpkin spreading rot to their ugli fruit. But there are people who recognise that their own arts need to be re-invigorated with new cultural stock in an organic way, rather than through the genetic modification of the market place. Collaborative Arts *are the buzzwords of this new decade, and community arts are the place of greatest pollination, as I argued in a keynote speech for a South West Arts millennium conference in the year 2000,* Right here; Right now.

What this new thinking about society will require from the arts is a new type of artist, who enables the leisure consumer to participate in a far wider and deeper way in the experience of the arts, free of taboos and the divisive labels of 'amateur' and 'professional'. We used to call this provision community arts, until government became too frightened of the liberating forces that became unleashed in individuals, and deliberately tried to asphyxiate them in the 1980s.

In one sense government was right. For it was the work of artists, film makers, poets and playwrights who undermined and destabilised the might of the USSR, and its satellite colonies, more than any threat, real or imagined, from USA President Reagan's 'Star Wars'. Ironically, it was the country that had vested more finance and status to artists than any society since the Renaissance which was to be undone by them.

Fortunately, a few community artists and thinkers, survived the British pogrom, the largest and most influential being Jubilee Arts transformation into THE PUBLIC, opening in 2006 as Europe's largest community arts centre and a regeneration of the town centre of West Bromwich. I am proud to have served as a member of their Board.

The concepts of community arts can be carried into every art form. In 1974, I was asked to undertake my first consultancy report by Merseyside Arts Association on the issue of Theatre Provision for Young People in their region. As has been my lifetime weakness, I greedily peeked into every foundation, forum and form of theatre I could discover, from Southport's Radio Doom, then working in a special school, to Liverpool's The Blackie where community arts had been invented by Bill and Wendy Harpe. But I could not leave a theatre report without comment about a music development that I believed should have been more widely noted.

This was Atarah's Band. Atarah Ben-Tovim was principal flautist with the Royal Liverpool Philharmonic Orchestra (RLPO) so was already involved in the orchestra's education

concerts. But her unease with traditional schools concerts led her to create a band that sought to entertain as well as to educate.

The band of eight RLPO musicians played a repertoire of pop, folk, rock and light music en route to a classical repertoire. Occasionally the band presented poetry (remember the Mersey Poets?) and a good deal of humour. Musicians even appeared dressed as Wombles or bears. The band were alive to the possibilities of working with actors and incorporating film into its presentations. But what most interested me was not only the direct two-way flow of communication with the audience about the music and the instruments involved, but also about the life of the musician.

Sadly my ears picked up no further notes on this score for over quarter of a century. Then in 2000 I heard booming reports about a new concept for The Sage Gateshead (whose funding I had already been party to, as a member of the Arts Lottery Board) which was to become the first true home of the Northern Sinfonia on Tyneside. What was remarkable were the cohabitants in this strikingly original Music Centre. It was to include a school for North East musicians and a home for folk music, alongside facilities for rock music and recording they could all access. The building, opened in 2004, has stayed true to its promise, and as audiences from any type of concert lean, drink in hand, on a glass balustrade, they find themselves looking down into the teaching centre below.

Even more exciting was a new heresy I first heard proclaimed by John Summers, now Chief Executive of Manchester's Hallé, which was to be embodied in the vision of The Sage Gateshead. It concerned the role of the 21st century musician and the regret at the increasing separation of performer, creator and teacher, which had led classical music in particular in the wrong direction. Echoes of Atarah's Band? John Summers declared:

> Specialism in classical music is a 20th century pheno-mena, and it is my contention that the musicians of the 21st century will want a musical life that is far less reliant

on a very narrow band of activity. It is felt that the musicians of the future will, like the musicians of the more distant past, be rounder and more involved with all the community, and be givers as well as takers in the aspects of musical life outside their first discipline.

Summers' words conjured for me not the musicians of Breugel's 16th century paintings, but the musician I spoke to when I was a 20 year old athletics coach in Uganda, who was on the same dusty track as my Landrover, on his way to play at a wedding, before returning next day to his regular role in the Kabaka's (King's) Royal Band. The presence of his instrument on the wall of my study stirs my guilt at having delayed the development of 'world music' – and in particular African music – from The Sage Gateshead's philosophy.

The Lawnmowers have performed at The Sage. But will a building be able to conceive a learning-disabled band, perhaps using the Drake Music Project's principles of enabling any disabled person, however inert, to create musical sounds by the slightest of movements? (*pace* Adam Reynolds' *Ring*.)

There are still unsolved issues. At the conference Sound Sense (Birmingham 1992) I had sensed a general feeling of uneasiness and anxiety about the relationship between community music and Disability Arts. Disabled people have the right to lead their own art, but where did this leave the community musicians who were used to being the workshop leaders and managers, and were now themselves experiencing feelings of rejection?

I had undergone that experience as a non-disabled person. The only expression I could find for supporting women's movements was to refuse to deliver a lengthily prepared speech after learning that all five speakers at an arts and media event were men.

A great deal can be done by non-disabled community musicians. There continues to be a need to facilitate disabled people in finding their way into the arts. Input is needed to the training of disabled people as tutors, development workers and managers, and political support will continue to

Aaron Williamson/Philip Ryder
15 mm Films 2003 7 minutes 30 seconds

In *Acute* a normal film-casting convention is reversed as a deaf performer – Aaron Williamson – acts as a hearing character. The engine of this short film is the notion of having 'acute' or hyper-sensitive hearing. Williamson appears to be hiding and running from some unheard and unseen threat in a labyrinthine and derelict Italian Castle. The centrepiece of the film is one unedited six minute take by Phillip Ryder's chasing camera. Ryder has limited use of his hands and is evolving a 'hands-free cinema'. *Acute* is a roller coaster ride through an entirely psychical visual and acoustic space.

Aaron has exhibited and performed extensively across Europe, North America and Japan. He was awarded the 2002 Helen Chadwick Fellowship in Rome, and was the 2003 Wheatley Fellow in Sculpture at the University of Central England, where he is now a three year AHRC Fellow.

be crucial. However, community musicians may need to wait for disabled people to come and ask for their services – when they have the freedom and power to ask for them on their own terms (co-authored in conversation with Mark Bick in *Sounding Board* 1993).

At that later Arts of the New Millennium Conference, the visual arts absorbed almost half of the three day agenda of speeches, tours, exhibitions and films. And although community arts draw massively on banner making, screen printing, posters, video making, murals, graffiti art and the full range of tools in the visual arts kit, I was still troubled by the contemporary image of the visual arts that so enrages the tabloids and often the wider public. I could not decide what was common to all visual artists – until three weeks of the Sydney Olympics of 2000 suggested an analogy to use in my speech.

Maybe visual artists are the decathletes of the arts world – the multi-taskers, not bound by the disciplines of a single sport such as the pedestrian 50km walker or the steroid-bulked hammer thrower. It's as if the decathletes had been allowed not just to compete in ten events but allowed to choose their own ten events from the whole catalogue of Olympic sport. So while one competitor chose to vault with his pole another was directly competing by high diving, or shooting clay pigeons. Wouldn't it make a superb, mind-blowing Olympic event, generated by the excitement to see which sports had been selected? That's a crucial part of the excitement of the visual arts today: no one knows whether the artist will select new technologies or a reworking of tradition, the mechanics of heavy engineering, or the ephemera of dust thrown in the air and photographed, the wrapping of an entire city or the gilding of a microdot.

Can the visual arts be the first chink in the wagon circle (see Chapter 2) to provide an opening for Disability Arts? Precisely because they are open to all interpretations, all subjects, and especially all politics and causes. It's just a pity that so few galleries, curators or commissioning bodies have sought out

Disability Arts instead of waiting for them to fight their way in. Hence my respect for Adam Reynolds, my hope that the International Institute of Visual Arts will shortly curate an exhibition of work by learning-disabled artists and that Tate Modern will create as much expectation for a major display of work by Survivors in 2007 as they did for Rachel Whiteread in 2005.

If you're a gambler, don't bet on which art form will be a runaway success in the 21st century. You'll probably get it wrong. In the 1960s we were told theatre was on the way out. Forget it! The more IT, laptops, play stations and iPods have us staring at little screens, the stronger becomes the urge for shared live performance – or football, the sport that was in its death throes in the 70s. Look at the evidence of how community plays integrate and interest the members of their communities. In the 1970s we were told books would be outmoded by 2001. Tell that to J.K. Rowling, whose Harry Potter books have led to a 20 per cent increase in sales of other children's books. In the 1980s it was obvious that film, the art form of the 20th century, was dying on its spools. One 'Year of Film Awareness', 50 multiplexes and five Imax's later, it's bursting at the frames. Art galleries were written off in the '90s as elitist, archaic, and unfit for subsidy. Only somebody forgot to tell local authorities and gallery directors, so they've become the boom industry of this new decade. So who can tell when it will be the turn of Disability Arts?

Well, against my own advice, I tip dance to become the most disability friendly art form in the next 50 years. My cover features David Toole in CandoCo Dance. And as a recently retired Board Member of the Foundation for Community Dance, I'm aware of the accessibility of dance to not only disabled people but people from age three to ninety-three.

The Arts Council itself commissioned a Vision for 21st Century Dance from Jeanette Siddal, which excited me to think laterally. Why should it not be realistic that the game boy and arcade games that still consist largely of gruesomely gunning down aliens with bullets could not one day be replaced by the

far more imaginative choice of moving 'CandoCo's' wheel-chairs by ever-gathering glissades guided by the 'Signs' to a woodland 'Carousel' ride, lit by 'Green Candles' and powered by an angelic 'Anjali' with a 'Blue Eyed Soul' opposed by the corps de ballet wailing to be swept from the screen by a welter-weight of wheelchair line dancers. (The names in inverted commas are all disability dance companies, listed in the Directory Data Base in Appendix 2.)

In 1996 I was asked to make the keynote address to CandoCo's annual three-day seminar. As well as my praise I had a couple of questions.

■ Why does an integrated company expend so much of its energy exploring the stereotypical dance themes of sexuality and relationships? Because while these are un-doubted areas of concern for many disabled people, most of us might place them second to issues of access to public transport, access to work, access to one's home or even someone else's, where sexuality or a relationship might be explored.

■ There might be a yardstick for the measure of achievement by any integrated company, but especially dance. For how-ever much we try to suspend disbelief, CandoCo's dancers using wheelchairs do not have the same freedom of move-ment that their non-disabled dancers express. Is this be-cause (in 1996) almost all the choreographers were non-disabled people? Could success only be achieved when a disabled choreographer created a dance world where those lacking wheelchairs were apparently more constrained in their choices, less free and less inventive than the dancers in the piece who were lucky enough to use wheelchairs?

I still hope to see such a piece, if only to tell me whether I'm right or wrong. The answer may be available sooner than ex-pected. In August 2005 a pilot professional programme to support the development of five disabled choreographers was established under the title Cultural Shift.

But whatever I may presume to challenge CandoCo to under-take in the future, this company gives me pride in being a

wheelchair user. And to be elderly, fat and unmuscled and yet think of myself as part of a family of grace and beauty is some empowerment!

I am fortunate to have been allowed two decades of asking questions. For that was the largest part of my work as an arts consultant.

Jeremy Newton had employed me three times when he was Director of Eastern Arts. It was he who generously alleged that I was the first arts consultant to measure the arts richness of a city or region by the number of its artists, rather than by the number of its art structures, facilities and institutions. Well, I've always been Mr Naïve, so it seemed common sense. Historically most governments have drifted along with the notion that funding buildings and institutions is much safer than funding artists. Buildings attract tourism, economic return and provide soporific musicals to dull social discord. Artists on the other hand challenge authority and mix logic, ridicule, laughter and pain. They ask the questions that governments wish to go unanswered. And no questions demand answers more loudly than those posed by Disability Arts.

It was this line of thinking that lead Avtarjeet Dhanjal, an acclaimed sculptor, to conceive an organisation in 1996 that he named The World Beyond 2000. It was to bring together at the millennium a concentration of international artists who would be asked to look back at their history in the 20th century to determine what the role of artists in a responsible new millennium should be. I was fascinated; honoured to be appointed Chair; enraged that the organisers of The Dome's activities would not even speak to us, while UNESCO and a number of other countries were supportive but sadly not the Arts Council of England. Without funding, the visual artists who were steering the project were obliged after four years to think of their own survival.

I remained so inspired by Jeet's concept that when the British Government decided to rejoin UNESCO in 2000, after Margaret Thatcher had withdrawn us, I was first in the queue to ensure that the UK UNESCO Commission's Culture Committee

included a disabled person. From this position I was able to approach the Director-General of UNESCO directly and ask about world disability policies, while sixteen civil hands tried to restrain me from such a breach of protocol. Alas, his response though charmingly expressed could have been the answer also to sixteen other questions.

THE YEAR OF THE ARTIST

The Arts Council of England and the then ten English Regional Arts Boards did mark the millennium with one hugely successful investment. The years of the '90s had been individually assigned as 'year of' a particular art form in a chosen region. The Year of the Visual Arts celebrated by Northern Arts was an outstanding example of how to use limited funding to achieve much greater public awareness.

So the year 2000 was designated Year of the Artist (YOTA) with the avowed aim of creating greater awareness and greater public involvement. Commitment to open thinking was positively expressed by appointing a disabled person to chair their Think Tank. Which is how Adam Reynolds, representing the artists of the South of England and I came to work together again and to find ourselves neither just a token presence but together a representative twenty per cent of that august tank.

In YOTA's concluding publication Breaking the Barriers *I was asked to contribute the introductory summary, from which the following is extracted.*

WHAT'S THE POINT OF ARTISTS?

Year of the Artist framed a dazzling kaleidoscope of diversity. Over four million pounds has delivered over 1000 artists to 1000 residences – from motorways to markets, prisons to pizza delivery, and science laboratories to hat factories. It has celebrated water and light, youth and heritage, hair, fish, and knickers; by providing pottery and poetry, bhangra and gospel, sculpture and stories, dance for elders and photography for disabled people.

Like it or not, the arts are all around us: in our advertising, in our newspapers, on TV, coming out of somebody else's Walkman, in fashion and in body adornment. Indeed, the arts are *inside* us, in our humming, in our dreaming, in our body language, even in our concepts of convention.

It is then a short step to the conviction that the arts should be placed in the shafts of all our actions, and harnessed to answering the most difficult questions our future poses.

And since education is the starting line for all our futures, it is an absurdity not to place the experience of the arts at the core of the education curriculum, where they then lead automatically to a passion for the three R's (*R*eading, *W*riting and *A*rithmetic), which are themselves tools for making the arts. But to insist solely on the virtues of the three R's as we do at our peril today, is to miss out on imagination, self-awareness, self-confidence, employment prospects and the ability to build relationships. This is not fantasy. Community arts projects similar to many created in Year of The Artist have been proving on so-called sink council estates for quarter of a century that learning to swim through life is a happier alternative than sinking.

There is one catch. Artists can only develop these skills themselves if they are liberated from the restrictive zoo cages called concert halls, galleries, cinemas or theatres, where they have been traditionally gawped at through history, and allowed to roam where they will in the wilderness of our real world. Year of the Artist has been a celebration of liberation.

A demonstration that dramas no longer revolve around monarchs, but can encapsulate the flavour of North Sea fisheries, or be enflamed by the passion of bikers; that portraiture is no more confined to the nobility (or their latter-day replacement – the 'celebs'), but can give us insight into the face of blind veterans of World War Two.

All this has melted centuries-old barriers between artists and their public, created collaborations where once there were jealousies, refreshed the inspiration of artists and provided a new century with an exciting demonstration of where and how the arts should develop. Just because people happened to be where a project took place, they were caught up, participated, allowed to question, and empowered to express themselves as the art 'became' theirs.

It was at least halfway to Jeet's even loftier aim. Responsibility for the development of Disability Arts should be the foremost priority of the community artists in whom we need to invest our futures. But if the embrace of community arts is as inclusive of disability as YOTA had demonstrated it could be, we might have less need of Disability Arts. For then we too could be everywhere in every form, choreographing our own histories in that responsible integrated future filled with sexuality and relationships.

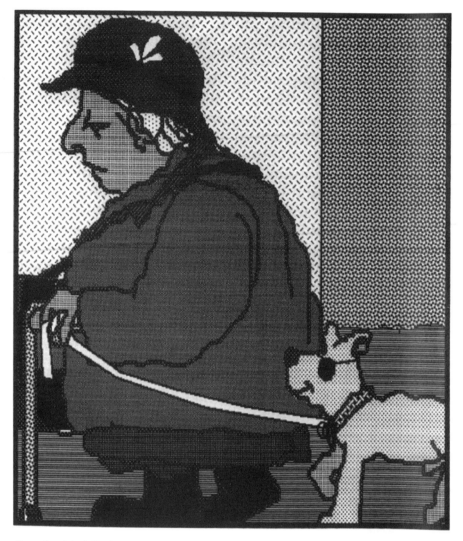

Despite his blindness, Bonzo leads a full life thanks to the devotion of his faithful guideperson Mrs Ada Pennington.

(ICON OF A DECADE #19)

ON THE RIGHT TRACK

Sometimes one gets lucky. My only meeting with Steve Cribb was when I'd painfully penned a speech with which to open the *Defiance Exhibition* in which Steve was featured. I must have muttered something exceptionally self-deprecating about my loss of instinctual writing as a result of my M.E.

Steve explained, almost gleefully, that the loss of the use of his own hands in 1989 placed him in the company of such greats as Michelangelo, who painted little of the Sistine ceiling himself but marked it up in numbers for his assistants! Steve had adapted to execute the same function prolifically, through the medium of his computer and later with a Head-start View Control Pack, which enabled him to change his mind far more often than Michelangelo.

I loved the analogy and it cheered me through the news of his death a few years later. Steve's work was sometimes criticised for being too light-heartedly amusing when he could have been producing something more serious. I'm happy still to be in his company on that one!

Chapter 12

GETTING TO KNOW M.E.

The nearest analogy I can find to describing the ex-
perience of living with M.E. is trying to run a large car on
a small torch battery. Before the battery becomes com-
pletely flat, the driver could sound the horn for fifteen
seconds, switch on the lights for ten seconds or
persuade the engine to turn over for five seconds. But
certainly not all three at the same time. I am today that
large automobile, and my fragile brain its driver.

Taken from *Living with M.E. –* A personal story, included in *A Feast
of Stories*, Edited by Clare Francis and Ondine Upton, first published
1996 by Macmillan and by Pan Books

LIFE IN THE NEW WORLD

One failure of the social model of disability is that it does not allow me to see the illness which is the underlying cause of my impairments in social discriminatory terms. This gave me two important reasons for keeping it firmly in my personal baggage.

■ In all the years I was promoting the value, skills and potential of disabled people, I didn't wish a single person to think all disabled people are ill. Actually very few are.

■ If I was pushing myself for appointment to a position of responsibility for large numbers of employees or discussing the disbursement of large sums of money, I did not want it to be prejudicially thought that in the middle of a meeting I would suddenly pass out. That is probably why the film producers and government ministers I knew to have M.E. tried to keep it concealed.

Only during the first two years of my illness, when I was a total allergic did I pass out, although this regularly happened up to four times a day. This afforded me a great deal of time to consider my future. Luckily my M.E. was so severe that I did not have to contend with the disbelieving who claimed that we were simply work-shy or seeking to draw attention to ourselves. It was suggested that if you could say what M.E. stood for – Myalgic Encephalomyelitis – then you didn't have it!

It was immediately clear that I could not be enabled to work again as a theatre director. The only time I was called back to advise a new director at my old theatre was when something went badly wrong with a rehearsal stunt. A character was to commit suicide by jumping off a rooftop, to be caught twelve feet below by six of the cast. I was called in, not because M.E. leads to a disproportionate number of suicides (though it does), but because I had become a theatre 'landlady' during the long wait while a benefit stream could be approved. My lodger who played the suicide came home hurt and frightened and I told him his director was risking his life. But

it was magical to see the faces of the six actors gathered on stage for me to instruct, when they saw that their 'stunt director' was in a wheelchair.

In the early days no system of short-term memory storage could be devised that would enable me to keep writing. Even a voice-activated computer programmed with *Dragon Dictate* could not solve my problems. Whenever it failed I had to remember a five-sequence pattern of step-retracing to correct it. So I am full of admiration for American artist Philip Martin Chavez, who paints prodigiously through *Dragon Dictate.*

It gradually became apparent that committee work was compatible with my M.E. I have lived for longer with my M.E. than I managed in three marriages. So it was a relationship I knew I had to work at, because we were tied together. The arguments for doing committee work were:

■ No stress. Even scathing comments have to be directed through the Chair and not at a protagonist

■ Short hours. Average committee meetings last three to four hours – until I encountered the Lottery Board

■ Preparation time for meetings could be dealt with in bed. (Since 1986 I have spent an average of eighteen hours out of every twenty four in bed)

■ In a sudden crisis the absence of one committee member does not bring its work to a halt

■ I would only work (unpaid) for organisations that had an equal opportunities policy from which I could insist on re-claiming the costs of nearby hotel stopovers before and after meetings

Thus it was that I became the first person in Britain to seek to sit on as many committees as possible – anywhere that a wheel in the door could enable me to put disability on their agenda as an item for change.

At home you just need to approach me a little more closely, particularly if the presence of a 'bug' and the absence of an immune system has confined me to bed. I've job-interviewed

NATIVE VOICES #7 (1998)
Philip Martin Chavez (California USA)
(22" x 31")
Inpired by the physical pain of disability to express himself in voice art,
Chavez sees it as a statement 'that you can't keep art down.
It's going to find a way to express itself'.

Rowen Jade
(ICON OF A DECADE #20)

Respected, admired and proudly representative of all her colleagues in disability. When Rowen was last hospitalised we were all required to write to the medical staff stressing her accomplishments and her value to society, lest someone decide to cut off the drip to another 'crip'.

applicants from my bed and been televised in bed. My grand-daughter played on my bed for hours, sharing her dripped custard with my bed covers. Now my daughter, when advising a disabled Minister in the interim Afghanistan Government, has suggested that ministerial protocols can still be observed in a bedroom.

But I found the courage to formulate a *revolving revolution solution* only after I met Rowen Jade in 1992 at a Theatre and Disability conference. Rowen is not an ill person. She is a disabled person of distinction, who chaired the National Disability Arts Forum Board in her early twenties and who chooses to operate in horizontal mode. I long to do so too, but am held back by lack of courage and initially by lack of apparatus. Adam Reynolds occasionally chose to operate in diagonal mode. So please colleagues, if you would come to order could you gather *on* the committee table rather than *round* it.

Just three times in fifty speeches was I unable to deliver a hand-grafted speech live, and as I could not then afford to make a video, I would courier a taped speech to the event. When I was invited to speak at the National Campaign for the Arts meeting about the policies of the Arts Council just after they decided to close their Disability Unit, I was chastened that an unexpected collapse confined me to bed. So Rowen had herself placed centre stage as a visual image fronting my recording. An access action that did far more for me than my conventional GP-prescribed antibiotics. And her status has also been no impairment to a long-term loving lesbian relationship, motherhood, and a fulfilling career as a teacher, consultant and adviser on disability issues.

As every writer knows, the bleakest hours often produce the most ridiculous comedy. Life was designed that way. I am doubly indebted to Allan Sutherland and his Edward Lear Foundation's archive project to document the history of Disability Arts. Both for the thumb-numbing eight hours he spent holding down the play button on my recollections of a life. And for his adroitness in turning some of those memories into what he calls transcription poems.

PROSE UNDRESSED BECOMES NAKED POETRY

When we switch on the radio, we can instantly tell whether we are listening to a play or an interview. Whereas script writers write in taut, articulate, comprehensible language, those working in journalism or the media will remember the shock of discovering from our first verbatim transcript that in real life we speak a garbled, at times nonsensical and un-punctuated ramble. When it is read back out of context, shorn of the speaker's fleece of gestures, facial emotions, and force-ful expressions of distaste or approval, it verges on the in-comprehensible.

Thirty-seven years after editing my first arts radio prog-ramme, I was still embarrassed when I read Allan's faithful transcript.

I am a dramatist, but Allan's writing skills encompass script writing and poetry. So from my daunting tangle of words, he was able to detach small sections, hang them up to dry, and then let them unfold into small abstract poems. While the words are mine, the origami is his. (All 32 can be found at *disability arts online* – dao.)

MUTUAL SUPPORT (an extract)
When we could meet in groups of up to twenty
or sometimes thirty people,
and share our experiences,
very often they'd be expressed in humour
as the great problems of life frequently are,
and the most common bad joke was that at night
you put the cat in the fridge
and left a pound of cheese on the doorstep.

It's a nice little joke
because it was true
and the nearest I got to doing it
(because I wasn't allowed to eat cheese
and didn't have a cat) was
in all seriousness
walking into a very small room in my house
that only contained a toilet and a basin
it was called the downstairs toilet room
and spending five minutes in there
going 'I'm on my way to recovery
I should be able by my mental powers
to work out why I've come into this room
what it was that I had a mind to do
by the clues around me
so look very carefully at everything in the room
and see if that provides an answer as to why I've come here,
and why I've shut the door behind me.

Hmmm...
no, not getting anything at all.
Okay, don't get distressed,
be aware this is a frequent occurrence.'

So I moved into the kitchen which was next door,
and discovered that I'd pissed all down my pants
even whilst in the toilet room.

What was wonderful
was to be able to say this very quietly
to a group of people of different ages
and different genders
and have them very quietly nod
or hold your hand, or give you a hug
and they would then tell you something that was far worse.

ONLY THE TEARS RUN NOW
Interestingly
the only other disappointment
I remember clearly
was not being able to run

it had been such a childlike delight
so much like the freedom a dog expresses
by jumping out of the car,
seeing the hill
and just running for fifteen minutes before you can get it
under control

and that was when I used to experience
going to the Malverns
and going up and running for three hours
from one end to the other,
getting back into my car and going home,
and I used to cry when I saw the Malvern hills,
(which as I lived in Worcester
was quite often)
that I couldn't do that.

TATTOO TO YOU TOO
By the time I got to 60
I'd also got the terminal cancer news. Okay
if this is not a situation where you go for something
then I don't know what is. It's going to be subtle and funny.
And Caroline my wife is going to design it for me.

I found out by accident off the back of a kitchen tea towel
that, used by the royal navy,
there was a flag which is one half of my tattoo
a red diamond on a white background
and the exact and only translation of this is
'I am disabled please communicate with me'
and I don't think this is an appropriate message for a ship to run up
if it's been run out of action
but I thought that the notion of ever meeting somebody in a hospital
who was able to translate that flag
would be wonderful, if unlikely,
so we then decided that the single flag would look ridiculous on an arm
so we thought we'd go for the crossed flags.

We managed to find one that was vaguely interesting
which meant 'you are running into danger'
so the two flags on my arm mean
'I am disabled please communicate with me'
and 'you are running into danger'.

It was only when we'd decided on that
that I discovered that each of these flags
also represent a letter of the alphabet
and if you read my arm
it's unfortunate that they just happen to read
FU

From: *Paddy: A life*
Transcription poems by Allan Sutherland from the words of Paddy Masefield

?SORRY

Forgetting,

Remembering,

Which is which.

That's true.

When I'm ill I recall

How well I forget.

Want to bet

That's the wrong way round?

Paddy Masefield

Chapter 13

RAILWAY TIME TABLES

When I was a scruffy little kid my stories were called fibs, and I'd be rewarded with a smack round the head; whenever I fell in love my stories became romances, and I'd earn a different smack. As I grew up I told my stories as plays. And when I got divorced one ex-wife called my stories typical, pathetic and as meaningless as our lives. Which may explain why today I just want my stories to be truthful.

ALL CHANGE ... FOR NO CHANGE

My interest in the railways started in 1969. My first co-authored play was a music hall documentary history about them (for 15 to 18 year olds). 'Blow the Whistle; Wave the Flag'; subsequently played in Working Men's Clubs and was the first ever drama to feature on the channel in which Ant and Dec grew up in Byker Grove. But it was one particular journey in 1993 that drove a navvy's rail spike through any claim that railway travel was accessible.

had lost the only second class wheelchair-designated space on the inter-city train to a particularly capacious and belligerent drunk, well capable of disabling me further; so instead, I had endured three hours in the guard's van; cold, bumpy, lonely, ill lit and with bursts of February-freezing damp air blasting through the open door at every station stop. You can imagine my delight therefore as we pulled into my destination. I rolled to the opened edge of the van, and began my usual peering into the late afternoon darkness for any sign of a member of staff crashing along the platform with the ramp that would enable me to alight.

Eventually I began to call out to the last drifting passengers straggling off the platform, beseeching them to inform the staff that I needed to get off before the train carried me off to ... Surbiton-on-Sea. After ten minutes (a not unusual delay), an official asked me to pipe down. 'You won't be going anywhere sunshine. The lift on this platform hasn't worked since 1957.' – 'But I have to get off I'm booked to open a con- ference tomorrow.' – 'Just be patient sir, it shouldn't take more than half an hour.' – 'Half an hour ...' I began, then lapsed into the silence of indignant acquiescence.

Forty-five minutes later, my guards van was shunted off into a siding. I searched in vain for a disembarkation point. There was no-one else left on the train. Would I be stuck here overnight? Even the staff who collect the passengers' unread newspapers were now warming their hours filling in the crosswords in their PRIVATE office. – 1 down. How to get one off?

After thirty minutes an unannounced series of wheel-chair-jerking bumps propelled me back into the station. I waited – the statutory ten minutes – before a member of the customer services staff approached unusually noisily with a ramp missing one of its two wheels. – 'There you are sir. There wasn't any need to fuss was there? We've brought you in at number seven, they've had a lift since 1857!' And with that he was off, leaving the ramp ten tantalising inches from the edge of the van.

'Three hours in the Guard's Van'

Eddy Hardy
(1.8m x 1.2m approx)
One of two works created during a residency at the Defiance
Exhibition at Stoke on Trent City Museum and Art Gallery 1993

Who was I to care about a further wait of thirty minutes? This was Gatwick: home of a modern airport. So once I made it up in the lift, across the bridge and eventually found someone with a key to take me down the next lift to the exit, I'd be fine on my own. There were bound to be wheelchair-accessible London-style black cabs, because so many elderly passengers fly now.

It was another thirty minutes before I reached the window-hole of the ticket queue – the only place now still open as the day finished its duties – 'Destination?'. I told him where my hotel was. 'Station, sir, this is a railway ticket office if you hadn't noticed.'

Twenty minutes later a reluctant lower management official appeared; 'Oh no sir, no black cabs, it's all franchised to a saloon-cab firm.' And he was off. He reappeared smugly complacent only fifteen minutes later. 'It seems that all the freelance black cab drivers in every company within five miles have clocked off for the night. It is getting late sir!'

I admit I finally lost a little patience. I know I shouldn't have; it might have come across as hysteria. Anyway – fifty minutes later, the official triumphantly lead me out to a – forty-six-seater coach!

No accessible entrance, no luggage compartment capable of carrying my chair. I think I may have begun to frighten them by now. Anyway, four assortedly suited strangers, enlisted from their own taxi queue struggled my wet-acid-heavy-batteried power chair up the steps, and then made an even greater business of sack-dragging me up the same route.

'Now sir, where to?'... By the time we reached my hotel, it too had scaled down to night staff. I waited – who knows how long? I could no longer read my watch in the darkness, after the driver had left the coach. But yes I did have a reservation, although the receptionist pointed out that I was incredibly lucky they'd held it for me; after all, I hadn't notified them – with 24 hours warning – that I would be checking in so late!

I found a solitary concerned figure congealed behind seven empty glasses, in the long-closed bar.

'Paddy, what happened to you? We thought you were joining all the speech-makers for dinner; we did wait half an hour.'

'So did I', I added sympathetically – 'several times!'

'But what happened?' she repeated.

'Oh, it's a long story Wendy, not so very unusual.'

It was too late to order any supper, and my accessible hotel room had no wheel-in shower, only a deep bath. I was so bloody cold from those three hours in the early afternoon in the guard's van that after the obligatory ten minute wait for the water to warm up, I collapsed rather over-enthusiastically into the bath. What bliss! I lay back in really hot water.

It had become remarkably cold by the time I left it. Having only seven years experience of disability at the time, I had failed to notice the total absence of grab bars to get myself out of the bath. I attempted to pull myself upright through the aid of the plug chain. The cold water slopped over the bathmat as I splashed back suddenly, staring at a small black plug in my right hand, as if it were a clue of some importance.

It's amazing what the human body can achieve when one becomes truly cold. So much, much later I rabbit-scrabbled my way over the enamelled rim of my jail, and added to the puddling flood seeping out into the bedroom carpet.

At 10:00 next day I prepared to deliver my keynote address. A member of the House of Lords graciously introduced me. 'I do hope the disabled people you're going to be hearing from today won't be whingeing on about their wants. I so hope they can set a positive tone!'

I did. I don't know why; but I did! So this particular experience never found its way into any of my fifty positive speeches on disability.

AND NOT A DRY KNICKER ON THE TRAIN

It was only five years ago that I experienced the delight of travelling on the railways' first new rolling stock to have a wheelchair accessible toilet. Since 1825 wheelchair users on a long train journey had become accustomed to trying to keep their legs crossed – not always a valid option (think about it: we are people using wheelchairs). Or asking for a hospital appointment to be catheterised – not for medical reasons but solely for recreational travelling interests.

But now we can rejoice – those of us who will live until 2020 – for that is the target date, only a little under 200 years since George Stephenson's first engineered railed road, by which every train will have to be fully accessible if it is to stay on track with the requirements of the Disability Discrimination Act (1995).

THE TALE OF PADDINGTON – (LAID BARE)

But perhaps my most frightening railway day was the time the bomb scare closed Paddington Station. It wasn't the imminent risk of being exploded. To be fair, the customer service staff got me off the premises really fast – with themselves. No. It was the announcement that no further trains would run out of Paddington that day that precipitated the crisis. Instead we were all asked to transfer to London Bridge, to catch trains that would take us out of London to wherever and from wherever, we could try to work out a different route home, requiring at least two more changes of trains.

MY FUEL CRISIS OF 1994

Now if you have severe M.E. as I do, it means that personally you run on very little fuel. To run out of energy completely, is to reach a close-down of the body. So I'm painfully aware that becoming unable to speak or move any muscle is not a good situation for me. And I know from experience that it's not any better for the people who have to cope with my shut-down either. Often a choice for them between panicking – 'Don't touch him, call for an ambulance' – gross insensitivity – 'You take his heavy end and I'll take – Blimey; his almost as heavy end!' or just abandoning me while explaining their decision to everyone within 100 yards – except me. 'I'm not trained. Sorry mate, I've been trained not to do things I'm not trained to do! Don't look at me like that, he's not my responsibility.'

In truth it was my responsibility. So if I was travelling home to Worcester after a fatiguing four hours chairing a meeting at the Arts Council near Westminster, I would book the various constituents of a well planned speedy return weeks in advance. So the instruction to abandon this carefully prepared programme, and wheel into the unknown, in the midst of a vast throng of non-disabled people complaining about the extra hours added to their own journeys, was doubly disabling to me.

One particular quality about Paddington Station was that it had a capable customer-relations unit, with a comfortable waiting room where disabled people could sit out of the cold and bustle, and genuinely accessible toilets. But this Friday at 17.30, at the height of the rush hour, the staff wanted us off their premises, pronto, and without assistance, for safety reasons. The queue for taxis stretched four hundred yards, or at least two hours wait. The inaccessible buses were already full before they reached Paddington; and I'd never been to London Bridge Station, so I knew nothing about its geography, access or proto-cols.

Eventually it came down to just four of us. On our side. Each feebly trying to seek a better solution than any the staff could offer. We could all understand the situation of the elderly

Fatma Durmush

Had written some poetry and had two plays performed before being
attacked and knifed at the age of 35. Since then her principal success
has been in painting. Her paintings speak for themselves. Her inspiration
is drawn from Muslim culture – a particular theme being the veiled
woman who is 'like me – downtrodden'. When she paints she says 'it's
like some driving force, something else becomes me.' She is also a
Survivor poet of distinction.

woman released from hospital only two hours earlier, and desperate to reach Truro in Cornwall before the painkillers and her copious stitches cut themselves out. We began to guess from his distress, that the inarticulate young man in the early grip of a panic attack was freaked out because he was travelling without his medication and needed to be in Basingstoke asap.

The individual none of us read correctly was desperately polite. So much so that she didn't wish to burden the staff with details of her medical condition. As she sat down next to me and the petalled tears began to fall down her cheeks I summoned up the presumption to ask her if there was anything I could do to help? But she said she didn't want to add to my own problems. My thought, based on the evidence of her clothing, was that perhaps a Muslim young woman might be especially disturbed if she had to travel through her epileptic seizure in public, and where all the customer service staff were men. Or was I just making stereotypically incorrect assumptions? It was certainly not being male that wheeled me to leadership of the assault force on the staff. Nor did my age necessarily qualify me for the role. My colour was irrelevant. It was probably those awful five years of army officer cadet training at school.

My first three attempts at, 'Sorry to bother you, but ...', 'Sorry to but in again, but ...', 'I say, I really, do think ...' all met with turned backs. Clearly what was needed was bluff. Equally clearly, although I couldn't act myself (in many senses), I'd passed twenty-one years regularly aiding actors to bluff themselves into unsuitably ill-fitting and uncomfortable roles. So I went for the big one!

'Where is he then?' I'd raised my voice considerably. 'The Manager, of course! I want a decision now, before you become legally responsible for the injuries I'm certain to acquire if I don't get appropriate assistance'. 'What is it you're actually trying to say sir'. – Well at least I'd got their attention. That was a start. 'I want four taxis paid for by the railway to get each of us home.' The demand was so presumptuous that they turned to each other in disbelief. 'The Manager,' I began

again, 'Now!' I insisted, 'otherwise I may go off unexpectedly' – a poor choice of words, I realised. Going off was what I was totally incapable of doing on my own.

The Manager, as always, was young, but partially trained in politeness. I asked the three musketeers by my side, if they were happy for me to act as spokesperson. Each nodded, as they had little option. I explained with newly-sharpened exactitude that our problems, were in fact his problems, and that he could get on with the rest of his undoubtedly illustrious career in middle management, if he could only think outside his usual box, and grasp our handle on things as they stood – or in my case sat.

Five minutes later, armed with a signed company chitty, a happy cabbie was there beaming at the prospect of a fare all the way to Reading via Basingstoke and Slough and back. He was even helpful about the considerable access issues of four of us being shunted into one cab. Each of us was only too painfully aware from our own experience about the physical discomfort we might unwillingly inflict on our neighbour.

It transpired that only the 'Truro-bound stitches' and the 'Worcester imminent collapse' needed to go as far as Reading Station. But by the concern on her mother's face when she saw her daughter being manhandled out of an over-crowded taxi-cab, propelled by the sticks of its other two occupants, I guessed that the young woman might have reached her destination only just in time.

FOREVER IN MY HEART

Before we finally leave Paddington Station, I need a moment of mourning. For reasons I have never understood, the entire staff at the old Paddington Buffet Restaurant, from chef to table-cleaner, were the most effectively and sensitively trained in understanding disability equality I have ever met. The moment I approached any counter or queue at any time of day, a quiet figure would vaporise beside me, gently asking whether or not I would like to let her/him know if I preferred some assistance in selecting my menu, or transporting it to the table, or whether I was comfortable doing it for myself.

The point is that if that bizarrely-backgrounded crew could attain such levels of excellence, so could every business in the country which currently doesn't. Thank you, buffet ladies and gentlemen, one and all. And how I miss you, now that your stately Victorian mock-baroque has tartily and in return for financial inducements become SockShop, Pop Shop, and Shop-u-Like.

In 2005, in the Edward Lear Foundation consultancy research for the Disability Rights Commission, it was found that issues of transport were the most commonly identified barriers to disabled people.

Chapter 14

A MILLENNIUM MISSION

To achieve any progress a disabled person needs to know that opportunity exists. And before s/he tackles access to independent living, to funding, to transport, to facilitation, to educational choice and to employment, s/he also requires the courage to know that ever-further hurdles, placed behind the finishing line, can also be crossed with dignity and humour rather than righteous rage.

WHO'S JOB IS IT ANYWAY?

In 1998 as I approached my final period of a five year term on the Arts Lottery Board, I was acutely aware of the extraordinary amounts of money that were washing over the country in an aimless and undirected way as the new millennium approached. The government had itself legislated that the Five Good Causes Lottery Boards could only respond to applications and were not allowed to create a policy, seek out neglected areas, or ensure that the rich did not just continue to get richer, as they were the only people who could afford to spend the time and money demanded to create successful bids.

had become more and more focused on the persistent lack of employment opportunities for disabled arts workers, particularly in the performing arts, even though in theory, stage, television and cinema have insatiable appetites for talent of every kind.

Pioneers such as Sarah Scott were urging debate about the possibility of creating an agency dedicated to representing disabled performers, in an industry in which 95 per cent of performers obtain employment through their agents. One such meeting was held at the Royal National Theatre in 1995 and I spoke briefly, as one of many contributors, tastily sandwiched between Nabil Shaban and Richard Wilson.

In 1997 I chaired and spoke at three meetings concerned with these issues. Time and again speakers from the floor began to denounce debate and to demand action. Importantly, the Disability Discrimination Act of 1995 had brought arts employers to the point of being required to ensure equality of employment opportunities for disabled applicants (1996). Many such employers were surprisingly enthusiastic about this potential, but almost everyone admitted that they had no concept of how to handle such a radical change. They usually returned to conferences saying: we advertise, but no *disabled people* apply. No one had paused to consider that even experienced disabled actors did not peruse the arts supplement of Monday's *Guardian*, nor stand in line in newsagents' shops for the moment when the weekly copy of *The Stage* was delivered. Though, to their credit, some employers were beginning to ask where they should be advertising. Yet almost all were ignorant of government schemes to supply support funding for the employment of disabled people requiring physical alteration to the work place or work equipment.

In my naivety it seemed as if Sarah's teachings, my colleagues' demands, legal requirement and potential employers were all coming together at this opportune moment when money for new initiatives in the arts was for the first time not in short supply. Over one billion pounds was handed out for arts building projects over five years.

'Had to be the only candidate for the job.'

Paddy with Caroline at home

The only missing piece of an almost complete jigsaw was an agency that could transform all these opportunities into realities. How was this to be achieved? No single organisation had such a remit. Many could say such a concept was officially ruled out by the constraints of their constitutional limits.

However, so great was my naivety that it occurred to me that a man entirely dependent on income support, who had been medically incapable of work for eleven years, was computer illiterate and found writing difficult and phone calls tiring, had to be the only candidate for the job. So in November 1997 I circulated an outline proposal to fifty influential individuals and organisations under the heading 'The Ball is Rolling. Who Wants to Steer Where it Goes?', appealing for others to take ownership of this project.

The contents of this proposal were drawn largely from material already set out in this book. The starting point was seen as the signing up to a charter of commitment, so start-up funding was needed from potential charter signatories. Two years later contributions had been received from the BBC, Royal National Institute for the Blind (RNIB) and four regional Arts Boards, covering the West Midlands, the East Midlands, Yorkshire and the South East of England.

The funding was used to appoint Liz Crow, a leading Disability Arts consultant, to shape systematically and starkly the heavy metal I had set out with and which had now been tempered and chamfered by a strong armed Steering Group. Liz produced a six-page document which was to be the basis of a push for full funding of what had by now been re-named JOB 2000. And for easy access, a single page *précis* was extracted to offer to national and local politicians, and now to you.

A DISABILITY EMPLOYMENT INITIATIVE FOR THE MILLENNIUM

2000: Year of Employment of Disabled People in the Arts and Broadcast Media Industries (Working title: JOB 2000)

The number of disabled people in the UK may be as high as one in five (20 per cent). Yet in the arts and cultural industries, disabled people may represent as few as one in five hundred of all those employed. *The need for JOB 2000 is great.*

JOB 2000 will promote and increase the employment of disabled people in the arts and broadcast media in England. It will complement and enhance key policy and organisational developments in employment, disability and the cultural industries: the New Deal to increase disabled people's employment, the Disability Rights Commission for the elimination of discrimination, increased Treasury funding for the cultural industries, and the spirit of the new Millennium. *The time for JOB 2000 is right.*

Through its three linking projects, JOB 2000 will guide and support the arts and broadcast media through the key stages of employing disabled people: gaining commitment, finding solutions and acting on them.

1. COMMITMENT: THE JOB 2000 CHARTER

JOB 2000 will sign 2000 prominent organisations and individual supporters to its Charter. Signatories will pledge practical support for equal employment opportunities as they apply to disabled people. JOB 2000 will support them to deliver that pledge.

2. SUPPORT AND SOLUTIONS: THE JOB 2000 EXCHANGE NETWORK

JOB 2000 will establish a permanent Exchange Network to support arts and broadcast media organisations in their employment of disabled people. It will coordinate existing resources and create new partnerships which will support enquiries to find and act upon solutions.

3. ACTION: THE JOB 2000 EMPLOYMENT AGENCY

In the first year of the new Millennium, JOB 2000 will double the number of disabled people working in the arts and broadcast media. Employers will register vacancies and disabled

people will register their career aspirations. JOB 2000 will link the two, with great emphasis on finding the right match. Information technology will be key to the delivery of an efficient response.

JOB 2000 will be managed by the National Disability Arts Forum (NDAF). Its day-to-day operation will be undertaken by a separate staff team based in its own premises and supported by a pool of specialist advisers. At least 50 per cent of staff, advisers and management will be disabled people.

JOB 2000 is currently managed by a Steering Group with representation from the Arts Council of England; Broadcast, Entertainment, Cinematograph and Theatre Union (BECTU); BBC: Broadcasters' Disability Network; Disability Database Project; Independent Theatre Council (ITC); Mediable; National Disability Arts Forum (NDAF); Royal National Institute for the Blind (RNIB); South Bank Centre (SBC) and West Midlands Arts, as well as individual artists, broadcasters and consultants. The JOB 2000 Project Leader is Paddy Masefield

Liz Crow 1999

With these new weapons we charged headlong and headstrong towards a pool of millennium funding for community developments. Advised by regional experts in the arts funding system, our initial target was £30,000 – enough to employ a full time professional disabled person as project leader and fund-raiser. Thus releasing me back to the comfort of a bed, which seemed increasingly important in light of the large but still unknown cancer already half-grown on one of my kidneys.

When I learnt that this application would be assessed by the Arts Council of England, I bought myself two more pillows. Until the previous year I had chaired their Initiative for the Employment of Disabled People, so I thought I was arguing their own thinking. After five months of silence, the Arts Council bleakly informed JOB 2000 that its proposal did not meet funding criteria – now too late to apply to other millennium funding pots.

Liz Crow
(ICON OF A DECADE #21)
Film-maker, writer, artist, arts adminstrator and consultant

with stills from

Frida Kahlo's Corset 2000
(Frida Kahlo – Isolte Avila)

Nectar 2005
(Walter – Jacob Casselden
Gloria – Poppy Roberts)

When I reasoned with, reassured and occasionally railed at senior Arts Council staff, many of whom I had worked with for years, I was consistently rebuffed with the statement that it was not their responsibility. In 2000 the Dome opened at an estimated cost of £750 million and with no positive representation of disabled people in any of its performances or themed spaces.

Without doubt this was the greatest failure of my professional life. And I felt loaded with guilt that if I could not achieve this with all my connections, no one else could. The strongest motivation for writing this book has been that my legacy should be not a Living Will but your willingness to pick up the baton that had been dashed from my hand with the disqualification of JOB 2000. I can never write 'being of sound mind' without giggling and wondering what artist is? Perhaps only Survivors of the Mental Health System? But JOB 2000 is still reasonable, still attainable, and without it our invisibility will continue.

But miracles may happen. For Arts Council England is expected in 2006 to send out a radical new policy towards disability and the arts for public consultation. It is said it will be rooted in the concept of self-ownership – that disabled people should lead, judge and advise arts organisations of disabled people. At the epicentre of this whirlwind for change *should* be the principles and concepts of JOB 2000. For that is what underpins current Arts Council policy for non-disabled people: support of the individual artist – a support which presumes employment, long-term development, and a career structure, predicated on our old friend CPD! Could there be a happier ending to this book?

Well yes, there could. For out there in the real world of over-optimistic treasury forecasts, a slow down in the growth of the economy, alongside commitments to end poverty in Africa, government has already announced that for the next three years at least, Arts Council England's grant will be frozen at a standstill, and will not be increased by the rate of inflation. In doing this, government effectively cuts the arts

budget over three years by at least 6 per cent. As a consequence the Arts Council will cease to fund regularly 121 organisations by 2008 and be unable to introduce any *new* funding streams as all their existing clients wail and queue at inadequate feeding stations, hungered by their own poor subsidy harvests. Grimm.

TRAILER

In 2005 Liz Crow was unable to attend a ceremony honouring her achievement as a woman when 93 per cent of film directors are men, because the *Birds Eye View* Film Festival event at London's Café de Paris was inaccessible to wheelchair users. So Liz, founder of Roaring Girl Productions, who has made several films, was obliged to party on the pavement, despite the cold. She believes the film industry is inherently discriminatory.

More inappropriately I, after attending a Royal Film Premiere, allowed my wheelchair to be carried down into the Café de Paris, only to find that in the scrum of 300 guests I could converse with no one higher than a navel, while people talked pointedly and pointlessly over my head.

The irony is that if JOB 2000 had been adopted, we might all have had a better view of cinema.

Chapter 15

WHAT HAVE WE LEARNED?

I won't ask you to pretend to be blind by pulling sleeping masks over your eyes, or to pretend to be deaf by putting pieces of fruit in your ears; or pretend to be mobility-impaired by sitting in a wheelchair. That would teach you as little as travelling through an underpass at night in a supermarket trolley, drunk.

As the retiring Chair of EQUATA Ltd's Board of Directors, I was persuaded out of retirement to make a keynote address in 2003. It was for the largest international Disability Arts festival held in the UK as part of the European Year of Disabled People and was organised by EQUATA Ltd.

I took as my text my first ever speech on disability (see Chapter Three) – The Three Doors. My question was whether, after eleven years, the third disabling door had finally been demolished.

Had it, Hell! Admittedly the lottery arts expenditure of one billion pounds for new building had, with my persuasion, financed automatically-opening doors, ramps and tactile maps, toilets that were not disabled but accessible, and lifts that spoke and flashed lights. But getting up in the lifts meant nothing when disabled people got out at the top floor and found it totally empty: devoid of people, trainers, funding cheques, or employment possibilities; with no boardroom table, and therefore no voice for disability. Because the same old non-disabled people had merely built another floor, reserved for themselves, ensuring that behind them, they left their usual self-protective glass ceiling. And it is the thickening impermiability of that glass ceiling that has actually resulted, over the last decade, in disabled people losing more than they've gained: Like what, you ask?

Like DAM – a superb quality Disability Arts magazine LOST

Like LINK – a weekly disability dedicated TV programme LOST (Along with its accompanying publication LOST)

Like SOLID FOUNDATIONS – LIPA's unique accessible community arts foundation course for disabled people LOST and with it the chance for students from Special Schools to reach University LOST

Like THE SUE NAPOLITANO AWARD for disability writing LOST after only one year, for lack of support, structure and funding

Like STRATHCONA, a 1980s born theatre company LOST

Like others whose births we never knew of, LOST

Like the first three ACE disabled apprentices LOST despite my mentoring, LOST from the arts world they found impenetrable

Like THE DISABILITY UNIT of the Arts Council LOST

Thus the GUARANTEED PLACE for a disabled person on every single ACE advisory committee LOST

And since 2004 all ACE Advisory Panels LOST

LOST, all lost. So now there is no protected funding specially set aside for growing annual expenditure on arts involving disabled people, in every art form. Amazingly, there is less financial support for Disability Arts than there was before the lottery windfall blew over us. (And in 2006 Survivors Poetry's Arts Council grant has been LOST. Who will chisel the tombstone: *Survivors Poetry* LOST?

I have tried to target Arts Council England positively, because it showed itself in new colours in 2002's *Year of Cultural Diversity.* It enterprisingly found new money to give black and minority ethnic arts a louder voice at *'Decibel'* level. And ACE announces that: 'by 2007/08 fourteen percent of regularly funded organisations will be led by Black and minority ethnic artists or key to the infrastructure that supports their work.'

Although I deplore notions of competition in arts funding, I am conscious that in the UK there are almost twice as many disabled citizens as ethnic minority citizens. So in a spirit of admiration for ACE, I expect them to at least double their support of Disability Arts and the arts and disability. They should remember too that disabled people are present in the other oppressed minorities whether because of their ethnicity, refugee status or sexual orientation.

Though no longer a practising arts consultant, my twenty years of disability (1986-2006) have led me to argue for innumerable recommendations throughout that time as shown in this book. To set down every one of my considered recommendations would take another book. I trust this will be commissioned by an earnest ACE every five years. For now let me draw together my strongest conclusions. Should these beacons be lit, much else will appear clearer in their light.

SOME CONCLUSIONS

PURPOSE: For society to cease to be an exclusive club it is required to bestow instant full life membership on every disabled citizen. For the other members to cease their historic 'black-balling', it is essential that disabled people's presence is portrayed positively across the arts and media. Any other option will ensure that the future of disabled people, like their past, will be lost.

DELIVERY: The majority of the UK's professional arts are delivered through partial subsidy, rather than being directly commercial. So it is the responsibility of all who receive national, regional or local authority arts funding to commit themselves to this campaign of rights. This is not Maastricht. There can be no opt out clause. Equal Opportunity Policies are not sufficient. They still fail women and ethnic minorities in a number of areas. There is a case to be made for dealing with the greatest failure first, because it can deliver the greatest self-rewarding success if achieved: the increase in representation of disabled people.

The Republic of Ireland, despite its religiously carved history and its concern with national freedoms, had managed to fail disabled people almost more than any other European nation. But in the 1990s their complete reversal on disability made Ireland a role model. A disabled person was appointed to their equivalent of the UK's Privy Council, so when President Mary Robinson made a historic visit to Belfast it was natural for her to be accompanied by this adviser. Can we imagine our Monarch summoning Bert Massie (Chair of DRC), Sarah Scott or even Dame Tanni Grey-Thompson to join her advisers? We should. It has to happen. When will the first disabled artist be given the Order of Merit or made a Companion of Honour? I'm speaking not of disabled politicians but of disabled artists whose achievements will be remembered far longer.

We cannot look elsewhere in Europe for leadership on this issue. Talk there has been aplenty, with the nomination of an annual day – and a year – of disabled people, but little funding (through EUCREA) to lead to real action. David Puttnam sug-

THE JEALOUS PSYCHIATRIST
Colin Hambrook
(ICON OF A DECADE #22)
Artist, Disability Arts Editor and inspirational consultant
(oil on canvas 4' x 4')

gests we make it an example of innovatory national pride to excel in our disability principles and purpose.

Less than 25 years ago, Welsh Guardsman Simon Weston, one of only six of his entire platoon to survive a horrendous fire on his Falklands Task Force ship, was barred from any role in the victorious commemorative march through London organised by Prime Minister Thatcher. Apparently royal, civil and military publicity advisers decided that such a horrendously scarred individual was not the acceptable face of victory. Weston's subsequent public and media work is an achievement to be admired by us all.

It is wholly unacceptable for policy makers at any level of government or the arts to assert that there is no need for making disability a special case because it will be dealt with automatically. It is currently being dealt with at no levels, not even 'O' levels. We have had an Arts Council Year of every art form, of artists, and of cultural diversity. Without a Disability Unit I doubt they'll read the signposts to a 'Year of Disability Arts'.

Government has a dedicated Disability Minister and an Arts Minister. Were they to begin joined up dialogue they might attract the odd Minister of Education, Housing, Transport, Welfare, Local Government and Treasury to talk to them too. Certainly we need a much stronger law than the present DDA. We need the DRC to stay in place until it has been strengthened. All laws require teeth if they are not to invite flouting. Thugs preventing you shopping or travelling would be prosecuted, so why not those who assault us with man-made barriers at every step. The logic is the same.

Governments respond best to crises, emergencies and disasters. They have one on their hands now. The Disability Rights Campaign is sometimes said to be the last great social campaign in the UK that is still to be won. I remain unconvinced that the recently unveiled statue of a wonderfully pregnant and proudly exposed Alison Lapper on the plinth in Trafalgar Square in 2005 can gaze down as confident of victory as Admiral Lord Nelson and the other smug generals of long forgotten wars.

BATTLEFIELDS AND PLAYGROUNDS

Admirals and generals usually emerged victorious by virtue of choosing the position on which to make their stand. Let me do the same.

We require the BBC to be obligated in seeking renewal of its Charter to commit to major disability programming and staffing, representative of the twenty per cent of the population whose license fees are greedily consumed without returned responsibility. Their Disability Department and occasional disabled employees have for the last decade been tokenistic. It is known that some BBC viewers even write to complain that the programme they have been watching should have included a warning that disabled people would be appearing, so rare is their presence.

Among their Charter renewal proposals should be a commitment to a major series not only on the lost history of disability but specifically reviewing the pitiful history of disability representation on television. We've had a historic programme on the first inclusion of Black representation on television and even had a history of swearing on TV – which, extraordinarily, featured no disabled people!

Central TV used to engage with disability representation, but has long since been swallowed by the uninformed Carlton, who have even dumbed down the old Granada convictions into an ITV of celebrity-prime-ministerial-holiday-island-wife-swapping. Channel 4 have flirted with disability issues for fifteen years with little result. If they can make enthralling television about a Liverpool housing estate, they surely have the imagination to tackle disability issues on a daily basis.

Radio has done a little better, the emphasis being on *little*. Disability publications need special funding. The economies of reporting and editorial staff, whether within the charity field of SCOPE or MENCAP or the arts field of *DAIL,* need a massive uplift. Roland Humphrey's *DAM* is now revered as much as an old *Wisden* or first edition *Marvel* Comic. But was never fully financially valued in its day. *DAIL*, Survivors

Poetry and essentially more publications, especially of visual Disability Arts, must be made a special case since prejudice or ignorance will preclude commercial gain.

Disability Arts Festivals are crucial. To grow the current pool of UK disability talent they must be annual and they must be international. The conspicuous failure of European Year of Disabled People (2003) was not that it was run by non-disabled civil servants – though this is true – but because no flagship arts buildings or arts institutions made themselves accessible and funding friendly. Why were Cheltenham Town Hall and Trafalgar Square the principal venues? Why not the Tate, Covent Garden, the RNT, the National Film Theatre and the existing Festivals from Edinburgh to Hay-on-Wye? Because we are derided if we think big, and a well paid CEO thinks their disability duty done by visiting a mother or a daughter monthly in a care home, rather than having their story centre stage.

The non-disabled Mark Ware was awarded a prestigious Fulbright Scholarship. This enabled him to receive a Master of Fine Arts degree at the school of the Art Institute of Chicago and then establish a career in the UK film, photography and video production market for a wide range of international clients. In 1996 Mark experienced a severe stroke that affected his sensory perceptions of sight, sound, touch, temperature and balance. As a result he is now producing disability informed art work of higher quality and quantity, yet he is precluded from featuring in the UK's most prestigious art festivals.

A specific annual International Disability Film Festival is also vital, as surveys show that film is the favourite art form of disabled audiences. Though for how long we cannot be certain, after *DAIL*'s reporter exposed the 2005 Oscar Awards as *Kill the Cripples* night.

However distasteful, awards can bring publicity, as the 1 in 8 group achieved in the Raspberry Ripple Awards for the best and worst examples of disability portrayal in the media. How little it would take for arts or publishing interests to re-esta-

MIND GAMES
Mark Ware 2005

The series *Mind Games* consists of digital photographic prints taken from a 36-minute video composition: *The Dog that Barked like a Bird*, created as a diary. Suddenly Mark was experiencing everything with a freshness that revitalised his fine art. For example he is now 50% ectothermic – half reptile, because he has no temperature sensation down the right side of his body: 'I feel drawn to lying on warm rocks during summer months.'

blish an annual Sue Napolitano Award. We have to learn from our female and culturally diverse colleagues. There are awards for women in a number of art forms, as a firefight in the campaign for equality of opportunity. Carnival and black music awards are a focal point for millions. We still have much to learn from Gay Pride. It has recently been announced that from 2007 Manchester is to stage a new biennial International Festival. No mention so far of Disability Arts inclusion. I challenge Manchester to remember their 1993 Paralympic ideals and to implement them now that the opportunity exists.

I greatly fear that disability representation, portrayal and employment in the arts are actually slipping backwards in this new millennium of public compassion and private selfishness. I see the disability wagon-wheels being reinvented and I hear the fresh pain of unrepresented and excluded voices reminding me of my own unanswered anguish over fifteen years.

As I said of the wagon circle, we need to attack everywhere. Inclusive education means nothing if not applied under the age of five and over the age of eighteen. How can we expect pupils or staff to learn when there is not one funded full time dedicated touring schools company representative of disability theatre, dance or even poetry? The Royal Academy of Dramatic Arts received millions of lottery pounds to make its new building disability accessible with my blessing. I must have missed the resultant stream of exhaustively trained disabled actors.

What can I suggest that is modest and immediately achievable? The funding of annual summer disability youth workshops in every region in every art form would uncover a multitude of aspirant actors, writers, musicians and dancers. But there has to be national strategic planning. Provision cannot be the responsibility of CandoCo, Graeae or The Lawnmowers when there are such calls on them to work as international role models. Perhaps the British Council's achievements should shame or inspire the Film Council or Arts Council into greater action.

I am not aware of any youth disability workshops run by the RNT, BFI or any major symphony orchestra. I see no particular commitment to disability by any national youth theatre, orchestra or jazz band. It comes back to 'it's not our responsibility', but history tells us otherwise. Sexism, racism, homophobia and xenophobia are all our responsibility. The strength of society is its inclusiveness.

It is for others to write precisely:

■ how to train the trainers

■ how to rewrite history and fiction so that they are not un-truthfully exclusive, and can be cleared of accusations of disability apartheid

■ how to train governors in prisons where the arts may have been admitted but mental distress is still ignored

■ how to plan housing for independent living

■ how to understand welfare as a right and not see it as a mis-used charity

■ how to train airline and cruise ships designers to provide for disability and make this a statutory requirement. Should one laugh or cry when twenty something Lisa Hammond is offered children's drawing books on aeroplanes, because she is a little shorter than I am? Economy airlines regularly refuse their legal responsibility to carry passengers using wheelchairs, or as in my case merely damage my own carriage. When I request disability equality on cruise ships I am told with a smile: 'We have no obligation to conform to the DDA or USA's ADA – we're not registered there and we're in international waters.' At present we lack the power to reply and the force to demand our rights.

The arts still remain our strongest and most realistic hope for change. But change is dependent not on disabled people, but on non-disabled arts funders, managers, directors, dramatists, choreographers, curators and film makers. If they want to know what is needed, ask us. If they need to see good practice, turn to Disability Arts. Only those still capable of learning when

in power can truly be said to be great. Those who ignore human rights on the excuse of other pressures, priorities and demands will be judged to have achieved nothing.

The days of the old 20th Century, of its old men, of the 'old world' and the old arrogance, and old class systems are over – consigned to room 101. They had their chance, but made the last century a murderous, land-grabbing, exploitative, enslaving failure. There were more wars, more mutilation, more death than even in the days of the Plague. So the 21st century, through its arts, has to belong to women, to young people and to developing countries, wise enough to recognise the importance and benefits of including disabled people, and all other marginalized groups of citizens.

But before we applaud with relief, we find that those despicable old males have left us a global legacy in the shape of their land mines and cluster bombs. With the certain result that not only will the number of disabled people world-wide rise incredibly quickly, but the double whammy is that it is those same women and young people, to whom we most look for our future, who in tending their own land and finding clean water are the most likely to have their arms and legs blown over their neighbours' houses!

What happens to old epileptics?
Do they simply fade from sight?
Do they halt and flicker and vanish away
Like a candle burnt down in the night?

Does a cure come with the pension,
An end to trouble and strife?
Will I stop having fits when I'm sixty-five
And be able to lead a new life?

Or is there a hospital somewhere
Infested with roaches and nits
Where nursing-home rejects are pumped full of dope
And still go on having fits?

Will a sudden fit in the bathroom
Mean that I end up drowned
Gradually decomposing
As it's weeks before I'm found?

I practice for death almost weekly
So far it's not been for real
But that doesn't diminish the terror
Or soothe the anguish I feel.

Allan Sutherland
(ICON OF A DECADE #23)
Scriptwriter, poet, performer, advisor, consultant

Chapter 16

A QUESTION OF TIME

MEDICATION TIME
Aidan Shingler

A QUESTION OF TIME

I n our struggle there remains a crucial question about time. It is easy to forget that there are some elderly men still living, in boardrooms or the House of Lords, whose mothers did not have the vote at the time they were born. Married women then were the property of men. My mother was already in her teens when women achieved universal suffrage in the UK. I greatly admire the courage and assertiveness of the suffragettes who brought this about in the face of venomous social abuse and even loss of liberty and all social respect.

So how soon can I and all my disabled colleagues expect our own struggle for reasonable rights and demands for respect to be met? Are we destined to sit out another 50 years? Two of the Consultant Editors of this book have been passionately engaged in this struggle for well over 25 years. As our numbers increase with every decade in every country, how much longer should we wait? And how should we behave?

If we are daily excluded, deprived of the opportunity of wealth acquisition, access to our own homes, work, re-creation, reading, sexual relations, parenthood and all that I have listed earlier, why should we be expected to wait patiently for patronage? Is civil disobedience warranted in pursuit of our birthright?

My most enduring frustration from living with M.E. is that I never felt physically strong enough to lie shoulder to thigh with my comrades from the Direct Action Network (DAN). Colleagues with brittle bones were indeed laying their lives on the line when a dozen activists chained themselves to double-decker buses in London, Birmingham and Manchester and brought the city centres to a grid-locked halt. Fuel price protesters have the wealth, transport and means to do the same, any time. It is perhaps a mark of how little disability protest has disrupted society that no new bills have had to be rushed through to prevent our campaigning. Absurdly, in the 1990s there was no accessible courtroom in London in which DAN activists could be found guilty of their proudly con-

fessed offences nor where they could have argued their cause in law.

The headline grabbing legal cases are instead preoccupied with the rights to die of newly-disabled people experiencing their first loss of independence. While the artists represented in this book have been inspired by their experience, other people have demanded of the law courts that once they can no longer wipe their own bottoms, it should be legally permissable for their lives to be wiped out.

Do people need to know that my friend Chris Davies, who was born with cerebral palsy, has required the facilitation of a personal assistant every day, to feed him, wipe his bottom and turn the pages of any book he wishes to read? Is it not more relevant to know and appreciate his career as journalist, author, teacher, arts administrator, historian and especially as a ground-breaking television presenter, during a working lifetime in which he acquired a BA and an OBE?

So it is unimaginable that Chris would ever ask the law courts for the right to end his life – which is clearly something he could not achieve on his own.

Wherever the debate on the ethics of eugenics, once a Nazi pre-occupation, abortion or survival take us, a society that seeks to screen us out over a couple of centuries will have no signposts, templates or role-models to demonstrate how disability acquired in middle age – the largest category of disabled people – need not be the end. For many of us it has been a new beginning.

However, given my knowledge that any day soon I may receive the confirmation that I really do have only weeks to live, how best can I choose to live them? Instead of Paddy Masefield Awards or books on STRENGTH, can the only logical way I can contribute to changing disability history be to disembowel myself on Parliament Green before the world's cameras? It would be a paradoxical attempt to communicate the right of disabled people to a long and full life, not its social or medical strangulation.

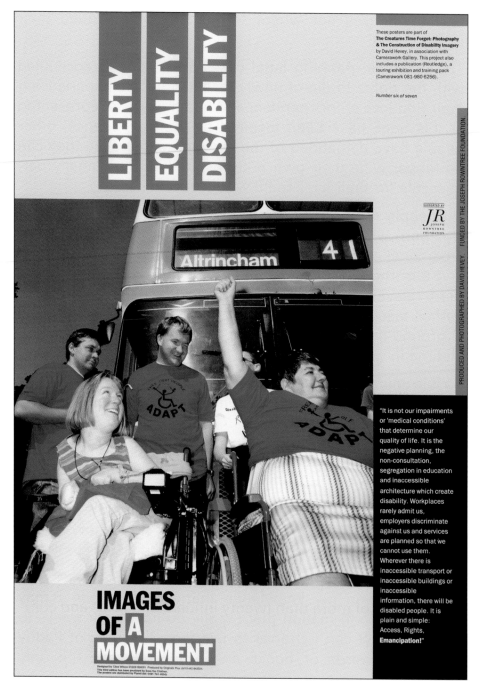

by David Hevey
(ICON OF A DECADE #24)
One of seven posters for 'The Creatures Time Forgot;
Photography and the Construction of Disability Imagery'

One self-immolated martyr failed in the 1960s to hold back the rolling of the tanks of the USSR into a Czechoslovakia desperate for democracy. The USA and UK are prepared to be party to the deaths of hundreds of thousands of innocent individuals in their determination in Iraq, Afghanistan and elsewhere to restore their citizens' rights to a full and free life. Do these political lessons signal to disabled people that we should pursue violent revolution rather than silent infiltration? Or should we rather draw our inspiration from Nelson Mandela who, after 27 years of the deprivation of all human rights, emerged from prison the wisest and most widely embracing politician of the twentieth century? How much longer does our sentence have to run?

If I am truly objective about my own life, I must acknowledge a second cancer in its history that I fear is not yet excised. It goes by many names: class is but one. I've described my dismay after my acquisition of disability status on discovering that not a single person born disabled had been enabled to achieve an arts career of the breadth and influence that I had by the age of 44. And in my twenty years of experiencing disablement, I have still not heard of a disabled person granted the access and freedom to influence the arbiters of the arts that my racehorse style breeding has afforded me. Almost all my achievements: the OBE for services to the arts; the nomination for 'Creative Briton of the twentieth century'; the appointment as first Honorary Life Member of the Directors Guild of Great Britain; the chairing of an International Board, a national 'Think Tank', and of an Editorial Board; the invitations to Dublin, Athens, Helsinki and Edinburgh; the access to membership of more than twenty influential boards and committees, on so many of which I was the token 'crip', were all attributable to my status – my status not as a disabled person but as an 'insider'.

Being a white, male, middle class, middle-aged Oxbridge product gave me the reputation for soft hands and hence for not breaking eggs at the conventional bourgeois heart of the subsidised arts funding system, just as certainly as my lack of title led to my candidature for RNT and BBC Governorships

being politely ignored. To this Old Boys Club, my disability was perceived as an insignificant war-wound, whereas in reality it had turned me into a double agent intent on achieving a successful coup.

This country is still so riddled with class and chauvinistic and xenophobic attitudes that it is completely unprepared for the acceptance of people who speak, move, sit or express themselves in different ways. Further, it is increasingly obvious that the Government of 2005 are losing their tepid interest in the arts as a social tool, while happily presiding over ever-widening differentials between rich and poor, and ever-widening schisms in our communities of age, faith and opportunity.

There seems little cause for optimism. Yet my mind rather than my heart finds a few hopeful signs for achieving what I seek for disability and the arts:

■ What I seek is inexpensive compared to any other proposed revolution – in health, education, transport or military budgets.

■ Its delivery will win enablers, plaudits, admiration and increased status.

■ It would be a strong testament for New Labour, that there is such a thing as society, and that it is capable of taking responsibility for it.

■ It will be far less alarming to capitalists, business and industry than was the introduction of the European notion of a minimum wage.

■ Changing current attitudes and practices towards disability through the medium of the arts would confirm to arts leaders that their chosen arenas – the arts – really do have purpose and reason today.

There may be other campaigns that deserve equally loud voices, other priorities that are crucial. But no coalitions *of* disabled people have had the platforms, financing, megaphones or access to the media of Greenpeace, the Red Cross

and Crescent, Oxfam and Amnesty International. And yet if those organisations were to look inwards, they will find us among them.

In the mid 1990s I was interviewed as a representative of disability by one of the staff of Price Waterhouse, contracted to look in fine detail at the downsizing of Arts Council staff. Her opening question was:

> Surely we can agree that the disability movement has had its day in the same way that the women's movement is historically behind us?

We have never had our day. We never will until we have persuaded every non-disabled member of society that this is not *our* issue alone nor *their* issue alone. It is a common cause that unites me with you. This book is testimony not only to a lost history but to a disgraceful present.

No person of conscience can contemplate a future lived with such blinkered self-deception. No one who reads this book can fall back on the plea of ignorance. Ignorance of the cause is no defence. My final request is your willingness to accept my gift. The riches I bequeath to you and your descendants are the jewels and the mints of the arts of disabled people and especially their Disability Arts.

The test of your response is how you receive my last iconic image.

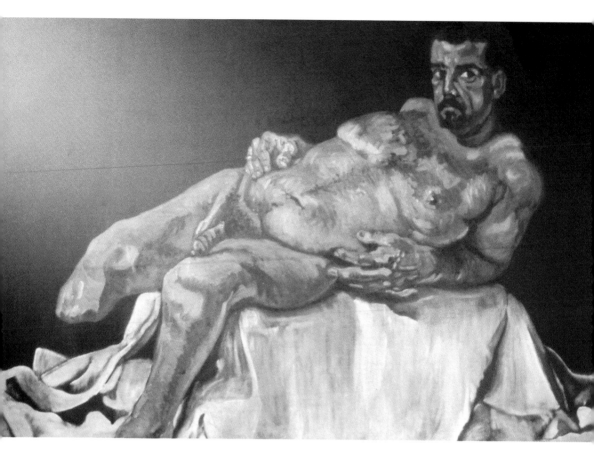

NUDE
Eddy Hardy
(ICON OF A DECADE #25)

I have a special love and respect for Eddy Hardy's work, and I steal the memory
of it wherever I go. It was the first art work to teach me who I really am when
I'm alone with myself. I first had the honour to 'open' him in 1993, as the
outstanding artist in the Defiance Exhibition. Eight years later I again opened
him at art + power's exhibition Strength to Strength.

He must have felt like a tin of sardines.

A BRIEF BIBLIOGRAPHY OF DISABILITY WRITING

Key Resources
Disability Arts in London *(DAIL) Magazine,* London: London Disability Arts Forum, monthly

Pointon, Ann with Davies, Chris, 1997 (eds), *FRAMED: Interrogating Disability in the Media,* London: British Film Institute

Sutherland, Allan, 2005, *Chronology of Disability Arts*, London: Edward Lear Foundation. (Online resource, available at Disability Arts Online, National Disability Arts Forum and elsewhere.)

Williams, Sian and Armstrong, Geof, 1995, *European Disability Arts Directory,* Newcastle-upon-Tyne: National Disability Arts Forum

Poetry/Creative writing
Bangay, Frank and Porter, Hilary (eds), 1992, *From Dark to Light,* London: Survivors Press

Brisenden, Simon, *Body Shopping*, Southampton: Self-published

Brisenden, Simon, *Poems for Perfect People*, Southampton: Self-published

Ford, Jenny, Hambrook, Colin and Porter, Hilary (eds), 1995, *Under The Asylum Tree*, London: Survivors' Press

Keith, Lois (ed) 1994, *Mustn't Grumble: Writing by Disabled Women*, London: The Women's Press Matter of Life and Death, Zero Books

Napolitano, Sue 1994, *A Dangerous Woman,* Manchester: GMCDP Publications

O'Reilly, Kaite (ed), 2003, *Shelf Life*, Newcastle-upon-Tyne: National Disability Arts Forum

Smith, Ken and Sweeney, Matthew (eds), 1997, *Beyond Bedlam*, London: Anvil Press

Sutherland, Allan and ap Hywel, Elin (eds), 2004, *Hidden Dragons: New Writing by Disabled People in Wales*, Cardigan: Parthian

Sutherland, Allan, 2004, Paddy: A Life. Transcription poems from the words of Paddy Masefield, Disability Arts Online: (http://disabilityarts.com/depth/paddy-masefield/)

Visual Arts
Earnscliffe, Jayne, 1992, *In Through the Front Door: Disabled People and the Visual Arts, Examples of Good Practice*, London: Arts Council of Great Britain

Hempstead, Michael, 1990, *Out of Ourselves* (Exhibition review) DAIL 41

Heaton, Tony, 1995, *Great Britain From a Wheelchair, DAIL* 101

Lapper, Alison with Feldman, Guy, 2005, *My Life in My Hands*, London: Simon and Schuster

Nicholls, David, 1997, *Pooling Ideas: On Art and Imaging*, Stoke on Trent: Trentham Books in association with NSEAD

Shingler, Aidan, 1999, *Beyond Reason: The Experience of Schizophrenia*, Self-published

Performing Arts
Goodley, Dan and Moore, Michele, 2002, *Disability Arts Against Exclusion: People with Learning Difficulties and their Performing Arts*, Plymouth: British Institute of Learning Disabilities BILD Publications

Bailey, Ruth, 2002, *Equal Opportunities Policy Into Practice: Disability*, London: Independent Theatre Commission

Representation
Barnes, Colin for British Council of Disabled People, 1992, *Disabling Imagery and the Media: An Explanation of the Principles for Media Representation of Disabled People*, Halifax: Ryburn Publishing

Hevey, David, 1992, *The Creatures Time Forgot: Photography and Disability Imagery*, London: Routledge

Norden, Martin F, 1994 *The Cinema of Isolation: A History of Physical Disability in the Movies*, New Brunswick, New Jersey: Rutgers University Press

Education

Saunders, Kathy, 2000, *Happy Ever Afters, a storybook guide to teaching children about Disability*, Stoke on Trent: Trentham Books

Sutherland, Allan, 1994, *Disability, Arts and Education: Report for the Arts Council of England*, London: Arts Council of England

Taylor, Michele, 2004 *Access All Areas: Disability and Youth Arts*, Maidstone: Dada-South

Tomlinson, Richard, 1982, *Disability, Theatre and Education*, London: Souvenir Press

Vine, Chris, 1993, *Setting the Scene: A Study of Provision in Greater London for Pupils with Special Educational Needs*, London: Graeae Theatre Company

History

Arts Council, 1991, *National Arts and Media Strategy: Discussion Document on Arts and Disability*, London: Arts Council

Boot, Penny, May 1996, Taboo and Censorship (Guest editorial), *DAIL* 113

Brisenden, Simon, December 1988, What is Disability Culture? *DAIL* 26

Campbell, Peter, December 1991, Survivors' Poetry: A Personal Introduction *DAIL* 61

Colleran, Mandy, June 1988, Integration or Segregation: Do Disabled People Have a Choice? *DAIL* 20

Finkelstein, Vic, June 1987, Disabled People and Our Culture Development, *DAIL* 8

Getting Noticed, Exhibition of Disability Arts posters with accompanying teaching pack, available from National Disability Arts Forum

Harris, Moya and Hancock, Wendy, 2003, *Above and Beyond: Celebrating a World of Disability Arts and Culture* (Festival and conference report), Sampford Peverell, Devon: EQUATA Ltd

Heaton, Tony and St George, Sara, 2002, *DA21: Disability Arts in the 21st century* (Conference report), Poole: Holton Lee

Markham, Natalie, November 1989, A.I.M.ing high and staying there! *DAIL* 37

Stanton, Ian, July 1991, Freewheelin', *DAIL* 56

Sutherland, Allan, September 1989, Disability Arts, Disability Politics (Paper presented at London Disability Arts Forum conference, July 1989) *DAIL* 35

Walsh, Katherine, November 1991, Disability Arts and Equality, *DAIL* 60

Organisation
Arts Council of Great Britain, 1993, *Report on the Initiative to Increase the Employment of Disabled People in the Arts*, London: Arts Council of Great Britain

Crow, Liz, 1993, *Disability Arts The Business*, Newcastle-upon-Tyne: National Disability Arts Forum

Delin, Annie and Morrison, Elspeth, 1993, *Guidelines for Marketing to Disabled Audiences*, London: Arts Council of Great Britain

Access
Holmes-Siedle, James, 1996, *Barrier-free Design: A manual for building designers and managers*, Oxford: Butterworth Architecture

Monahan, Judy, McMullan, Emma and Jentle, Ian, 1995, *Free For All: Access for Disabled People to Sadlers Wells,* London: London Boroughs Grants Committee

North West Disability Arts Forum, 2004, *Action for Access*, London: Arts Council England

Sutherland, Allan, *Access to the Arts: A Study of Good Practice at the London Coliseum*, 1992, London: London Boroughs Disability Resourse Team

SOME DISABILITY COMPANIES AND ARTISTS

[Details have been checked with Disability Arts Online (DAO) October 2005, with organisations' own websites or directly with organisations.

For details of individual artists and for updated details check Disability Arts Online, www.disabilityarts.com/map/links , National Disability Arts Forum website www.ndaf.org or local Disability Arts organisations (see below)]

For information on local events, see local organisations and their websites, Disability Arts in London Magazine, *DAIL* (published by London Disability Arts Forum) and the e-bulletin Etcetera (produced by the National Disability Arts Forum).

■ **Disability Arts organisations**
arcadea (formerly Northern
Disability Arts Forum)
Mea House
Ellison Place
Newcastle upon Tyne NE1 8XS
T 0191 222 0708
F 0191 233 1771
Minicom 019 1261 2238
info@arcadea.org
www.arcadea.org

Serving Cumbria, Durham,
Northumberland, Teesside and
Tyne and Wear, arcadea seeks to
empower disabled people
through the promotion of
Disability Arts and culture.

Artsline
54 Charlton Street
London NW1 1HS
T 020 7388 2227
F 020 7383 2653
Minicom 020 7388 7373
access@artsline.org.uk
www.artsline.org.uk/

London-based provider of
disability access information
service to the arts, leisure and
entertainment, including
multicultural project and youth
project.

Carousel
113 Queens Road
Brighton
BN1 3XG
T 01273 234734
F 01273 234735
www.carousel.org.uk
enquiries@carousel.org.uk

Carousel 'inspires people with
learning disabilities to achieve
their artistic ambitions'.

CREATE
c/o Vauxhall Centre
Johnson Place
Vauxhall Street
Norwich NR2 2SA
T/F/Minicom 01603 626972
www.vcentre.fsnet.co.uk/>
create@vcentre.fsnet.co.uk

A voice for disabled people in the
arts, particularly in Norfolk.

Dada-South
PO Box 136
Cranbrook
Kent
TN17 9AD
T/F 01580 714642
info@dada-south.org.uk
www.dada-south.org.uk

Deaf Arts Development Agency
(John Wilson, Director)
SHAPE London
LVS Resource Centre
56 Holloway Road
London N7 6PA
T 020 7700 0100
F 020 7700 8143
Minicom 020 7700 8138/9
john.wilson@shape_uk.co.uk
info@shape-uk.co.uk

Disability Arts Online
www.disabilityarts.com

Disability Arts in Shropshire (DASH)
DASH
Pimley Barns
Sundorne Road
Shrewsbury
SY4 4SA
T 01743 272625/271236
F 01743 271516
Textphone 07732 614592
info@dasharts.org
www.dasharts.org

Produce an annual Disability Arts festival

Edward Lear Foundation
60 Bonham Road
London
SW2 5HG
info@learfoundation.org
www.learfoundation.org

Disability Arts think-tank, currently focusing on preserving the history of Disability Arts. Closely involved with development of the National Disability Arts Collection and Archive.

Equal Arts
Swinburne House
Swinburne Street
Gateshead NE8 1AX
T 0191 477 5775
F 0191 477 0775
www.equalarts.org.uk
information@equalarts.org.uk

Equata UK
Bradninch Place
Gandy Street
Exeter EX4 3LS
T 01392 219440
Textphone 01392 219 441
F 01392219441
info@equata.co.uk
www.equata.co.uk

'Equata is an organisation of disabled people which promotes equality and access within the arts, primarily in the South West.'

Full Circle Arts
Greenheys Business Centre
10 Pencroft Way
Hulme
Manchester M15 6JJ
T 0161 279 7878
F 0161 279 7879
www.full.circle_arts.co.uk

A Disability Arts development agency controlled and managed by disabled people.

Holton Lee
East Holton
Holton Heath
Poole
Dorset BH16 6JN
T 01202 625562
F 01202 632632
info@holtonlee.co.uk
www.holtonlee.co.uk

Holton Lee is home to a dedicated Disability Arts gallery (Faith House). Offers accessible holidays, retreats and arts activities within 350 acre setting leading down to Poole Harbour. Home to National Disability Arts Collection and Archive.

Inspire (formerly Cross Border Arts)
Wysing Arts Centre
Fox Road, Bourn
Cambridge CB13 7TX
T/Minicom 01954 718181
F 01954 718333
admin@inspire.org.uk
www.inspire.org.uk

Inter-Action MK
The Old Rectory
Waterside
Peartree Bridge
Milton Keynes MK6 3EJ
T 01908 678514
F 01908 233634
interaction@claranet.co.uk

Arts development agency in the Milton Keynes region. Produce an annual Disability Arts Festival

London Disability Arts Forum (LDAF)
20-22 Waterson Street
London E2 8HE

(Phone numbers at this new address are not available at the time of writing. Check website for details.)

www.ldaf.net
info@ldaf.net

The first Disability Arts Forum, and still a cutting-edge organisation. They publish *Disability Arts in London* magazine, run the Disability Film Festival and hold an annual exhibition at ICI headquarters which marks a new partnership between Disability Arts and business sponsorship.

National Disability Arts Collection and Archive
Holton Lee
East Holton
Holton Heath
Poole
Dorset BH16 6JN
T 01202 625562
F 01202 632632
archive@holtonlee.co.uk
www.holtonlee.co.uk

National Disability Arts Forum (NDAF)
59 Lime Street
Newcastle upon Tyne NE1 2PQ
T 0191 261 1628
F 0191 222 0573
Textphone: 0191 261 2237
ndaf@ndaf.org
www.ndaf.org

Leading national (and, to some extent, international) Disability Arts organisation. They produce the weekly bulletin *EtCetera*. Their website is an important source of information about individual artists.

North West Disability Arts Forum (NWDAF)
MPAC Building
1-27 Bridport Street
Liverpool L3 5QF
T 0151 707 1733
Minicom: +44 (0) 151 706 0365
F +44 (0) 151 708 9355
nwdaf@nwdaf.co.uk

Prism Arts
Unit 1 Brampton Business Centre
Union Lane
Brampton
Cumbria BA8 1BX
T 01697 745011
F 01697 745006
office@prismarts.fsnet.co.uk
www.prismarts.co.uk

Prism Arts exists to promote and support disabled people's access to creative arts activities in Cumbria.

Shape London
The London Voluntary Sector
Resource Centre
356 Holloway Road
London N7 6PA
T 020 7619 6160
F 020 7619 6162
Minicom 020 7619 6161
www.shapearts.org.uk
info@shapearts.org.uk

Shape is an arts organisation for people with disabilities, deaf people and older people. (See also Shape Deaf Arts.)

Shape Deaf Arts
LVS Resource Centre
356 Holloway Road
London N7 6PA
F 020 7619 6162
Textphone: 020 7619 6164
John@shapearts.org.uk
www.shapearts.org.uk/deafarts.htm

Shape Deaf Arts produces the quarterly magazine Deaf Arts UK. The organisation aims to increase access to the arts for deaf and hard of hearing people; to promote arts and culture by deaf people and to support deaf artists in finding opportunities.

West Midlands Disability Arts Forum (WMDAF)
116 Greenhouse
The Custard Factory
Gibb Street
Digbeth
Birmingham B9 4AA
T 0121 224 7881
office@wmdaf.custardfactory.co.uk
www.wmdaf.org

West Midlands Disability Arts Forum is a disability-led organisation focused on promoting Disability Arts and the work of disabled artists in Birmingham and the West Midlands area.

■ Performance groups

Most of the following organisations provide workshops as well as formal performances.

■ Dance

Anjali Dance Company

Mill Cottage
The Mill Arts Centre
Spiceball Park
Banbury OX16 8QE
T/F 01295 251909
http://www.anjali.co.uk/
info@anjali.co.uk

Professional contemporary dance company of people with learning disabilities

Blue Eyed Soul

Belmont Arts Centre
5 Belmont
Shrewsbury SY1 1TE
T 01743 245998
F 01743 344773
www.blueyedsouldance.com/
blue-eyed-soul@fsmail.net

Blue Eyed Soul is the West Midlands leading inclusive community Dance Company. Provides 'performance, education and training for disabled and non-disabled people of all ages'.

CandoCo Dance Company

21 Leroy House
436 Essex Road
London N1 3QP
T 020 7704 6845
F 020 7704 1645
www.candoco.co.uk
info@candoco.co.uk

Leading European professional integrated dance company, jointly founded by disabled dancer and a non-disabled dancer.

Common Ground Sign Dance Theatre

Gostins Building
32-36 Hanover Street
Liverpool L1 4LN
T 0151 707 8033
F 0151 707 8033
Textphone: 0151 707 8380
info@signdance.com
www.signdance.com

Common Ground is a Cultural Performing Company who create unique performances through the fusion of sign language, dance and physical theatre, which are accessible to all audiences. (*This company is likely to change its name in December 2005. See website for details.*)

Green Candle Dance Company
Oxford House
Derbyshire Street
Bethnal Green
London E2 6HG
T 020 7739 7722
F 020 7729 0435
info@greencandledance.com
www.greencandledance.com

Community dance company.
Have produced a Dance Summer
School for Deaf Children in
collaboration with Sadler's Wells
annually since 1999.

Sign Dance Collective
C/O WS Everdina Amstel t/o 95
1011 PX Amsterdam
T 0031613295734
The Netherlands
signdance@ruebarree.nu
www.signdancecollective.com

An international artists-led deaf
and hearing collective, promoting
equality, sustainability and
creativity through performances
and workshops that mix sign
dance, live music, poetry, and
sign theatre.

■ Drama
Extant
Unit 3 40 Dealtry Road
London SW15 6NL
T 020 8780 0334
Mobile 07956 557 390
Extant1@btinternet.com
www.extant.org.uk

Professional theatre company of
visually impaired people

Full Body & The Voice
Lawrence Batley Theatre
Queen's Square
Queen's Street
Huddersfield HD1 2SP
T 01484 484441
F 01484 484443
www.fullbody.org.uk
fullbody@lbt-uk.org

Graeae Theatre Company
LVS Resource Centre
356 Holloway Road
London N7 6PA
T 020 7700 2455
F 020 7609 7324
Textphone: 020 7700 8184
info@graeae.org
www.graeae.org

Leading professional theatre
company of disabled people.

Heart 'n Soul
The Albany
Douglas Way
London SE8 4AG
T 020 8694 1632
F 020 8694 1532
info@heartnsoul.co.uk
www.heartnsoul.co.uk

A dynamic arts organisation for people with learning disabilities. Has pioneered an original and innovative way of working, using contemporary music, theatre and club culture. Programme includes touring performances, clubs, training, residencies and an extensive programme of workshops, providing opportunity for people with learning disabilities to realise their talents and personal potential.

Jigsaw Theatre Company
Queens Park Arts Centre
Queens Park
Aylesbury
Bucks HP21 7RT
T 01296 436363
anything@jigsawtheatre.org.uk
www.jigsawtheatre.org.uk

Small theatre company of disabled people.

The Lawnmowers Independent Theatre Company
Swinburne House
Swinburne Street
Gateshead NE8 1AX
T/F 0191 478 9200
thelawnmowers@onetel.net.uk

Theatre company run by and for adults with learning difficulties, tours nationally and internationally, provides Krocodile Klub disco and specialises in excellent resource packs.

Mental Health Media
356 Holloway Road
London N7 6PA
T 020 7700 8171
F 020 7686 0959
info@mhmedia.com
www.mhmedia.com
www.mediabureau.org.uk

Mental Health Media uses all media to promote people's voices in order to reduce the discrimination and prejudice surrounding mental health and learning difficulties.

Mind the Gap
Queen's House
Queen's Road
Bradford BD8 7BS
T 01274 544683
F 01274 544501
www.mind-the-gap.org.uk/
arts@mind-the-gap.org.uk

Yorkshire-based theatre company of people with learning disabilities.

No Limits Theatre Company
Dundas Street
Sunderland
Tyne And Wear SR6 0AY
T 0191 5532821
info@nolimitstheatre.org.uk
www.nolimitstheatre.org.uk

Professional touring company of actors with learning disabilities.

Oily Cart
Smallwood School Annexe
Smallwood Road
London SW17 0TW
T 020 8672 6329
F 020 8672 0792
http://www.oilycart.org.uk/
enquiries@oilycart.org.uk

Theatre work with young people with severe learning disabilities, including a project specifically designed for the Profound and Multiple Learning Disability (PMLD) units of SLD schools.

Other Voices Theatre Company
The Angel Centre,
Angel Place,
Worcester WR1 3QN
T 01905 724 801

A learning disabled, touring theatre company who seek to promote a wider public awareness and understanding of people who are learning disabled.

The Shysters Theatre Company
Belgrade Theatre
Belgrade Square
Coventry CV1 1GS
T 024 76 846713
T 024 76 256431 (ext. 214)
F:024 76 550680
lleech@belgrade.co.uk

The Shysters are a company of learning disabled performers, and team of theatre practitioners who create new plays together through a devising process.

Wolf + Water Arts Company
The Plough
9/11 Fore Street
Torrington
Devon EX38 8HQ
T 01805 625533
Mobile 07968 108150
w+w@eclipse.co.uk
www.wolfandwater.org

Wolf + Water Arts Company 'use arts techniques creatively and as part of the therapeutic processes with groups who are socially, mentally or physically impaired'.

■ Film, Video and Multimedia

Disability Film Festival
20-22 Waterson Street
London E2 8HE
www.disabilityfilm.org
dff@disabilityfilm.org
(Phone numbers at this new
address are not available at the
time of writing. Check website for
details)

Remark!
13 Greenwich Quay
Clarence Rd
Greenwich
London SE8 2EY
T 020 8691 0210
F 020 8469 3689
Textphone: 020 8691 0226
info@remark.uk.com
www.remark.uk.com

Television, video and multimedia
production company, established
by two young deaf entrepreneurs,
specialising in providing access to
the 70,000+ British Sign Language
users in the UK.

Roaring Girl Productions
1c Birchall Road
Bristol BS6 7TW
T/F 0117 944 6882
info@roaring-girl.com
http://www.roaring-girl.com

'Roaring Girl Productions is a
creative media projects company
based in Bristol. We undertake
media productions, training and
associated projects. Our work is
defined by imagination and
quality and underpinned by a
strong sense of humanity and
constructive change.'

■ Poetry

Survivors' Poetry
The Diorama Arts Centre
34 Osnaburgh Street
London NW1 3ND
T 020 7916 5317
F 020 7916 0830
survivor@survivorspoetry.org.uk
www.groups.msn.com/
survivorspoetry

Also regional branches, and
poetry readings as well as
publications.

■ Music

Drake Music Project
The Deptford Albany
Douglas Way
Deptford
London SE8 4AG
T 020 8692 9000
F 020 8692 3110
info@drakemusicproject.org
www.drakemusicproject.org

■ Visual Arts

The Art House
Wakefield College
Margaret Street,
Wakefield. WF1 2DH
T 01924 377 740
Minicom: 01924 377 310
F01924 377 090
info@the_arthouse.org.uk
www.the_arthouse.org.uk

'An inclusive organisation that
believes in enabling all artists to
have access to work, training and
exhibition opportunities in
accessible settings.'

■ Combined Arts

art + power
St Werburghs Community Centre
Horley Road
St Werburghs
Bristol BS2 9TJ
T 0117 908 9859
F 0117 908 9861
Textphone 0117 908 98 60,
www.artandpower.com
info@artandpower.com
Also home to Portway Players
theatre company. Hosts Annual
Paddy Masefield Award.

Action Space
Cockpit Arts
Cockpit Yard
Northington Street
London WC1 2NP
T 020 7209 4289
F 020 7209 0198
www.actionspace.org
office@actionspace.org

Learning Disability Arts
organisation who encourage
integration into the community
through visual arts projects in
local arts venues. Participants
contribute to all areas of project
organisation and management
and have opportunities to
become workers and volunteers.

Appendix 3

Disability Arts: A Brief Chronology
(For a more detailed chronology of the events of Disability Arts, by
Allan Sutherland see www.disabilityarts.com, www.ndaf.com and
elsewhere.)

1976
SHAPE founded

1977
Basic Theatre Company founded by Ray Harrison Graham

1980
Graeae (Theatre group of Disabled People) founded by Nabil Shaban
and Richard Tomlinson. First production: Sideshow

British Council of Organisations of Disabled People founded

1981
International Year of Disabled People

Ian Dury's *'Spasticus Autisticus'* banned by the BBC

'Carry On Cripple' season at National Film Theatre, programmed by
Allan Sutherland and Steve Dwoskin

Artsline founded

1982
Strathcona Theatre first public performance

1986

Arts Integration Merseyside (later to become North West Disability Arts Forum) withdraws from the SHAPE Network

London Disability Arts Forum (LDAF) founded

LDAF launch 'The Workhouse', the first Disability Arts cabaret, which becomes a fortnightly event at the Tabernacle Arts Centre in West London. Featured artists include Heart'n Soul, sign language poet Dorothy Miles, singer Kate Portal, jazz group Jodelko, poet Simon Brisenden, sign song performer Sarah Scott, singer Ian Stanton, singer Johnny Crescendo, comic Wanda Barbara. Regular MC is Allan Sutherland.

Heart 'n Soul founded

Disability Arts in London (DAIL) magazine started

Common Ground Sign Dance Theatre set up

1988

David Hevey's 'Sense of Self' exhibition, Camerawork gallery

Disability Arts Conference, Manchester Subjects explored include: working definition of 'culture', short history of oppression of disabled people, 'Disability Arts – a segregated or mainstream culture?'. Plus a strong debate on issue of integration: Is integration acceptable if it isn't on disabled people's terms? Why do disabled people need a separate space to explore their identity and culture?

1989

Moving On Festival, organised by LDAF and SHAPE London: Over 40 artists and organisations in eight locations around London, plus a two-day conference on Disability Arts

New Breed Theatre Company founded

1990

'Out of Ourselves', exhibition of disability visual art organised by LDAF at the Diorama Gallery. Artists include Tony Heaton, Lucy Jones, Nancy Willis, Trevor Landell, Gill Gerhardi

National Disability Arts Forum (NDAF) founded

North West Disability Arts Forum (NWDAF) launched

1991

'Disability Art and Culture' seminar arranged by SHAPE London, Open University and DAIL magazine

Survivors' Poetry founded

1st Block Telethon demonstration led by a mixture of disabled political activists and disability artists. Speeches by Mike Oliver, Mike Higgins and others, performance by Johnnie Crescendo, Ian Stanton, Allan Sutherland and others

LDAF Euroday. LDAF commission Tony Heaton to produce 'Shaken Not Stirred', a sculpture built from charity collecting cans

CandoCo founded

1992

2nd Block Telethon demonstration. 'Shaken not Stirred' repeated as part of press launch

David Hevey: *The Creatures Time Forgot: Photography and Disability Imagery* published by Routledge

Disability Arts Magazine (later DAM) becomes the first arts organisation run, staffed and controlled entirely by disabled people to obtain revenue funding from the Arts Council of Great Britain

Paddy Masefield chairs Steering Committee to establish West Midlands Disability Arts Forum (WMDAF)

1993

Deaf Arts UK founded by SHAPE London

From Dark to Light, first Survivors' Poetry anthology

NDAF presents 'The Ghetto', International Disability Arts Cabaret at the Edinburgh Festival.

Open Theatre Company organises a national Festival of Theatre by Learning Disabled People. 30 companies attend

1994

Blue Eyed Soul Dance Company give first performance at the Shrewsbury Music Hall

North West Shape relaunches as Full Circle Arts

July Demonstration by Disability Arts Consortium to protest against Arts Council's decision to close its Disability Unit

'Out to Lunch', exhibition of photography by Mandy Holland documenting her experiences in the psychiatric system

DAIL feature on Disability Theatre reports on: Strathcona Theatre Company; Heart 'n Soul; Graeae Youth Theatre; TX True Expression; Graeae Theatre Company; Julie Fernandez; Mockbeggar Theatre company; New Breed Theatre; Invisible Cabaret

Graeae Theatre Company present 'Ubu': Jamie Beddard, Mandy Colleran, Simon Startin, Vicky Gee Dare, Sara Beer, Caroline Parker. Adapted Trevor Lloyd. Directed Ewan Marshall

'Defiance – Art confronting Disability'. Exhibition opens at Stoke-on-Trent Art Gallery and tours nationally

1995

'Unleashed: Images and Experience of Disability' (Laing Art Gallery, Newcastle). Artists exhibiting include Nancy Willis, Tony Heaton, Tanya Raabe. Steve Cribb, Gil Gerhardi, Eddy Hardy, Tony Heaton, Ann Whitehurst

Launch of NDAF's European Disability Arts Directory

Allan Sutherland inaugurates LDAF postcards project as a way of providing commissions for artists and barrier-free access to disability art

Under The Asylum Tree (Survivors' Poetry anthology)

A Dangerous Woman. Poems by Sue Napolitano, with drawings by Val Stein, GMCDP Publications

'Exposed – Great Britain from a Wheelchair' Solo exhibition by Tony Heaton at Diorama Gallery

Lawnmowers' video of 'The Big Sex Show'

1996

'Moving from Within' Video about Disability Arts by Chris Ledger. (AVA/East Midlands SHAPE production)

Graeae Theatre Company touring 'Flesh Fly'

Aidan Shingler's 'Beyond Reason' shows in Bishop Auckland

'1 in 8' media pressure group established to increase disability representation in television

1997

Tottering Bipeds Theatre Company's 'Waiting for Godot' with disabled actors Jamie Beddard and Simon Startin

Inmates by Allan Sutherland and Stuart Morris (BBC Radio Four). A ninety minute play set in a long stay institution for disabled people, starring disabled actors Matthew Fraser, Daryl Beeton, Jonathan Keeble, Gerard McDermot, Mandy Colleran, Mandy Redvers-Higgins and Dave Kent

Blue Eyed Soul create their first dance video, Soul Agents, filmed on location at Shrewsbury Railway Station

FRAMED: Interrogating Disability in the Media, edited by Ann Pointon with Chris Davies, published with major funding from both ACE and BFI, launched by Paddy Masefield

1998

'Postal Strike', truncated form of above postcards project, provides commissions for Meena Jafarey, Tanya Raabe, Nancy Willis, Ann Whitehurst and Steve Cribb among others

Heart 'n Soul create the Beautiful Octopus Club, where people with learning disabilities can enjoy a professional-standard clubbing experience

Full Body and The Voice founded

art + power set up

1999

Survivors' Poetry 'Fresher than Green, Brighter than Orange'. An exhibition of poems by Irish women (Diorama Foyer). Anthology of same name available from Survivors Press

'Wrong Bodies' festival at Institute of Contemporary Arts includes disability artists Mat Fraser and Katherine Araniello

Graeae Theatre Company launches 'The Missing Piece', intensive six month training course for disabled actors

Katharine Araniello, an artist who attended special school, graduates from London Guildhall University with First Class Honours in art. She receives the Owen Rowley Prize for the end of year degree show, after showing disability-based video installations

'Lifting the Lid' , LDAF's first Disability Film Festival

Launch of Sue Napolitano Award (An award of £10,000 to be made to a disabled writer to produce a body of writing which explores issues of disability as its main theme.) Won by Lois Keith. Now discontinued for lack of funding

2000

'Getting Noticed' (NDAF exhibition, of posters for Disability Arts events, for young people)

Second LDAF Film Festival

Liz Crow's film 'Frida Kahlo's Corset' is commissioned by the Xposure Festival

'Strength to Strength' exhibition in Bristol. A Year of the Artist project by art + power through residency with Eddy Hardy

2001

Third LDAF Film Festival

'Large' – New show from Heart 'n Soul breaks new ground by exploring cast members' past experience of discrimination

Survivors' Poetry *Write on the Edge* anthology

Victoria Waddington Associates, leading disability access consultancy, develop 'one per cent for Disability Arts' policy, encouraging clients to commission disabled artists as part of making buildings accessible under the Disability Discrimination Act

'Adorn Equip' Exhibition examining issues around design of equipment and accessories for disabled people at City Gallery, Leicester

2002

LDAF's Fourth Disability Film Festival, held for the first time at the National Film Theatre

Allan Sutherland founds the Edward Lear Institute, a Disability Arts think tank. Its first project is to look at ways of archiving the achievements to date of Disability Arts

Xposure Festival of Disability Arts, at six venues around London

Faith House, at Holton Lee, is the first purpose-built exhibition space devoted to promoting the work of disability artists. Designed by architect Tony Fretton, it was chosen by the *Guardian* as the Best British Building of 2002

2003

art+power Artist's residency at Tate Liverpool

LDAF, in partnership with ICI, launch a rolling programme exhibiting disability art at ICI's corporate headquarters

'Shelf Life' NDAF project providing writing workshops for people with limited life expectancy, leading to publication *Shelf Life*, illustrated by a range of established disability artists

Julie McNamara writes and performs 'Pig Tales'

Equata run 'Above and Beyond', an international conference and festival of Disability Arts. The event includes the presentation of the first Paddy Masefield Award for learning-disabled artists, won by Ali Cuthbert for Disabled Friends Together.

Paddy Masefield Award for learning-disabled visual artists in the South West launched at Above and Beyond

2004

Holton Lee receive funding to create a National Disability Arts Archive, to be housed in a purpose-built building. A steering committee of leading figures from Disability Arts embarks on the process of planning the archive and creating policies

Arts Disability Wales run 'The Write Stuff', a series of writing classes which lead to production of anthology, *Hidden Dragons*

Brenda Cook winner of 2004 Paddy Masefield Award presented by Sandy Nairne Director of the National Portrait Gallery (NPG). NPG becomes the first national art gallery to create a portal from their own website to a Disability Arts website – art + power

2005

Extant, a new theatre company of visually impaired people, present 'Extant' by Maria Oshodi, with audio description built in to the play

Julie McNamara writes and performs 'Pig's Sister'

Mat Fraser writes and co-performs 'Thalidomide: A Musical'

Paddy Masefield Award 2005 is presented by Sir Christopher Frayling, chair of Arts Council England, to Jonathan Barr Lindsay

Liz Crow directs and produces short film NECTAR

Appendix 4

LIFE? IT'S A GAME OF TWO HALVES

PADDY MASEFIELD a CV
Born: 17.09.1942 Kampala, Uganda

1947 Returned to UK

1956-61 Repton School, Derby

1961-62 Miscellaneous employment and travel N, E and W Africa

1962-66 Cambridge Univ. BA and MA Social Anthropology

BEFORE	DISABILITY	AFTER
1966 Partly unemployed	**1986** Became a disabled person	
1967 Appointed North East Arts Assoc. Drama, Film and Literature Officer	**1987** Diagnosed severe M.E. Daily blackouts – Severe allergies	
1968 Appointed to 5 N E. Theatre Boards	**1988** Appointed Chair of Collar and T-I-E	
1969 Trainee theatre director Newcastle Founded Stagecoach YPT theatre Wrote first play – *Blow the Whistle*	**1989** Appointed Vice-Chair M.E. Association Appointed ACGB Disability Monitoring Committee Appointed ACGB Planning Board	
1970 *Play with Fire* wins Welsh National Dramatists Award (co-author)	**1990** Appointed First Honorary Life Member of Directors Guild of Great Britain	

1971
Stagecoach subject of Tyne Tees
TV Documentary – *Not so much
a Theatre, more a way of Life*

1972
Delegate to USA and Canada`
ASSITEJ Festival
Stagecoach tours nationally

1973
Full time playwright
3 plays at national YPT Festival
Awarded ACGB grant for book

1974
Artistic Director Oldham Rep
First consultancy Report, for
MAA
First National Arts Conference
speech
Guest Lecturer Rose Bruford
Drama School

1991
Appointed First Honorary Life
Member UK branch of ASSITEJ
international

1992
Appointed to Board of W
Midlands Arts
Chair Steering Committee
WMDAF
Appointed Vice-Chair ACE
Disability Monitoring Committee
Gives first Disability Speech

1993
Appointed to BFI National Forum
Appointed to Board of NDAF
Appointed to Regional Board of
Central TV
Appointed Chair Editorial Board
FRAMED
Delegate to Helsinki Human
Rights Conference. Chair Working
Group.
Disability Advisor to Arts
component of Manchester
Olympic bid

1994
Acting Chair ACE Dis. Monitoring
Cte.
Chair Disability Employment
Initiative
Board Member Coventry
BelgradeTheatre
Appointed to Arts Lottery Board
(ACE)
Opened *Defiance* Exhibition
Mentored 2 RSC Disability
Apprentices

1975
Associate Director Hornchurch
Rep.
Director Bruvvers Community
Theatre Co.

1976
Consultancy Report
'Development of Theatre in
Yorkshire'
Directed national tour of *The
Great Discovery Show*

1977
Artistic Director Worcester Swan
Theatre
Advisory Drama Panel ACGB
Guest Director Bruvvers
Consultancy Reports Gröningen,
Holland

Keynote speaker Dublin Disability
Conf.
6 speeches on Disability and Arts
– including TMA Centenary
Conference

1995
Appointed Hon. Pres. Worcs. M.E.
Groups
Speeches for: Museums Assoc.
Annual Conference; NCA; RNT;
Shropshire Arts Forum;
Hampshire Community Arts
conference

1996
Awarded OBE for 'Services to the
Arts'
Appointed Chair The World
Beyond 2000
Member 1 in 8 media campaign
committee
Speeches for: CandoCo
Symposium;
School Governors and Head
Teachers (NEC);
Birmingham Education Arts
Forum;
University of Central England

1997
Member Channel 4 Disability
Advisory Group
Chair Edinburgh International TV
Festival Comedy programme
Speech and workshops for
European Theatre Directors
Forum (Athens)
Chair Equity/1 in 8 Forum

Opened Belle Vue Sculpture Trail
Opened Retrospective Exhibition
of Avtarjeet Dhanjal
Launched *FRAMED* at MOMI
Speech for Independent Theatre
Council

1978

Director of International theatre
company Gröningen
Appointed Drama Panel WMA
First Young People's Theatre
Festival Swan Theatre,Worcester

1998

Nominated for ABSA's 'Creative
Briton of the twentieth century'
Launched JOB 2000 – Project
Leader
Appointed Education sub
committee ACE
Appointed Architecture
Committee WMA
5 speeches, including Southern
Arts 'Arts and Disability'
Conference.

1979

Adapted *Treasure Island* for
stage
Directed 250th production at
Swan Theatre
1st Rep Co. to stage *Godspell*
Wrote first pantomime – *Aladdin
and Panda*

1999

Appointed to Board of THE
PUBLIC, Sandwell
Appointed national artists rep. on
Board of Year of the Artist
Appointed to Touring Panel ACE
Founder Sue Napolitano Award
Adviser to LIPA's 'Solid
Foundation'
Course for disabled students
Set up JOB 2000 Steering Group

1980

Adapted *Wuthering Heights* for
stage
Adapted and directed *Animal Farm*
Wrote pantomime *Puss in Boots*
Appointed to Arts Lottery Board
(ACE)

2000

Appointed National Chair of
YOTA Think Tank
Judges panel Sue Napolitano
Award
Appointed Chair of EQUATA Ltd.
S.W.

Keynote speech for SWA *Role of the Artist in the New Millennium*

1981

Consultancy report for
Professional Co. at Redditch
Palace Theatre
Ran Newcastle Upon Tyne
marathon

2001

Speeches for: Arts Marketing
Assoc; and 'CPD Matrix Retreat'.
Opened art + power YOTA
Exhibition
Lead article YOTA final
publication
Presented views of YOTA Think
Tank

1982

Wrote report *Marketing to Young
People* for Theatre Managers
Assoc
Directed season of improvised
plays for Palace Theatre Redditch
Ran Redditch Marathon

2002

Diagnosed with terminal cancer
Appointed Board of Foundation
for
Community Dance

1983

Appointed founding Council of
DGGB
Appointed Member Directors
Training Committee ACGB

2003

Keynote speech for 'Above and
Beyond'
European Year of Disabled
People Festival Presented 1st
Paddy Masefield Award
Travelled in India and round
South America and West Indies

1984

Consultancy reports for: Arts
Development strategy St Helens
Puppetry Centre in
Northumberland
Building report for Hereford
Theatre
Visited Moscow/Leningrad for
YPT
Theatre study exchange

2004

EQUATA UK launched as all
disabled led and staffed.
2nd Paddy Masefield Award
presented by Sandy Nairne,
director of National Portrait
Gallery
Travelled to Norway and Arctic
Circle

1985

Wrote Community Play
Woodbine Willlie.
Appointed Management
Committee of new Worcester
Concert Hall
Wrote Arts Development
strategies for Lincoln and for
Peterborough

1986

Directed Community Play Carlisle
Advised Bishop of Lincoln's
Working Group
Report on future of Drama
Education for County of Hereford
and Worcester
Report on Unity Theatre
Liverpool

2005

3rd Paddy Masefield Award
presented by Sir Christopher
Frayling, Chair ACE
Travelled circumnavigation of
globe.
Wrote *STRENGTH*

2006

STRENGTH published

WHO'S LIFE IS IT ANYWAY?

Index